Lamen Laughter

Lament and Laughter

The Psalms in English Verse

David G. Preston

Copyright © 2021 Mavis Preston

First published in 2021 by Piquant Editions, Manchester, UK
www.piquanteditions.com

ISBNs
978-1-80329-000-3 Hc
978-1-80329-001-0 Pb
978-1-80329-002-7 Epub

David G. Preston has asserted his right under the Copyright, Designs and Patents Act 1988 to be identified as the Author of this work.

All Rights Reserved. No part of this publication may be reproduced, stored in a retrieval system or transmitted, in any form or by any means, electronic, mechanical, photocopying, recording or otherwise without written permission. Permissions for use of content can be requested from The Piquant Agency, www.piquanteditions.com

All biblical quotations, unless otherwise stated, are from the *English Standard Version*

British Library Cataloguing-in-Publication Data
A catalogue record of this book is available in the UK from the British Library.

ISBN **978-1-80329-000-3**

Cover art: *Psalm 24* © 2005 Anneke Kaai. Used with permission.

Cover and book design by projectluz.com

Piquant Editions actively supports theological dialogue and an author's right to publish but does not necessarily endorse the individual views and opinions set forth here or in works referenced within this publication, nor guarantee technical and/or grammatical correctness. The publishers do not accept any responsibility for or liability to persons or property as a consequence of the reading, use or interpretation of its published content.

Contents

Foreword .ix
Preface. .xiii
Acknowledgements. xiv

1. Rhymes and Reasons . 1

The Psalms in English Verse

Book One: Psalms 1-41 15	Psalm 24 36
Psalm 1 15	Psalm 25 37
Psalm 2 16	Psalm 26 39
Psalm 3 16	Psalm 27 40
Psalm 4 17	Psalm 28 41
Psalm 5 18	Psalm 29 42
Psalm 6 19	Psalm 30 43
Psalm 7 20	Psalm 31 44
Psalm 8 21	Psalm 32 45
Psalm 9 22	Psalm 33 46
Psalm 10 23	Psalm 34 48
Psalm 11 24	Psalm 35 49
Psalm 12 25	Psalm 36 50
Psalm 13 26	Psalm 37 51
Psalm 14 26	Psalm 38 55
Psalm 15 27	Psalm 39 56
Psalm 16 27	Psalm 40 57
Psalm 17 28	Psalm 40 (alt.) 58
Psalm 18 29	Psalm 41 60
Psalm 19 31	
Psalm 20 33	Book Two: Psalms 42-72 61
Psalm 21 33	Psalm 42 61
Psalm 22 34	Psalm 43 62
Psalm 23 36	Psalm 44 63

Psalm 45	64	Psalm 79	102
Psalm 46	65	Psalm 80	103
Psalm 47	66	Psalm 81	105
Psalm 48	67	Psalm 82	106
Psalm 49	68	Psalm 83	106
Psalm 50	69	Psalm 84	108
Psalm 51	70	Psalm 85	108
Psalm 52	71	Psalm 86	109
Psalm 53	72	Psalm 87	110
Psalm 54	72	Psalm 88	111
Psalm 55	73	Psalm 89	112
Psalm 56	74		
Psalm 57	75	**Book Four: Psalms 90–106**	**115**
Psalm 58	76	Psalm 90	115
Psalm 59	77	Psalm 91	116
Psalm 60	78	Psalm 92	117
Psalm 61	79	Psalm 93	118
Psalm 62	79	Psalm 94	119
Psalm 63	80	Psalm 95	120
Psalm 64	81	Psalm 96	121
Psalm 65	82	Psalm 97	122
Psalm 66	82	Psalm 98	123
Psalm 67	84	Psalm 99	124
Psalm 68	85	Psalm 100 (1)	124
Psalm 69	87	Psalm 100 (2)	125
Psalm 70	88	Psalm 101	126
Psalm 71	89	Psalm 102	126
Psalm 72	91	Psalm 103	128
		Psalm 104	129
Book Three: Psalms 73–89	**93**	Psalm 105	131
Psalm 73	93	Psalm 106	133
Psalm 74	94		
Psalm 75	96	**Book Five: Psalms 107–150**	**136**
Psalm 76	97	Psalm 107	136
Psalm 77	98	Psalm 108	139
Psalm 78	99	Psalm 109	140

Psalm 110141	Psalm 131167
Psalm 111142	Psalm 132168
Psalm 112143	Psalm 133169
Psalm 113144	Psalm 134169
Psalm 114145	Psalm 135170
Psalm 115145	Psalm 136171
Psalm 116146	Psalm 137173
Psalm 117147	Psalm 138174
Psalm 118147	Psalm 139175
Psalm 119149	Psalm 140176
Psalm 120161	Psalm 141177
Psalm 121161	Psalm 142178
Psalm 122162	Psalm 143178
Psalm 123163	Psalm 144179
Psalm 124163	Psalm 145180
Psalm 125164	Psalm 146181
Psalm 126164	Psalm 147182
Psalm 127165	Psalm 148184
Psalm 128165	Psalm 149184
Psalm 129166	Psalm 150185
Psalm 130167		

2. Valuing and Using the Psalms . 187

3. Metres and Music . 213

Foreword

"I have a dream…"; if I dare to borrow the iconic words of Martin Luther King Jnr (Washington DC, 1963). Because 'If you don't have a dream' (Oscar Hammerstein II, *South Pacific*, 1949), 'How you gonna have a dream come true?'

For I have something between a hope and a vision, as I think of how church might look when my grandchildren are grandparents, if they and their planet are spared that long.

To focus on Sunday, that irreplaceable first day of the week, without forgetting other days: I cannot foresee what form the music may take, nor with what instruments, nor the place of the players, the length of the gatherings, what leaders will emerge or what they will wear. Many of our trappings are culturally flexible; in a short span some of us have lost collection bags, hymn-number boards, lecterns and pulpits, padded kneelers and unpadded pews. But I cannot bear the thought of no singing, or even no meeting, which some of us have endured during pandemics, and as have our persecuted brothers and sisters in many hard places.

In my more-than-dream I picture a moment when, not mechanically but meaningfully, not invariably but regularly, not wearily but delightedly, the congregation rises to sing a version of one or more of the biblical Psalms. And then they will be mightily enriched, and God will be glorified, if they have access to these metrical texts written by my late beloved brother in Christ, stimulating colleague and good friend, Dr David George Preston.

David was born on All Saints' Day, November 1st 1939, in Streatham, South London; a birthplace shared with Mayor Ken Livingstone and from earlier show business Tommy Trinder and June Whitefield. From Archbishop Tenison's

Grammar School opposite Kennington Oval, he went to Keble College Oxford, adding a Dip Theol (later a Dip Ed) to his degree in Modern Languages. There we first met as members of OICCU, the exuberant Christian Union.

David embarked on a career teaching French, taking him to Africa for eleven years. In Nigeria he completed his PhD and met Mavis, sweetly enough as they rehearsed together for Handel's *Messiah*. They married in 1970; his death in June 2020 narrowly forestalled their hoped-for golden wedding.

Mavis has been a constant support of David's writing among much else; he often sought advice on whether one phrase or another more accurately embraced the right contemporary flavour. Back in the UK David worked briefly for publishers IVP in Leicester; later the Prestons were active members of Carey Baptist Church, Reading, and latterly of St John's Yeovil.

It has proved difficult to pinpoint David's first Psalm-writing. But several texts were in progress well before 1980, adding up to over forty years at the craft where he came to excel. *The Book of Praises* was published in 1986, his metrical versions topped up by others of his choice. He joined the Editorial Board of *Praise!* where he and I overlapped again; we all valued his prayerful commitment, acute wisdom, musical expertise, gracious honesty, and flashes of dry wit. Published in 2000, this hymnbook included seven of his tunes and more than forty texts in the ground-breaking Psalm section.

David was by nature eirenic; he responded robustly to some of the predictable rubbishing of recent verse, but always with courtesy, maintaining sincere respect for some of the opposition. His writing and fine-tuning continued for another two decades, during which he often sought advice on whether a particular phrase accurately embraced both the intention of the Hebrew Psalmist and the capacities of today's congregations.

Here, for me, is where his work is a class apart. Our generation is richer than many in varied approaches to the Psalms. We are blessed by the pen of Timothy Dudley-Smith (from the 1960s onwards), closely followed by three Michaels (Baughen, Perry, Saward) and the often anonymous Scots. Among those completing singable paraphrases of the complete Psalter are Adam Carlill, Martin Leckebusch, Emma Turl and Carl Daw Jnr. Sadly, many of these are among the contemporary church's hidden jewels and best-kept secrets.

What marks David out? He masterfully combines a reverent care to stay as close to his sources as the English language, rhythm and rhyme will allow, while crafting versions which cry out to be sung. Such is their lyrical flow,

suggesting an easy fluency but truly the result of painstaking drafting, rethinking, adjusting, revising and finally concluding in the versions now so happily available here.

David had much in common with Isaac Watts, including a magisterial brain within a small stature, a love of the Saviour, a biblical mindset and a catholic spirit. But unlike the father of English hymnody, he did not make King David 'sing like a Christian'. He added no Trinitarian doxologies or New Testament glosses, and insisted on retaining from his originals much colourful imagery and uncomfortable truth. It is up to the preacher (he greatly valued the expository sort) and singers to make the necessary transpositions and applications.

But we know who is on our David's mind and heart in these Psalm 24-driven lines:

> Lift up your heads, you gates:
> you ancient doors, make way!
> See where the King of glory waits
> to enter in today.

<div style="text-align: right;">Christopher Idle, August 2021</div>

Preface

Since David was suddenly 'called home' in June 2020, it has been my dearest and prayerful wish that his Psalms manuscript would become the book he had intended. A labour of love for the Lord over the almost 50 years of our marriage, maybe longer – alongside his teaching career, his support, mentoring and encouragement of many young people (and old!) in their faith. I am indeed thankful that the manuscript was finished and 'publisher-ready'. I am, therefore, so grateful to Pieter and Elria Kwant of Piquant Editions for their enthusiastic response to it, coming as it did at a difficult time for many publishers.

I must also gratefully thank longstanding friends for not only contributing the Foreword and endorsements, but also for encouraging David down the years, offering constructive criticism where needed as he honed and re-honed each Psalm. I know how grateful David himself was for this.

Last but most certainly not least, I proffer my most grateful thanks to Doug Johnson for his unstinting and patient advice and encouragement in getting this book off the ground; and for the time he has given to overseeing it into production. Without his help I would, at best, have been floundering.

Let everything that has breath praise the Lord! (Ps 150)

Mavis Preston, September 2021

Acknowledgements

The chapter 'Valuing and Using the Psalms' is a lightly edited version of three articles David Preston wrote for *Reformation Today*. We are grateful to the editor, Kees van Kralingen, for permission to use them:

> 'The Value and Use of the Psalms, Part 1', *Reformation Today*, November-December 2009, issue 232, pp.3-12
>
> 'The Value and Use of the Psalms, Part 2', *Reformation Today*, January-February 2010, issue 233, pp.3-12
>
> 'The Value and Use of the Psalms, Part 3', *Reformation Today*, March-April 2010, issue 233, pp.3-8

The version of Psalm 131 is copyright © 1978 Christopher Idle. It was originally titled 'At Rest'. Used with Permission.

The cover image is *Psalm 24* by Anneke Kaai: "There is a huge, dynamic spaciousness in this work. The old gates are lifted up out of their buttresses for the Almighty King, Lord of the Heavenly Armies, to enter. He is represented by a bright, three-pointed crown which, joined to its (fainter) reflection, forms the shape of a star - a reminder that this King is also the New Testament King Jesus."

1

Rhymes and Reasons

This new collection of Psalms in English verse is presented not only to provide texts for singing, but also to help you, the reader, get to know a wide range of these ancient songs. Not that my texts are an end in themselves; my hope is that you would return to your Bibles to develop your knowledge and use of the Psalms from there. An explanation of some of the main principles concerning poetry (rhymes) and vocabulary (reasons) that I have followed may help you in that process.

POETIC LICENCE?

Rendering the Psalms in modern English faces two considerable challenges: the lingering legacy of Victorian devotion and the materialistic cast of today's Anglo-American English. A wealth of modern Scripture versions are there to show the way.

The old Italian pun (*Traduttore, traditore* – often rendered as 'the translator is a traitor') linking translation to treachery echoes constantly in the mind and ear of anyone working from one language into another. In the case of poetry it is indeed the actual poetry of the original that is lost, its beauty, its music. But also to a greater degree than in prose its verbal allusions, play on words, multiple meanings and the centuries-long bond between the language and the history and thought of its speakers. Commentaries and concordances can help the translator better understand key words, but much is lost in the limits of the poetic forms of the translator's own language.

Two features distinguish Hebrew verse. First, the number of stresses in a line, with a variety of weak syllables. Something similar is found in some English verse of the late 19th and early 20th centuries. This is inevitably lost in regular English verse.

Secondly, the repetition of the thought of the first line in a second line, whether by way of echo, intensification, enlargement or contrast. Known as parallelism, this feature remains in prose translations of the Hebrew, or in freer poetic forms such as the version of Miles Coverdale, found in The Book of Common Prayer.

The metrical versions in this book use rhyme and regular metre, which go back at least to the 13th century in English, to be developed by Chaucer and others, into a great flowering in the 16th century. These are found in the classic Psalm versions in German and English of the Reformation. (The French versions issuing from Geneva have a more flexible use of rhythm, but maintain strict length of line as well as rhyme.) In this collection the demands of regular stanza length and of the overall length and shape of a text mean that parallelism is sometimes clearly present, while at other times the two lines merge as one.

WORDS, WORDS, WORDS

Every effort has been made to render a number of vital Hebrew words consistently. Some of the most important are included below.

THE NAMES OF GOD

As far as possible I have sought not to change 'God', 'the Lord', 'God Most High', and so on, for one another.

1. 'the LORD' is the regular English rendering of 'YHWH' in English Bibles, though it is also rendered as 'Yahweh' and 'Jehovah'. This name, known to the Patriarchs, had its fuller meaning revealed to Moses. It speaks of his eternal being, and in the revelation to Moses also as the redeemer of his people, bound to them by his covenant promise: the God who is and the God who saves. It evokes great reverence, faith, hope and love. In times of need his people, including the Psalmists, appeal to him as the LORD. It is no mere formula for

making a request. In some Psalms, e.g. 77, 90, its single use is of enormous significance. Like *Psalter Hymnal* (1987) of the North American Christian Reformed Church and *Sing Psalms* (2003) of the Free Church of Scotland, this collection gives this divine name where it appears in the Psalter.

2. 'the Lord', in Hebrew *adonai*, is the word for a Lord or master, one who is over others and is to be obeyed. In the Psalms it usually refers to God, though it is also used of a human master in 45:11 and 110:1.

3. *el* and its plural *elohim* are the standard words for God. The former speaks of God as transcendent, the latter of his fullness and uniqueness. Both are rendered as 'God', the word *el* being also used for any god, as in 81:9, and *elohim* for other gods in the plural, as in 95:3.

4. 'God Most High', *el elyon*, is the title by which the almighty Creator and supreme God was known outside Abraham's circle and that of his descendants. We first meet the name in Genesis where Melchizedek is priest of God most High, in whose name he blesses Abraham.

5. 'the LORD of hosts', in Hebrew *YHWH Sabaoth*, speaks of the almighty power of God commanding all the armies (= hosts) of heaven. In *The Message* Eugene H. Peterson gives 'Yahweh of the Angel Armies'. Used frequently by Isaiah and Jeremiah, it appears in seven Psalms, most notably in 24, 46 and 84. The word 'host' strictly speaking used to mean a very large number, as in Wordsworth's famous 'host of golden daffodils', hence an army. But the Psalms use the word also of the stars in the sky (33:6). In Exodus 12:41 it means the many thousands of Israelites who walked out of Egypt to freedom. Altogether the word appears nearly 300 times in the Hebrew Scriptures. Its popular uses today are the compère of a piece of entertainment, one who receives guests, and the victim of a parasite. Hence NIV and NLT have rendered this title as 'the LORD Almighty', which is clearly correct. But I have retained the distinctive and grand 'the LORD of hosts' of the AV, RV, NASB, RSV, NRSV, ESV, the *Jewish Bible* (1985) of the Jewish Publication Society and the *New American Bible* (1992) of the Catholic Book Publishing Co. of New York.

OTHER KEY TERMS

The Hebrew term *hesed* is translated generally in the AV as 'mercy', roughly half of its appearances occurring in the Psalms. AV also renders it by the beautiful

old word 'loving-kindness'. The word speaks of God's faithfulness to his covenant people. NIV renders it 'unfailing love' or often simply as 'love'. NLT gives 'faithful love' and 'unfailing love', the *New Jerusalem Bible* favours 'faithful love'. Norman Snaith used the term 'covenant-love', other scholars give 'committed love' or simply 'commitment'. NRSV and ESV repeat RSV's 'steadfast love', as does the *Jewish Bible* of 1985. This is the rendering I have followed. It appears over one hundred times in the Psalms, including repeated use in Psalms 107, 118 and 136. The word 'grace' occasionally appears for this in my versions, though in fact the Hebrew word *chen* appears only twice in the Hebrew Psalter, in 45:2 and 84:11.

Sheol is the place of the departed. In the Psalms the AV renders it seven times as 'hell' and nine times as 'the grave'. The Hebrew Scriptures say little on the subject, beyond its being the end of 'life as we know it', a place of darkness and abandonment. I render it variously as 'the grave', 'death', 'dust', 'Hades'. The sense of darkness and oblivion is conveyed in Psalms 49 and 88.

Older translations of the Psalms started with the word 'blessèd' (Ps 1:1), two syllables, a word that has largely disappeared today, and whose meaning is neither clear nor obvious. The Hebrew *ashre* appears 26 times in the Psalms. Nineteen times the AV renders it 'blessèd' and seven times 'happy', the latter only in Book 5. This latter is widely used in today's translations, which also use 'blessed' (one syllable) and 'how blessed'. I use 'happy' and 'how blessed', the former a little more often than the latter.

A number of Psalms start with 'I will bless the LORD' or 'Bless the LORD'. In the Psalms this word and this usage appear well over twenty times. When God blesses us, he does us good. When we bless God, we speak well of him. It is, of course, similar to 'praise', if not quite identical. I retain it where possible both for faithfulness to the text and also for the sake of varying the vocabulary.

The omission or slurring of an unstressed syllable, known as elision, goes back in European poetry to Virgil and beyond him to Homer. Nobody today says 'reverence' as three syllables, nor did James Montgomery two hundred years ago when he wrote

> LORD, teach us how to pray aright,
> with reverence and with fear.

Words pronounced today as two syllables are to be read or sung the same from this collection, e.g. family, covenant, victory, conqueror, warrior, prisoner,

radiant, mockery, desperate, glorious, violent, alien, company, cruelty, carefully, faithfully, and so on. The one word that needs explanation is 'enemy', which does not easily fit the metres used in most hymns and metrical psalms. Like the Free Church of Scotland's *Sing Psalms*, I treat the word, singular and plural, as two syllables, not three. The opening of Psalm 3 cannot be 'How many are my en-e-mies' – not in today's English. In fact the word was treated as two syllables by Sternhold and Hopkins (1562), for example in this eight-syllable line: 'lest thus mine enemy say to me' (Ps 13:4), and this six-syllable line: 'and enemy to the LORD' (Ps 37:20). John Milton did likewise in this richly elided ten-syllable line 'to stint th'enemy, and slack th'avenger's brow' (Ps 8:2) in 1653.

Likewise the following are treated as trisyllabic: delivering, remembering, enlightening, victorious, contemptuous, obedient, inveterate, oblivion, adulterers, and so on.

The following are treated as single syllables: seven, heaven, even, driven, hidden, power, flower, and silver in the phrase 'silver and gold' in Psalm 105. The heavens and heaven's are usually two syllables, so is iron, but it is reduced to one in 'iron-hard'. The following are also treated as monosyllables: liar, lion, cruel, fuel.

The following Hebrew names are treated as two syllables: Abraham (as in 'the God of Abraham praise', 1772), Babylon, Benjamin, Sirion, Phinehas and Zion (this last with two obvious exceptions). Israel can be two or three syllables. When treated as trisyllabic, it is written 'Isra-el'.

Jerusalem has appeared as four syllables in hymns for centuries. Twice it appears in Hubert Parry's glorious setting of William Blake's 'And did those feet in ancient time'. In fact it scans as three syllables in Blake's seventh line, and as four syllables in his fifteenth. Parry easily disguises the fact in his choral writing. The half dozen or so times that it appears in this collection, all in Book 5, it is treated as three syllables.

THE SHAPE OF THE PSALTER

The last thirty years or more have seen a number of studies on patterns in the Psalter, beginning with the work of Brevard Childs and Gerald H. Wilson. There are several articles and books on the subject, among others O. Palmer Robertson's *The Flow of the Psalms* (Presbyterian & Reformed, 2015). Some reputable scholars view with caution, if not scepticism, conclusions drawn along

these lines. But at least a basic pattern is observable, if not a detailed placing of each Psalm in a significant relation to all other one hundred and forty-nine.

To start with, the one hundred and fifty Psalms are divided into five books. Most translations of the Bible indicate that, though not all stand-alone versions of the Psalter do. When these texts were assembled no one actually knows, nor who gave them their present order and grouping in five sections. Certain features and pointers are clear, which may help us appreciate the richness and variety of the whole collection.

It is generally supposed that the five parts correspond symbolically to the five Books of the Law, Genesis to Deuteronomy, perhaps to indicate an essential connection between the Law and the Psalter.

Each section ends with a doxology. That is very clear in Books 1 and 2, Book 3 has a very attenuated doxology, Book 4 has a more expanded doxology, while Book 5 picks up the cry of 'Hallelujah!' from the end of Book 4, echoing until the prolonged doxology of Psalms 146–150, with Psalm 150 sounding the climactic cry of praise to the Lord, calling 'All that breathes' to join the universal hymn of adoration.

Psalms 1 and 2 declare the two dominant subjects of the Psalms: Psalm 1 the word of God, his holy law, loved and studied by the righteous to their blessing, ignored by the wicked to their peril; Psalm 2, the anointed King of God's people, victorious over all his enemies. The Hebrew word for 'anointed' turns into 'messiah' in English. (The Greek translation turns into 'Christ'.) These two Psalms are frequently spoken of as the introduction to, or door into, the Psalter.

Books 1 and 2 together conclude with a unique editorial note: 'the prayers of David, the son of Jesse, are ended.' So this dual collection of praises is also a book of prayers, of which David is in most cases (at least) the author. This matches the majority of the headings that we find at the start of most of these 72 Psalms. The authenticity of these headings, or titles, will be discussed later. For the time being these will be taken as belonging properly to their respective Psalms.

Book One contains 41 Psalms, of which 37 are ascribed to David. The other four are the introductory pair, Psalm 10 (possibly an extension of Psalm 9) and Psalm 33. The majority are cries to the Lord for help against wicked enemies. Some look for help with on-going need, some give exhortation to persist in prayer and trust. Psalm 18, one of the longest, is explicitly messianic, and

precedes a famous text combining the glory of God in creation with the perfection of God's law, leading to prayer for obedience in life, speech and heart. Two more messianic texts lead to a remarkable trio of 22 (great suffering leading to global trust in God), 23 (rescue, peace and assurance for the individual dependent of God) and 24 (the victorious king). Psalms 8 and 29 join 19 in giving us well-known passages on the beauty and wonder of God's creation, reflecting the glory of the Lord. No less than three of the seven 'penitential' Psalms are found in Book 1: 6, 32, 38, as David faces not just his earthly enemies but also sin in his life and God's displeasure and wrath. Psalm 32 provided important material for the Apostle Paul as he discussed justification by faith alone in Romans 4. The theme of sin recurs in the later Psalms (i.e. 36–41), the final Psalm finding David facing human enemies, sickness and sin, concluding however rather like Psalm 23, before closing with the doxology of Book 1. The book focuses essentially on David, his struggles, potential, victories, failures and his relationship with God.

Book Two (42–72) begins with eight Psalms ascribed to the Sons of Korah, musicians connected with worship at the temple in Jerusalem (1 Chron 6:22). Whilst Psalms ascribed to David in this book refer in most part at least to his continued battles with King Saul, these eight appear to belong to a later period. David is king of a nation with foreign enemies whom he expects to defeat with God's power, 46, 47, 48, from his impregnable city with its impressive defences and its spacious temple courts. There was one bad set-back, 44, causing great puzzlement which seems to anticipate some of the Psalms from Book 3. Nevertheless, the Lord will be exalted over all the earth, 46, 47. These eight begin with David's longing to be back with his people and their worship, 42–43, suggesting they come from later, from David's flight from his rebel son Absalom. The whole set are beautifully illuminated by a unique royal prothalamion, which must refer to the marriage of King David's son, Solomon.

Psalms 49 and 50 speak in contrast of judgment, individual and national. These prepare the way for eighteen Psalms of David, beginning with the most detailed of the penitential Psalms, 51, his great cry of penitence for his adultery and murder of the woman's husband, the defining act of King David's reign. Immediately follows denunciation of the sin of ruthless accumulation of wealth, 52, and of atheism, 53. The next group, 54–64, are Psalms of personal struggle or danger, or of battle, all ending on a note of victory following

prayer to God for rescue. Five of the headings relate the text to David's flight from Saul, while 60 and 63 refer to his trials as king. Psalms 65-68, renew the worldwide focus of 46 and 47, calling the nations to join the praises of God's people in response to God's goodness and greatness. The last of these, 68, is a graphic celebration of the journey of the Ark of the Covenant to Zion. Then 69 and 70 return to the Psalmist's cry for help in his sufferings, confident that God will protect and restore. The book closes with a prayer for deliverance from a man near the end of life (surely David?), and Solomon's Psalm 72 portraying the ideal reign of the Lord's anointed king, its idealism reminiscent of the royal wedding of Psalm 45.

Book Three (73-89) leaves David and Solomon behind (except 86, 'of David'). Events from the days of the kings clearly lie behind all or most of the book. It opens with an individual's query about what is happening in or to Israel? Whilst 76 refers to the invasion and departure of the Assyrian Sennacherib in 701 BC (2 Kings 18-19), 74 and 79 lament the destruction of Jerusalem and the temple by Nebuchadnezzar's forces in 587 BC (2 Kings 24-25). 'Why?' and 'How long?' are the recurrent notes. Some close on a note of faith and prayer (73, 75, 77, 83); while several others desperate to see God act (74, 79, 82, 83) or cry for revival (80, 85). The sins of God's people are recalled and their constant disobedience to God's law (78, 81, 82); yet this Book alone contains no penitential Psalm. Hope rises towards the end as 84-87 reflect on God's goodness, focusing in turn on the temple, the land, the king and the city. Yet the conclusion is deeply pessimistic, both personally (88) and nationally (89). The Babylonian exile has come.

Book Four (90-106) takes us into the exile. References to the land and the great city of the Lord's people are rare. The true home of his people is the Lord himself (90, 91), whose worship they still perform on the Sabbath (92). Despite the catastrophic humiliation of 587 BC, the God of Israel is King (93-100), to whom all nations shall come and pay homage (echoes of 22, 72, 87). But there remains a desire to return and rebuild Jerusalem (102) - this book's one penitential Psalm. This lament leads to one of the most positive and popular texts in the whole Psalter, 103, David's great cry of praise to his covenant-keeping God. At its heart is the revelation of God's mercy to Moses, 'slow to anger, rich in grace', previously recalled in David's last Psalm in Book 3 (86). It also sounds

the same personal note that distinguishes Psalm 23. The Book closes with three magnificent texts praising the LORD the faithful creator (104), the protector of his people as promised to Abraham (105), and the preserver of his rebellious nation (106) who pray to be restored to their own land. Each closes with "Praise the LORD!", or rather "Hallelujah!", praise to the covenant-keeping God who saves his people. This famous Hebrew word occurs in the Hebrew Scriptures only in these three Psalms and in a dozen or so in Book 5. It relates essentially to God's covenant faithfulness to his people.

In **Book Five** (107-150) Israel is back from exile. Psalm 107 thanks God for his unending 'steadfast love', (a cry that recurs to become a refrain in 136), the return from exile and deliverance from a range of crises and dangers. Psalm 108 tells of victory over enemies, 109 of an individual's (Israel's) most vituperative and malign accusers, 110 by contrast acclaims the LORD's victorious king of Psalm 2 both king and priest, raised to divine heights. Psalms on the wise life, based on God's covenant and written word, lead to the 'Egyptian Hallel' (113-118) sung at major Jewish festivals, celebrating the restoration of city and temple to those once rescued from slavery in Egypt. The last of these again celebrates God's steadfast love and presents a victorious figure saved from death and identified with part of a prominent building – the temple – discarded at first before being set as the cornerstone. Clearly Psalm 118 is messianic and, like Psalm 18, it is followed by an extended meditation on the perfection of God's written law and its inestimable value. Psalm 119 is an acrostic. It has 22 stanzas comprising of 8 lines, each line beginning with the same letter. The stanzas follow the order of the Hebrew alphabet. This device was commonly used to emphasise the perfection, completeness and richness of its subject. The written law now plays a much more significant part in the life of the Jewish people, and like the Ten Commandments, it addresses the individual.

The 'Songs of Ascent' (120-134) are songs for pilgrims going up to the restored city for annual festivals, remembering their rescue from slavery, God's subsequent provision (Deut 16) and his deliverance from a range of adversaries. In *Journey* (IVP, 2009) Alec Motyer views them as triads: each of the first four moving from this world's trials to Zion's blessings, the fifth triad (132-134) envisioning the city of the covenanted king, its people united and worshipping the LORD our creator. Among these is the shortest and most profound penitential Psalm (130) and 132 on the recovery of the Ark of the

Covenant (1 Samuel 6:21-7:2), which had led to the Lord's covenant with David (2 Sam 7). A pair of Psalms then recall God's deliverance of his people in the past, 136 bearing the refrain on his steadfast love, and then a heart-wrenching elegy on exile in Babylon, concluding however with God's destruction of that terrifying oppressor. Eight Psalms of David link this last Book with the first two, including the popular 139 on God's universal presence and knowledge, 143 the seventh penitential Psalm, and 144 a victory Psalm reminiscent of 18. Psalms 146-150 are the grand concluding doxology.

WHO'S WHO?

Well over 100 Psalms carry a title or heading about authorship, and in some cases specify the events that gave rise to its composition. These also contain musical directions whose meaning is often not clear to us. The status of these titles is disputed. Were they there from the composition of the Psalm? Were they added a generation or two later by older people who remembered the past? Or are they really not an authentic part of the Psalms, added maybe centuries later and of dubious value?

Nobody actually knows. However, they appear in every Hebrew manuscript we have, and are verse 1 in those manuscripts which give verse numbers. They also appear in the *Septuagint*, the Greek version of the Old Testament made around 270 BC by the large Jewish community in Alexandria. Apparent discrepancies or errors in some instances in the translation suggest that the Hebrew of the titles was too early for the translators of the 3rd century BC to be familiar with some of the terms. These factors indicate that in the Hebrew Bible the titles enjoyed canonical status.

Arguments for their authenticity include the examples of Hezekiah's Psalm in Isaiah 38 and Habakkuk's Psalm in his concluding chapter, which appear in their texts with their title. Then there is the case of Psalm 7 whose title refers to circumstances not found in the Bible, so presumably not added afterwards but dating from the composition of the Psalm or soon after. In the case of Psalm 51, it seems very doubtful that anyone would have added a speculative reference to David's adultery with Bathsheba, which was so catastrophic for his family and the nation. Who would have added a heading to remind everyone of the gigantic failure of such a great hero?

Most translations of the Bible include the titles of the Psalms, with their plausible life-settings. So they are retained in this volume too.

ON ORIGINS

A number of the versions in this book have appeared before. Unlike many who write hymns or Psalm texts, I have revised several of these for this publication, whether to strengthen the wording or to approximate more to the sense of Holy Scripture. I do not envisage any future amendments. People who have sung earlier versions are quite at liberty to stick to what they know, if they wish.

Many of my earliest texts were simply modernisations of classic texts by Isaac Watts, Charles Wesley and a few others. My revisions have cut my reliance on earlier writers to four cases. Psalm 33 borrows from Tate & Brady (1696) in its opening stanza, and there are echoes later. The first stanza of 82 leans heavily on C. H. Spurgeon (1834-92), and there is an echo in the last stanza. Psalm 133 stanza 1 is largely that of Charles Wesley (1707-88). The first two stanzas of Psalm 150 are adapted from H. F. Lyte (1793-1847).

Christopher Idle, a friend from university days, an invaluable critic of my work and generous with his time, has kindly allowed me to include here his version of the beautiful Psalm 131: an acknowledgment of my debt to him.

Lastly, the text of the great elegy 'By the waters of Babylon', Psalm 137, comes from the pen of William Cowper (1731-1800), the only poet to have been a major hymn-writer. I have updated the text where with time Cowper's language has lost its original sense and/or force.

But whichever versions are preferred in succeeding generations, the Psalms continue to set forth the character of God as Creator, Redeemer, Judge and King. They show how we should respond to him in awe, adoration, wonder, delight, penitence, gladness and hope. It is little wonder that these ancient Hebrew hymns have held a special place in Christian worship down the centuries.

The Psalms
in
English Verse

2 I kept on crying to the Lord,
 he answered from his holy hill:
 I lay down, slept, and woke restored
 because the Lord sustains me still;
 their tens of thousands I'll not fear,
 though all around me they appear.

3 Rise up, O Lord, and rescue me,
 strike all my enemies on the cheek
 and break their teeth that they may be
 forever left disarmed and weak;
 salvation's from the Lord alone:
 your blessing rest on all your own!

Psalm 4

To the choirmaster: with stringed instruments. A Psalm of David.

1 O God, my source of righteousness,
 I call to you in my despair;
 give me relief from my distress,
 show grace to me and hear my prayer.

2 "How long will all you people try
 to turn my glory into shame?
 How long will you distort and lie
 and bring dishonour on my name?

3 "Know this: the Lord has set apart
 the godly one to be his own;
 the Lord will hear when from the heart
 I call to him upon his throne.

4 "You angry men, don't sin! At night
 explore your hearts, without a word;
 bring sacrifices that are right
 and put your trust in him, the Lord!"

5 Yet there are many still who say
 "But who will show us any good?"
 Lift up your light on us, we pray,
 the radiance of your face, O Lord. . . .

6 You've filled my heart with more delight
 than when their grain and wine abound;
 I'll sleep in peace, O Lord, all night,
 by you alone kept safe and sound.

Psalm 5

To the choirmaster: for the flutes. A Psalm of David.

1 Lord, listen to the words I bring,
 my inner thoughts survey,
 hear this my cry for help, my King,
 my God – to you I pray.
 As morning dawns, O Lord, you hear
 my voice ascend on high;
 prepared each morning, I draw near
 and watch for your reply.

2 For evil gives you no delight,
 it's not your welcome guest:
 the proud you banish from your sight,
 the wicked you detest.
 Your hand destroys all those who cheat
 and lie and thirst for blood:
 the men of darkness and deceit
 are hated by the Lord.

3 But by your steadfast love
 I'll now within your house appear,
 towards your holy temple bow
 and worship you with fear.
 Lord, lead me in your righteousness?
 my enemies lie in wait:
 direct my steps that I may trace
 your pathway clear and straight.

4 For all they say is insincere,
 they're all corrupt at heart,
their throat's an open sepulchre,
 their tongue is smooth and smart.
O God, pronounce them guilty,
 may their own plans bring them down;
drive such transgressors far away,
 for they've defied your crown.

5 But let all those who run
 to you their joy in song proclaim;
protect them, fill with gladness too
 all those who love your name.
For you, O Lord, will surely bless
 the just, his prayers fulfilled,
encircling him with guardian grace
 like some enormous shield.

Psalm 6

To the choirmaster: with stringed instruments; according to The Sheminith. A Psalm of David.

1 O LORD, do not in anger
 rebuke me or chastise;
have mercy, Lord, upon me:
 I grow too weak to rise.

2 Heal me, O Lord: my body
 feels shaken, troubled, wrong;
my very soul is shaken,
 but you, O Lord – how long?

3 Return, O Lord, and save me:
 your steadfast love I claim;
if I am left to perish,
 how can I praise your name?

4 I'm wearied with my groaning,
 I flood my couch with tears,
depression clouds my vision,
 my enemies fuel such fears. ...

5 Away, you doers of evil!
 The Lord knows my despair,
the Lord has heard my pleading,
 the Lord accepts my prayer.

6 My enemies all frustrated
 and shaken by defeat,
shall turn back in an instant
 in shameful, swift retreat.

Psalm 7

A Psalm of David which he sang to the Lord concerning the words of Cush, a Benjaminite.

1 From my pursuers keep me safe,
O Lord my God, my refuge be,
or like a lion they'll tear me apart
with no one there to rescue me.
Lord God, if mine are guilty hands,
if I've betrayed my comrade's trust,
then let my accuser have my life
and lay my glory in the dust.

2 Arise, O Lord, in wrath against
the fury by my enemies shown;
awake, let judgment be declared!
The nations gather round your throne
above them take your seat on high;
O Lord, their judge, receive my plea:
pass judgment on my righteousness,
pronounce on my integrity.

3 Let wicked people's evil cease,
the righteous soul uphold and bless,
for you examine minds and hearts,
O God of constant righteousness.
My shield is God who saves all those
of upright heart who walk his way;
God is a righteous judge, a God
who is indignant every day.

4 His deadly weapons he's prepared:
his sword is sharp, his bow is bent,
his clutch of arrows tipped with fire
for any who will not repent.
The wicked man conceives his scheme,
gestating it until complete
and then he brings this evil forth:
his shameless lies, his cruel deceit.

5 He's dug a pit and made it deep,
but he has stumbled in instead,
the wickedness that he had planned
has now recoiled on his own head.
I'll thank the Lord, whose righteousness
with grateful heart I magnify,
and I'll sing praises evermore
to his great name: the Lord Most High.

Psalm 8

To the choirmaster: according to The Gittith. A Psalm of David.

1 O Lord, our Lord, in all the earth
 how glorious is your name!
Your majesty and sovereign worth
 the heights of heaven proclaim;
and yet your praises here are sung,
 as you in wisdom chose,
by voices of the very young
 to silence all your foes.

2 When I behold the midnight sky,
 the heavens your fingers made,
the moon and stars you set on high
 for all to see displayed,
what then are we, held in your mind,
 whom you with care surround?
So godlike you have made mankind
 with glory and honour crowned. . . .

3 You've set us over flocks and herds
 and wildlife roaming free,
 you've named us guardian of the birds
 and all the shimmering sea.
 Your majesty and sovereign worth
 your creatures here proclaim:
 O Lord, our Lord, in all the earth
 how glorious is your name?

Psalm 9

To the choirmaster: according to Muth-labben. A Psalm of David.

1 I'll praise you, Lord, with all my heart,
 your wonders I'll proclaim,
 and glorying in you, O Most High,
 sing praises to your name.
 My enemies turn before your face
 and are reduced to dust,
 for you maintain my righteous cause,
 my Judge forever just.

2 You have rebuked the godless world,
 the wicked put to rout;
 their cities you have swept away,
 their name long blotted out.
 But yours is an eternal throne,
 in righteousness you reign,
 and everywhere throughout the world
 true justice you maintain.

3 The Lord's a refuge for the oppressed
 when storms of trouble break,
 for those who know and trust his name
 he never will forsake.
 Then sing the praises of the Lord,
 his acts of power proclaim,
 who's mindful of the afflicted souls
 that call upon his name.

4 Grant me your grace, Lord, as you see
 my enemies' hatred blaze:
 preserve my life, that I may yet
 with joy declare your praise.
 The godless snare themselves – so is
 the Lord as Judge revealed:
 the wicked are caught up in nets
 they had themselves concealed.

5 The wicked shall return to dust,
 their godless fate is sure;
 but God himself will not forget
 the afflicted and the poor.
 Arise and judge the nations, Lord,
 let not mankind prevail;
 put them in fear, Lord: let them know
 they are mere men – and frail!

Psalm 10

1 Why, Lord, remain so far away
 when troubled times arise?
 The arrogant oppress the poor
 with schemes that they devise.
 The wicked man parades his greed
 and ridicules the Lord;
 too proud to seek him, in his thoughts
 all sense of God's ignored.

2 His ways are prosperous all the time,
 to your just ways he's blind;
 he scorns his enemies: "No mishaps
 will come, or shake my mind!"
 He utters curses, lies and threats,
 he causes sin and strife,
 and he waylays the honest man
 to rob him of his life. . . .

3 He watches for his victim, like
 a lion inside its lair;
he waits to seize the hapless man,
 to take him in his snare.
The victim, crushed, sinks down and falls
 beneath that iron claw;
the wicked man says, "God forgets –
 I doubt he even saw."

4 Rise up and act, Lord God – do not
 forget the oppressed, I pray;
how dare the godless cynic think,
 "He'll never make me pay!"
For, yes, you see the pain and grief,
 and these you will requite;
the victim puts his trust in you,
 who ease the orphan's plight.

5 Destroy the power of evil men
 till not a trace remains:
the godless perish from your land –
 the Lord for ever reigns!
Lord, listen as the humble hope,
 encourage them, and hear;
defend the poor, that earth-born man
 no longer may strike fear.

Psalm 11

To the choirmaster. A Psalm of David.

1 I've found my refuge in the Lord;
 how can you say to me,
"Flee to the mountains like a bird!
 for in the shadows, see:
the wicked, ready armed, deployed
 to assail the upright few;
when life's foundations are destroyed,
 what can the righteous do?"

2 The Lord is in his holy place
 upon his heavenly throne;
his eyes behold the human race,
 our very thoughts are known.
The Lord sees what the righteous do:
 their faith and life he tests;
he sees the men of violence too
 and these his soul detests.

3 Upon the wicked he will rain
 his searing fires of death,
as when the cities of the plain
 were withered by his breath.
For he, the Lord, loves righteousness,
 a righteous God is he;
and those who walk in uprightness
 his holy face shall see.

Psalm 12

To the choirmaster: according to The Sheminith. A Psalm of David.

1 Help, Lord: the godly are no more,
 the faithful few have gone;
so lying spreads from door to door
 and flattery drives it on.

2 Lord, silence all the lips that lie
 and every boastful word;
"We'll triumph with our tongues," they cry,
 "They're ours! Who'll be our lord?"

3 "Now," says the Lord, "I will arise
 to save the exploited poor;
I come in answer to their sighs
 and they shall sigh no more."

4 Like silver seven times purified
 his promises are pure,
and all who in the Lord confide
 will prove his word secure. ...

5 The wicked freely strut about,
 the vilest things they praise;
protect us, Lord, that we may not
 fall victim to their ways.

Psalm 13

To the choirmaster. A Psalm of David.

1 Lord, how long will you forget me,
 how long turn your face away?
How long must this pain and anguish
 rack my heart both night and day?
How long will my enemy triumph?
 Answer, Lord, my cry of faith;
give my eyes your light, I beg you,
 lest I sleep the sleep of death –

2 Lest my enemies be exultant,
 overjoyed to see me fall;
but your steadfast love I trust in
 to protect me from them all.
In your grace my heart rejoices,
 your deliverance I shall see;
Lord, I'll sing such thankful praises
 for your goodness shown to me.

Psalm 14

To the choirmaster. Of David.

1 The fool says in his heart, "There is no God."
 Depraved in thought and deed, not one does good.

2 The Lord looked down from heaven upon our race;
 was any wise enough to seek God's face?

3 Along corruption's path together gone,
 not one of them does good, not even one.

4 By such remorseless men are we devoured:
 Will they not learn, nor call upon the Lord?

5 Now see them filled with dread, see God arise!
 In God the poor man hopes, on him relies.

6 O that by God his people were restored!
 Then we would praise his name, glad in the Lord!

Psalm 15

A Psalm of David

1 Lord, who may venture where you dwell,
 or live upon your holy hill?
 The pure in heart, whose blameless lives
 by word and deed obey your will.

2 They never do their neighbour wrong
 and utter no malicious word;
 the sinner's folly they despise,
 but honour those who fear the Lord.

3 They keep their oath at any cost,
 and gladly lend, though not for gain;
 they hate all bribery: come what may,
 secure for ever they remain.

Psalm 16

A Miktam of David

1 O God, my refuge, keep me safe:
 on you my good depends;
 O Lord, you are my Lord alone,
 your saints my choicest friends.

2 Whoever turns to other gods
 will find remorse and shame;
 to them I make no sacrifice,
 nor will I speak their name. . . .

3 The Lord is my inheritance,
 a prize beyond compare;
 his word instructs me day and night,
 his own beloved heir.

4 At all times I have set the Lord
 before my face to stand;
 no trial, no pain can shake my hope
 with him at my right hand.

5 My heart and soul rejoice in you
 and in your power to save:
 you will not leave your holy one
 to perish in the grave.

6 You lead me to the path of life,
 before your face to stand
 and drink my fill of endless joys
 that flow at your right hand.

Psalm 17

A Prayer of David.

1 Lord, hear my plea, my innocence declare;
 give judgment, for your eyes can see within:
 you've tried my heart by night, there's no wrong there;
 I've pledged to keep my mouth from uttering sin.
 I have not followed others' violent acts,
 because your spoken word directs my way:
 my steps have kept entirely to your tracks,
 my feet have neither slipped nor gone astray.

2 O God of answered prayer, hear now my cry:
 reveal your steadfast love, do wondrous things;
 protect me as the apple of your eye,
 and hide me in the shadow of your wings
 from wicked enemies with a hunter's skill
 to match their callous hearts and boastful talk:
 ones like a lion that's hungry for a kill
 and crouches, set to end its patient stalk.

3 Arise, O Lord, bring down my enemy, then,
 and save me from the ungodly by your sword;
 deliver me, O Lord, from worldly men
 who only look to this life for reward,
 whose satisfaction's in what they possess
 and what they'll leave their heirs when they have died;
 but I shall see your face in righteousness,
 awaking to behold you, satisfied.

Psalm 18

To the choirmaster. A Psalm of David the servant of the Lord, who addressed the words of this song to the Lord on the day when the Lord delivered him from the hand of all his enemies, and especially from the hand of Saul. He said:

Part 1 (1-19)

1 I love you, Lord: my power,
 my saviour from defeat,
 my God, my rock, my tower,
 my shield, my safe retreat;
 the Lord be praised to whom I cried:
 my enemies' will has been denied.

2 The entangling cords of death
 struck terror in my soul,
 constricting life and breath
 with merciless control;
 I cried to God in my despair:
 from heaven he heard my dying prayer.

3 The earth then rocked and shook
 beneath its Maker's ire,
 his anger breathed out smoke
 and flaming coals of fire,
 and down he came, the heavens he bowed:
 beneath his feet was darkest cloud. ...

4 On angels' wings he flew,
 sped swiftly on the wind,
 by clouds of blackest hue
 and deepest darkness screened,
 yet, from his brightness, through the smoke
 a storm of hail and lightning broke.

5 From heaven his thunder came,
 the Most High's voice rang out:
 with hail and shafts of flame
 he put them all to rout:
 the depths of land and sea lay bare
 at his rebuke, out through the air.

6 His arm took hold of mine,
 to raise and set me free
 from one man's cruel design
 and those too strong for me:
 the Lord upheld me by his grace
 and brought me to a spacious place.

Part 2 (20-42)

7 He'd seen I was sincere,
 resolved to keep his ways,
 to walk in godly fear
 beneath his holy gaze;
 before my eyes I set his laws
 and he upheld my righteous cause.

8 You honour simple trust:
 the faithful find you true,
 the blameless prove you just,
 the crooked you undo;
 for you make lowly people rise,
 but humble those with haughty eyes.

9 My lamp, O Lord, you keep
 aglow in darkest night;
 all barriers I can leap
 enabled by your might:
 your way is perfect, like your word;
 you shelter all who seek you, Lord.

10 With God what gods compare?
 He fits me for the fight,
 and swifter than a deer
 I scale the topmost height;
 his shield protects me, and his hand
 secures the ground on which I stand.

11 My enemies, caught at length,
 soon fell beneath my feet;
 you armed me with your strength,
 their ruin was complete;
 they cried for help, but no one stirred:
 they even prayed, but were not heard.

Part 3 (43-45)

12 The Lord's anointed King
 is made the nations' head:
 once alien, now they bring
 their vows to him instead,
 and bow before his throne in awe,
 surrendering to his royal law.

13 O praise the Lord!
 He lives, my Saviour in such need!
 What victories our God gives
 to David and his seed!
 So for his steadfast love I'll praise
 the Lord throughout my earthly days!

Psalm 19

To the choirmaster. A Psalm of David.

1 The heavens declare the glory of God,
 his craftsman's art the skies proclaim;
 from day to day the wonder's told,
 and night to night transmits the same.
 There are no words, there is no speech,
 no voice, no sound to us descends,
 yet everywhere their echoes reach,
 as far as earth's remotest ends. . . .

2 He's pitched a tent there for the sun
which, radiant as a bridegroom's face,
comes like a champion, set to run
with joy its dazzling day-long race.
From eastern frontiers see it rise:
its heavenly circuit once complete,
it dips beneath the western skies;
and nothing's hidden from its heat.

3 How perfect is the Lord's whole law,
it gives the soul the strength to rise;
his godly statutes have no flaw,
they make the simple-hearted wise;
the precepts of the Lord are true
and fill the heart with sheer delight;
the Lord's commands are radiant, too,
enlightening eyes with heaven's clear light.

4 The fear the Lord inspires is pure,
and lasts when all this world is dust;
the judgments of the Lord are sure,
together and entirely just.
More prized than finest gold are they,
more sweet than honey from the bees;
they warn your servant not to stray:
there's great reward in keeping these.

5 One's hidden errors who can see?
Forgive me all my unknown faults;
from wilful sins, too, keep me free,
may I not yield to their assaults:
thus blameless, from rebellion kept,
my every thought and every word
be such, O Lord, as you'll accept,
my rock and my redeeming Lord.

Psalm 20

To the choirmaster. A Psalm of David.

1 The Lord hear you and answer, this grave day:
 the name of Jacob's God keep you secure,
 and from his holy place send help, we pray:
 from Zion his support for you ensure.

2 May he recall the offerings you have made,
 the sacrifices brought by your own hand,
 give you your heart's desire as you have prayed
 and bring to full fruition all you've planned.

3 Your victory we shall greet with great acclaim,
 rejoicing in our God to be so blessed,
 and we shall raise our banners in his name:
 the Lord grant fully all that you request.

4 And now I have the Lord's assurance given,
 that he'll deliver his anointed king;
 his cry he'll answer from his holy heaven
 with saving power that his right hand will bring.

5 Some trust their charioteers to win the war:
 we trust the Lord our God's name – they will fall,
 but we'll rise up and firm we'll stand once more:
 Lord, save the king, and answer when we call.

Psalm 21

To the choirmaster. A Psalm of David.

1 The king rejoices in your strength, O Lord;
 how he exults in your victorious aid?
 His heart's desire with favour you accord,
 withholding not the help for which he's prayed:
 abundant blessings on his path you spread,
 and crown with finest gold his royal head. . . .

2 He asked for life: you granted his request,
 a long life, victory, glory by your grace;
 for evermore you make him richly blessed,
 rejoicing in the brightness of your face.
 The king trusts in the Lord; and having proved
 the Most High's steadfast love, he'll not be moved.

3 Your hand will find and overpower all those
 who hate you, making them like flames of fire:
 the Lord himself will swallow up your foes,
 consuming them in his enkindling ire.
 Of their descendants you'll remove all trace:
 they'll vanish from among the human race.

4 Although they plot against you, they will fail,
 whatever evil plan they may propose;
 you'll stop them dead, you'll make them all turn tail
 when targeting them head-on with your bows.
 So be exalted in your strength, O Lord:
 we'll sing and praise your power with one accord.

Psalm 22

To the choirmaster: according to The Hind of the Dawn. A Psalm of David.

1 My God, my God, O why have you forsaken me?
 Why so remote, so blind to my ordeal?
 My God, I plead with you all day, all night I call:
 no answer comes to my forlorn appeal.
 Yet you are God, the Holy One of Israel,
 you sit enthroned upon your people's praise;
 our fathers put their trust in you to rescue them,
 a trust you honoured all their earthly days.

2 But I'm a worm and not a man, the scorn of all;
 men sneer at me with mockery glib and grim:
 "He trusted in the Lord to save him. Let him, then,
 deliver him, since he delights in him!"
 Yet you're the one who took me safely from the womb
 and made me trust you at my mother's breast;
 yes, since my mother bore me you have been my God:
 now trouble's near, don't leave me like the rest.

3 Like mighty bulls of Bashan they've surrounded me
 and roar like lions that tear apart their prey;
poured out like water, all my bones are out of joint,
 like wax my heart within me melts away.
My strength's dried up, my swollen tongue seals up my mouth,
 here in the dust of death I'm laid by you;
like dogs a pack of evil men encircle me,
 and they have pierced my hands and feet right through.

4 So gaunt my failing frame that I can count each bone,
 while people stare and everybody gloats;
already they share out my clothes among themselves,
 dividing up their spoil by casting lots.
But you, O Lord, how can you still be so remote?
 My Strength, come quickly, help me – hear my plea!
Save me from sword, from lions' jaws, from wild oxen's horns,
from death and darkness – you have answered me!

5 I'll tell my brothers of your name, and join in praise
 with Israel's people: serve the Lord with fear!
For he's not spurned the suffering of the afflicted one,
 nor hidden his face, but turned a listening ear.
Before all those who fear him I'll fulfil my vows
 to him, the source and object of my praise;
the poor shall join the feast, and those who seek the Lord
 will praise him throughout heaven's undying days.

6 All corners of the earth shall turn their minds to him,
 in worship all before him shall bow down;
because the Lord is sovereign over all the world,
 its every nation subject to his crown.
Both rich and poor, the fit and frail, shall end as dust,
 and kneel before him, each and every one,
and future ages serve him and proclaim afresh
 his saving righteousness: this he has done!

Psalm 23

A Psalm of David

1. The Lord's my shepherd:
 all my needs his goodness will supply;
 he makes me rest in grassy fields
 with peaceful pools nearby.

2. And he restores my soul again
 when lost and shelterless,
 and for his name's sake leads me
 in the paths of righteousness.

3. "When I descend the darkening path
 where death awaits its prey,
 you're with me there: your rod and staff
 drive all my fears away.

4. "For me a royal feast you spread
 before my watching foes;
 your fragrant oil anoints my head
 and my cup overflows."

5. Yes, his goodwill and steadfast love
 pursue me all my days,
 then I'll dwell with the Lord above
 and ever sing his praise.

Psalm 24

A Psalm of David

1. The whole earth is the Lord's
 and all its bounds contain,
 the world and its unnumbered hordes
 belong to his domain;
 for all the eye can see,
 the oceans and the land,
 were made at first by his decree
 and fashioned by his hand.

2 Who may ascend his hill
 and worship at his feet?
 The pure in heart, who do his will,
 in whom is no deceit;
 on such the Lord bestows
 his righteousness and grace:
 like Jacob they are truly those
 who seek their Maker's face.

3 Lift up your heads, you gates:
 you ancient doors, make way?
 See where the King of glory waits
 to enter in today.
 Who is the glorious King
 that waits before these doors?
 The Lord, the all-victorious King,
 triumphant in his wars.

4 Lift up your heads, you gates:
 you ancient doors, make way!
 See where the King of glory waits
 to enter in today.
 What glorious King is this,
 whose victory all can see?
 The Lord of hosts this conqueror is,
 the King of glory he!

Psalm 25

A Psalm of David

1 I lift my soul, O Lord, to you,
 my God, my trust the whole day through;
 keep me from failure's blushing face,
 from those who'd gloat at my disgrace:
 for hope in you will banish shame,
 whilst traitors earn their worthless name. . . .

2 Teach me to walk the path I should,
 your way of truth, my Saviour God;
 recall your mercy and your grace
 which long precede our fallen race:
 my youthful sins do not record-
 I plead your steadfast love, O Lord.

3 The Lord is good, and he will show
 the lost, the meek the way to go;
 his paths are faithful love to those
 who keep his covenant with its laws –
 For your name's sake, O Lord, I plead,
 Forgive – my guilt is great indeed.

4 Fear him: he'll teach you how he's planned
 to bless your family and your land;
 the Friend of those who fear his name,
 he makes his covenant known to them;
 I ever look to him in prayer
 to free my feet from every snare.

5 Be gracious to me, turn to me,
 alone in my adversity;
 the torments of my heart increase:
 from such deep anguish grant release;
 my pain you know, my disarray:
 take all my sins and guilt away.

6 See how my enemies' numbers grow,
 how fierce the hatred that they show!
 Protect me, rescue me from shame:
 in you I trust to keep from blame.
 Redeem Israel, O God, I pray,
 from all its troubles, come what may.

Psalm 26

A Psalm of David.

1. Uphold me as my Judge, O Lord,
 for I have striven to walk your way,
 and ever trusted you, O Lord,
 to keep my feet from going astray.

2. Subject me to your searching light,
 survey my heart, my thoughts assess,
 and help me daily keep in sight
 your steadfast love and faithfulness.

3. The liar's company I've not sought,
 nor will I join the hypocrite
 or those corrupt in act and thought,
 nor with the wicked will I sit.

4. I wash my hands in innocence,
 around your altar, Lord, I go,
 my heartfelt thanks my voice presents
 and tells the wonders that you do.

5. Lord, how I love your house, for there
 your glory dwells in hallowed state;
 don't sweep my soul away, to share
 the violent, scheming sinner's fate.

6. But may I strive to walk your way,
 redeemed by grace from sin and shame;
 so shall my feet not go astray,
 and with your saints I'll bless your name.

Psalm 27

A Psalm of David.

1 The Lord is my light and salvation;
 what person on earth shall I fear,
what power in the whole of creation?
 The Lord, my life's stronghold is near.
The wicked may look to devour me,
 but they merely stumble and fall;
though warriors could well overpower me,
 my trust shall not waver at all.

2 For one thing alone I implore him:
 I long to remain all my days
at prayer in his temple before him,
 and there on his beauty to gaze.
In danger he'll be my defender,
 on rock will my feet be secured;
triumphant in trouble, I'll render
 my offerings of praise to the Lord.

3 O Lord, hear my voice, I beseech you:
 respond to my cry with your grace;
my heart ever tells me to seek you:
 I will, Lord – O hide not your face.
Nor yet in your anger reject me,
 O God, my salvation, my hope!
Though family no longer protect me,
 the Lord will himself take me up.

4 Lord, teach me your way, lest I wander
 or step in my enemies' path;
preserve me from them and their slander,
 their hatred, their violence and wrath.
I know in the land of the living
 I'll see the Lord's goodness outpoured;
be strong, such assurance receiving:
 take courage and wait for the Lord.

Psalm 28

A Psalm of David.

1 O Lord, to you I cry,
 the Rock in whom I trust:
if you are silent, I shall die
 and vanish into dust;
 O hear me when in prayer
 I call for help, for grace,
and lift my hands towards you there
 in your most holy place.

2 Don't carry me away
 with those of evil will,
whose kindly words do not convey
 the malice that they feel;
 repay them, everyone,
 O Lord, for their disdain
of all you've done: then tear them down
 in ruins to remain.

3 The Lord has heard my plea!
 With joy my heart is filled;
in him my trust shall ever be:
 the Lord my strength, my shield!
 Since he will save his king,
 his people too he'll keep,
and bear them safe through everything,
 the shepherd of his sheep.

Psalm 29

A Psalm of David.

1 Ascribe to the Lord,
 in earth and in heaven,
ascribe to the Lord
 all glory and power;
to his name, his only,
 the glory be given:
in his holy splendour
 the Lord God adore.

2 His voice skims the sea,
 as thunder he speaks,
his voice comes in power,
 majestic and full;
his voice splits the cedars
 on Lebanon's high peaks:
Mount Sirion rears up like
 an angry young bull.

3 His voice utters fire
 in lightning's swift flare,
the desert he shakes
 and sifts at his whim;
his voice bends the oak trees
 and strips the woods bare,
and all in his temple
 cry "Glory!" to him.

4 The Lord sat enthroned
 commanding the Flood,
and still he is King:
 his rule shall not cease;
the Lord keeps his people
 with his strength endued,
and pours out upon them
 his blessing of peace.

Psalm 30

A Psalm of David. A Song at the dedication of the Temple.

 1 I'll lift my voice, O Lord,
 to glorify your name,
 for you have lifted me
 above defeat and shame;
 you heard my cry to heal and save,
 and stooped to raise me from the grave.

 2 Then to his holy name
 let all his saints give praise:
 his wrath is brief, his grace
 is with us all our days,
 for grief and tears may last a night,
 but joy will come with morning light.

 3 In easy times I'd felt
 secure from all life's ills:
 your hand upheld me, Lord,
 like Zion's timeless hills;
 but with your smile no longer there
 assurance plunged to deep despair.

 4 To you, O Lord, I cried:
 "What can my death achieve?
 From bones among the dust
 what praise will you receive?
 O Lord, be merciful to me!
 Come quickly, help me – hear my plea!"

 5 O how I leapt for joy
 as grief was put to flight!
 My sackcloth you removed
 and clothed me with delight,
 that you, O Lord, I might adore
 and give you thanks for evermore.

Psalm 31

For the choirmaster. A Psalm of David.

1 In you, O Lord, I shelter: never fail me,
 but in your righteousness deliver me;
O listen to me, hurry to my rescue,
 my Rock, my Fortress: keep me safe and free.
Yes, you're indeed my rock, you are my fortress:
 for your name's sake, then, lead me, be my guide,
help me avoid the trap they've been preparing,
 for you're the tower of refuge where I hide.

2 Into your hand do I commit my spirit,
 Lord, my redeemer, God for ever true;
I hate all those who keep to worthless idols,
 but I, O Lord, have put my trust in you.
Your steadfast love has set my heart rejoicing:
 you've seen my cares, you know my soul's distress,
and you have kept me from my enemy's clutches
 to walk at large in freedom's open space.

3 Show grace to me, O Lord, in my deep trouble:
 half-blind with grief, my soul and body fail;
my life consumed with sighing and with sorrow,
 my sin and guilt have left me spent and frail.
I have become the scorn of all my enemies,
 a horror to my neighbours if we meet,
a thing of dread to everyone who knows me
 and shunned by every stranger in the street.

4 I've passed from memory like one long departed,
 like broken china trampled in the ground;
yet I can hear the whispering voice of many –
 the sense of terror looming all around! –
as they together now conspire against me,
 for my life's final moment they have planned;
but I am trusting you, O Lord, declaring
 "You are my God", my times are in your hand.

5 Deliver me from those who now pursue me,
 smile on your servant in your steadfast love;
 O let me not be put to shame: don't fail me,
 for I cry out to you, O Lord, above.
 Instead let sudden shame engulf the wicked,
 sent down to Hades, speechless and forlorn;
 let lips be sealed which denigrate the righteous
 with endless lies, in arrogance and scorn.

6 How vast and how abundant is your goodness,
 stored up for those who fear and reverence you,
 bestowed on those who find in you their refuge,
 for all the watching world around to view.
 You hide them in the secret of your presence
 from men's intrigues, from slander's cutting edge:
 the Lord be blessed, for wonderfully he showed me
 his steadfast love when I was under siege.

7 In my alarm, at bay before such enemies,
 I'd said, "I have been cut off from your sight."
 But when I raised my voice in supplication
 you heard my cry for mercy in my plight.
 Then love him, all you saints! He guards the faithful,
 but pays the proud in full their just reward;
 be strong and ever let your heart take courage,
 all you whose living hope is in the Lord!

Psalm 32

A Psalm of David. A Maskil.

1 Happy the one who had transgressed
 but knows that all has been forgiven,
 the one whose sin with grief confessed
 is covered in the sight of heaven.
 Happy the one to whom the Lord
 does not impute iniquity;
 gone is their guilt, their past deplored,
 from all deceit their heart is free. . . .

2 Whilst I kept silent all my bones,
 crushed by your pressure night and day,
 withered amid my fevered groans:
 like summer mist, life burnt away.
 Then I declared my sin to you,
 all my iniquity confessed;
 pardon for sin and guilt I knew:
 at last my harrowed heart had rest.

3 Therefore let every godly soul
 pray to you while you may be found;
 though surging waters round them roll,
 safe shall they be on solid ground.
 You are my secret hiding-place,
 whenever trouble may arise;
 round me you cast your guardian grace,
 with victory songs you fill the skies.

4 Teach us, O Lord, the way to lead
 lives that are pleasing in your sight,
 not to be mindless mules that need
 bridle and bit to walk aright.
 How many griefs the wicked have,
 but those who make the Lord their trust
 are guarded by his steadfast love:
 rejoice in him, all you the just.

Psalm 33

1 Let all the righteous to the Lord
 their joyful voices raise!
 how right that they should play and sing
 to him new songs of praise!
 For faithful are his word and works
 beyond all human worth;
 the Lord loves what is right and just,
 his goodness fills the earth.

2 The heavens and all their host were made
 by his all-powerful word;
 at his command the seas appeared
 and in the deep are stored.
 Let all the earth in awe and fear
 before him bow the knee:
 the Lord, at whose direct command
 creation came to be.

3 The Lord confounds the nations' pride,
 he foils what they had planned,
 but his designs and purposes
 for evermore shall stand.
 O happy nation, then, in which
 the Lord as God is known,
 called forth by sovereign grace to be
 a people of his own.

4 From heaven the Lord sees humankind:
 all live within his view;
 and he who forms the hearts of all
 considers, all they do.
 An army cannot save a king
 despite its strength and speed;
 the Lord sees those who trust in him
 to save in time of need.

5 We wait with patience for the Lord:
 he is our help and shield;
 and he has given our hearts a joy
 which cannot be concealed.
 Our trust is in his holy name:
 O Lord, our lives endue
 for ever with your steadfast love,
 even as we hope in you.

Psalm 34

A Psalm of David, when he feigned madness before Abimelech, so that he drove him out, and he went away.

1 I'll bless the Lord throughout my days,
at all times I will sing his praise;
in him I boast with heart and voice:
the humble hear and they rejoice;
come all and magnify the Lord,
exalt his name with one accord.

2 I sought the Lord, he answered me,
from all my fears he set me free;
look up to him with radiant face,
unblushing, glorying in his grace;
in my distress he heard my prayers
and rescued me from all my cares.

3 Round those who fear him angels stand,
delivering them at his command;
O taste the goodness of the Lord,
our refuge and our great reward;
young lions may hunger till they faint,
but he provides for every saint.

4 Come, children, listen to my word,
learn what it means to fear the Lord:
who wants to know the way to live
and have the best that life can give?
Let evil talk and lying cease,
do good and always strive for peace.

5 He sees the righteous, hears their plea,
and from their troubles sets them free,
but frowns on men of evil ways:
all memory of them he'll erase;
the Lord is near the broken heart
and mends it with his healing art.

6 Though on the just afflictions fall,
 the Lord will keep them safe through all;
 while he protects them, every bone,
 the wicked reap what they have sown;
 the Lord redeems his servants here:
 no condemnation now they fear.

Psalm 35

A Psalm of David

1 Contend, O Lord, with those contending now with me:
 arise, defend me with your massive shield;
 take up your arms against them, and assure my soul:
 "I'm your salvation on this battlefield."
 Let those be put to shame who seek to end my life,
 let those who plot my end be put to rout,
 like winnowed chaff, their path a dark and slippery one,
 the angel of the Lord in hot pursuit.

2 For without cause they dug a pit to catch me in,
 and without cause concealed their wicked snares;
 let them instead fall victim to their evil plans,
 let ruin overtake them unawares.
 Then I'll rejoice in you, O Lord, for saving me,
 with all my being cry, "Who is like you?
 Who else can save the weak from those too strong for them,
 and save the poor from exploitation too?"

3 Malicious witnesses appear who question me,
 although I have no knowledge of the affair;
 with evil they repay me for the good I've done,
 and leave my soul forlorn and near despair.
 Yet I, when they were sick, wore black and kept a fast;
 and when my prayers had brought them no relief
 I looked like one who mourned a friend or brother even,
 as if my mother's end had caused my grief. . . .

4 But when I stumbled they rejoiced and gathered round,
 like strangers, hostile, tearing me apart,
each one a voice of jeering and profanities
 and angry noises from a furious heart.
O Lord, how long will you look on? Deliver me
 from savage beasts that soon could end my days;
then I will give you thanks with your assembled saints:
 amid the mighty throng I'll sing your praise.

5 Don't let my enemies unprovoked gloat over me,
 who undermine the peaceful in the land;
they sneer at me, "We've seen you in the very act!"
 – You've seen this, speak, O Lord: stay close at hand!
Awake, rise up in my defence and fight for me,
 acquit me in your righteousness, O Lord;
don't let them laugh and boast: "We've eaten him alive?"
 and reckon they have had the final word.

6 Let those who look with joy on my adversity
 be covered in confusion and in shame;
let those whose great delight is in my righteousness,
 with joy and gladness evermore exclaim:
"The Lord be magnified, whose true delight is in
 his loyal servant's welfare and his peace!"
Then shall my willing tongue declare your righteousness,
 and praise you all day long and never cease.

Psalm 36

To the choirmaster. A Psalm of David. The servant of the Lord.

1 Transgression rules the wicked person's heart:
there is no fear of God before his eyes;
for, blinded by his own deceptive art,
his sin and guilt he cannot recognise;
his speech is false, corruption is his creed,
all good he spurns in thought, desire and deed.

2 Your steadfast love, O Lord, transcends the skies,
above the cloud-caps towers your faithfulness,
your truth and righteousness like mountains rise,
your judgments are profound as the abyss;
across the world your goodness is outpoured,
as you provide for man and beast, O Lord.

3 How precious is your steadfast love, O God!
Earth's children shelter underneath your wings;
they feast upon the abundance you've bestowed,
and drink delights from your unfailing springs:
from you flows life, a fountain pure and bright,
and it is in your light that we see light.

4 Maintain your love and righteousness to all
who know you, those of upright heart and true;
let not the proud prevail and cause my fall,
nor let the wicked drive me away from you.
There every evildoer now prostrate lies:
thrown down at last, they nevermore shall rise.

Psalm 37

A Psalm of David.
Part 1 (1-11)

1 Don't fret and don't complain
when evil men succeed;
don't envy what they gain
by fraud or some misdeed,
for all their wealth and power will pass
and quickly wither like the grass.

2 Trust always in the Lord,
do good with heart and hand,
be faithful to your word,
and so dwell in the land;
delight in him and he'll impart
what you desire with all your heart. . . .

3 Surrender to the Lord
 yourself and all your ways:
 trust him to keep his word,
 to act on what he says;
 he'll bring your righteousness to light,
 your justice like the noonday bright.

4 Before the Lord be still,
 don't fret although it seems
 a man of evil will
 might carry out his schemes:
 refrain from anger, turn from wrath –
 don't fret, for that's a dangerous path.

5 The wicked soon will cease,
 all trace of them be gone;
 the meek, though, shall possess
 the land from that day on:
 with peace abundant they'll be blessed,
 the heirs of God's long-promised rest.

Part 2 (12-20)

6 The wicked plot against
 the godly and the just,
 embittered and incensed
 that God should be their trust;
 the Lord just laughs: he sees the day
 when they will all be swept away.

7 The wicked bend their bows
 and brandish sword or knife,
 to slay the poor and those
 who lead an upright life;
 their bows will break, and they shall feel
 their heart cut through by their own steel.

8 The little that the poor
 in righteousness obtain
 excels by so much more
 the wealth the wicked gain,
 whose powers will be reduced to dust
 while he, the Lord, upholds the just.

9 His watchful eyes perceive
 each day the blameless spend;
 the heritage they leave
 will last and never end;
 when times are dark, they're buoyant still:
 in famine they shall eat their fill.

10 But we may rest assured,
 the wicked soon shall pass:
 the enemies of the Lord
 will wither like the grass,
 will simply vanish at a stroke –
 yes, vanish like a wisp of smoke.

Part 3 (21-29)

11 The wicked take a loan,
 but they do not repay;
 yet what the righteous own
 they share or give away:
 God's blessing leaves his heirs the land,
 but those he curses shall be banned.

12 The Lord directs aright
 the steps a good man takes,
 and watches with delight
 the headway that he makes;
 though he may fall, he'll rise and stand
 because the Lord upholds his hand.

13 These eyes have never seen
 the just cast off in need,
 nor have their children been
 sent begging for their bread;
 they freely lend their whole life through,
 their children share in blessing too.

14 Shun evil and do good,
 for that's the way to ensure
 you live here as you should,
 secure for evermore;
 for he, the Lord, loves justice, hence
 he never will forsake his saints. ...

15 The wicked will not last:
 they vanish soon enough,
 their memory quickly past,
 their children all cut off;
 not so the just: the land is theirs,
 the eternal home God gives his heirs.

Part 4 (30–40)

16 The righteous man is wise
 and speaks with wisdom's tongue;
 true justice he applies,
 discerning right from wrong:
 God's law is in his heart, its grip
 will never let his footsteps slip.

17 The wicked form a scheme
 to kill the righteous man;
 the Lord will not leave him
 to perish as they plan,
 nor let him be condemned when brought
 to stand accused before a court.

18 Wait for the Lord in hope,
 observe his way with care,
 and he will raise you up
 to honour as his heir:
 you'll take possession of the land
 and watch to see the wicked banned.

19 I've seen a ruthless man,
 as prosperous as could be,
 imposing as the span
 of some great timber tree;
 he disappeared without a sound:
 I looked – no trace of him was found.

20 Mark how the blameless tread
 this earth in righteousness:
 a future lies ahead
 for those who cherish peace;
 transgressors perish soon enough,
 their future shall be quite cut off.

21 Salvation for the just
 comes from the Lord alone,
 the stronghold they can trust
 when troubled times are known;
from evil he delivers them,
 because their refuge is in him.

Psalm 38

A Psalm of David, to bring to remembrance.

1 Rebuke me not in anger, Lord:
 restrain your wrath, I pray;
so chasten me that I'm restored,
 not judged and cast away.
I feel your arrows deep within,
 I sink beneath your hand
and underneath a weight of sin
 too great for me to stand.

2 For sinful folly now I pay:
 I'm humbled to the ground,
I go round mourning all the day
 and no relief I've found.
I feel my body racked with pain,
 diseased in every part:
so numbed and crushed, I can't contain
 the groaning of my heart.

3 My longings, Lord, to you are known,
 my every sigh you hear;
my strength, my sight are almost gone,
 my friends will not come near,
while others lay their lethal snares,
 all day they plot, they lie;
like one who neither speaks nor hears
 I offer no reply. . . .

4 O Lord, for you I've waited here:
 you'll answer, Lord, my call,
 for I'd said, "Do not let them jeer
 and glory in my fall."
 I'm set to fall, I realise,
 my pain just will not cease;
 my wickedness I recognise,
 my sin gives me no peace.

5 My many enemies are so strong,
 though groundless is their feud;
 my kindness they repay with wrong
 whilst I'm pursuing good.
 "O Lord be with me to the last,
 my God be ever near;
 come to my rescue, come with haste:
 O Lord my Saviour hear!"

Psalm 39

To the choirmaster: to Jeduthun. A Psalm of David.

1 I vowed to watch my ways and guard my speech,
 to seal my mouth and keep my tongue from sin,
 while there the wicked stood within close reach,
 yet scarcely could I keep my anguish in.
 My torment grew, my smouldering heart became
 a burning ire that drove my tongue to exclaim:

2 "Lord, let me know my end, my life's extent,
 how short its measure and how swift its flight:
 an inch or two of time is all you've lent,
 my life-span is as nothing in your sight;
 the merest froth, man rushes round in vain,
 amassing wealth for other people's gain.

3 "Now, Lord, where can I turn in such an hour?
 On you my hope is fixed, on you alone:
 save me from all my sins – their guilt, their power –
 and from the fool's contemptuous, withering tone;
 I seal my mouth, contented now I see
 that you yourself ordained this path for me.

4 "But in your mercy lay aside your scourge:
 your chastening hand has bruised me deep within;
 for you chastise us when our ways diverge
 from your commands, rebuking us for sin,
 consuming all we treasure like a moth:
 each man is surely but the merest froth.

5 "Lord, hear my prayer, O listen to my cry:
 you see my tears, don't turn away your ear!
 For on this earth your passing guest am I,
 like all my fathers, just a pilgrim here.
 Withdraw your frown, that I may smile again
 before that hour when I no more remain."

Psalm 40

To the choirmaster. A Psalm of David.

1 Patient in hope, I sought the Lord;
 he turned to me, my cry was heard!
 Raising me from the miry pit,
 on solid rock he set my feet.
 He turned my cry to newborn song:
 from heart and voice God's praises sprang;
 many who see such grace outpoured,
 fearing, will turn and trust the Lord.

2 Happy are those who put their trust
 in him, the Lord: not like the lost,
 following leaders blind and proud,
 worshipping some pretended god.
 How many wonders you have done,
 what blessings still for us you plan,
 O Lord – my God beyond compare! –
 mercies too numerous to declare. . . .

3 You have desired not sacrifice
but open ears to obey your voice;
"I come," I answered, "at your call,
as written of me in the scroll.
I come your purpose to fulfil,
glad, O my God, to do your will;
joyful obedience is my part:
your law is written in my heart."

4 Now have your gathered people heard
news of your righteousness, O Lord;
I have not failed to tell them of
your saving acts and steadfast love.
Lord do not hold your mercies back:
so many storms around me break;
my countless faults come crowding in,
my heart is overwhelmed by sin.

5 Be pleased, O Lord, to rescue me
from all who seek my life today;
let all who laugh at my distress
be put to flight in sheer disgrace.
May all whose hope on you is set
constantly say: "The Lord is great!"
Poor and in need, to you I pray;
hear, O my God, do not delay.

Psalm 40 (alternative version)

To the choirmaster. A Psalm of David.

1 In patient hope I sought the Lord;
he turned to me, my cry was heard!
he raised me from the miry pit,
on solid rock he set my feet.
He turned my cry to newborn song:
from heart and voice God's praises sprang;
as many see such grace outpoured,
in fear they'll turn and trust the Lord.

2 How happy those who put their trust
 in him, the Lord's not like the lost
 that follow leaders blind and proud
 and worship some pretended god.
 So many wonders you have done,
 what blessings still for us you plan,
 O Lord – my God beyond compare! –
 Too many are they to declare.

3 You have desired not sacrifice
 but open ears to obey your voice;
 "I come," I answered, "at your call,
 as written of me in the scroll.
 I come your purpose to fulfil,
 glad, O my God, to do your will;
 obedience is my joyful part:
 your law is stamped upon my heart."

4 Now have your gathered people heard
 your righteousness proclaimed, O Lord;
 I have not failed to tell them of
 your saving acts and steadfast love.
 Lord do not hold your mercies back:
 so many storms around me break;
 my countless faults come crowding in,
 my heart is overwhelmed by sin.

5 Be pleased, O Lord, to rescue me
 from all who seek my life today;
 let all who laugh at my distress
 be put to flight in sheer disgrace.
 May all whose hope on you is set
 forever say: "The Lord is great!"
 Yet poor, in need, to you I pray;
 my God, O hear: do not delay.

Psalm 41

To the choirmaster. A Psalm of David.

1 Happy the one concerned for those in need:
the Lord will save him in the evil day,
protect his life and help him here succeed,
and will not let his enemies have their way;
sustaining him in sickness and in pain,
the Lord will raise him back to health again.

2 But I cried out, "Have mercy, heal me, Lord,
for I have sinned, I have offended you."
My enemies' malice marks their every word:
"When will he die, his memory perish too?"
If one calls by, his talk is all deceit:
he's gathering lies to broadcast in the street.

3 My whispering enemies all discuss my state,
they're watching for my imminent demise:
"This deadly thing within him seals his fate;
he'll never leave that bed on which he lies."
And even my most dear and trusted friend,
who shared my bread, has spurned me in the end.

4 But you, O Lord, have mercy: heal me now,
that I may recompense these mutineers;
you look on me with favour, that I know,
for they have halted their triumphant jeers.
And you will keep me upright by your grace,
for evermore to stand before your face.

Doxology

All blessing, praise and honour to the Lord,
the God who has redeemed his chosen race,
from everlasting God, supreme, adored,
to everlasting God of power and grace!
Let all who glory in his endless reign
for ever bless his name! Amen! Amen!

BOOK TWO: PSALMS 42–72

Psalm 42

To the choirmaster. A Maskil of the Sons of Korah.

1 As the fainting deer cries out
 for the streams in time of drought,
 so my soul cries out aloud
 thirsting for the living God.
 All the day I feed on grief,
 night allows me no relief,
 while the taunts go on and on:
 "Where's your God now? Where's he gone?"

2 Broken-hearted I recall
 how I used to lead them all
 to the temple, where the throngs
 sang with joy their festal songs.
 Why, my soul, are you distressed?
 Why so anxious, so oppressed?
 Hope in God, for I'll yet praise
 God my Saviour all my days.

3 Darkness and despair return;
 far from you, for you I yearn:
 deep to deep incessant calls,
 as your thunderous torrent falls;
 waves and breakers you control
 overwhelm my anguished soul:
 Lord, command your grace by day,
 share your song at night, I pray. . . .

4 Why forget me, God my Rock?
 Still you let the tongues that mock
 bruise and break me bone by bone:
 "Where's your God now? Where's he gone?"
 Why, my soul, are you distressed?
 Why so anxious, so oppressed?
 Hope in God, for I'll yet praise
 God my Saviour all my days.

Psalm 43

1 God defend me; traitors rise,
 slandering me with monstrous lies;
 God my refuge, hear my plea:
 why have you deserted me?
 Why have I been left to mourn,
 crushed by their deceit and scorn?
 Send your light and truth to guide
 to your hill, where you reside.

2 To God's altar then I'll go,
 to the highest joy I know;
 I will praise him with the lyre,
 God, my God, my heart's desire.
 Why, my soul, are you distressed?
 Why so anxious, so oppressed?
 Hope in God, for I'll yet praise
 God my Saviour all my days.

Psalm 44

To the choirmaster. A Maskil of the Sons of Korah.

1 O God, our ears have heard our fathers tell us
> of all that you accomplished in their day:
> you planted them among the pagan nations
> which your hand dispossessed and drove away.
> For it was not their weapons nor their prowess
> that won the land and conquered in the fight,
> but your right hand, your arm, your smiling countenance,
> because in them you simply took delight.

2 O God, you are my King, and Jacob's saviour:
> our enemies we put down through you alone;
> I put no trust in bow or sword to save me,
> nor any other weapon I may own.
> But you have rescued us from all our enemies,
> and those that hate us you have put to shame;
> in you our God unceasingly we glory,
> and shall for ever praise your holy name.

3 But now you have rejected and disgraced us,
> abandoning our troops when they march forth;
> you've made our men retreat before the enemy,
> and they have plundered us of all we're worth.
> You've given us up like sheep consigned to slaughter
> and scattered us abroad in foreign lands;
> you've sold your chosen people for a pittance
> and left with next to nothing in your hands.

4 You've made us a reproach to all our neighbours,
> we're mocked and scorned by those on every side;
> you've made our name a joke among the nations,
> the laughingstock the peoples all deride.
> The whole day long is my disgrace before me,
> and all day long my face parades its shame
> before the cries of mockery and the insults
> of those who make revenge their dearest aim. . . .

5 All this has happened, though you're not forgotten:
 we've not betrayed the covenant that you made;
our heart has not turned back, our feet not wandered,
 yet you have covered us in death's dark shade.
Had we forgotten *our* God for some other,
 since God reads every heart, he'd surely know;
yet all day long have we been slain for *your* sake:
 like sheep for slaughter, to our death we go.

6 Wake up, O Lord, wake up! Why are you sleeping?
 Get up! Don't cast us off for evermore.
Why do you hide your face? Why don't you notice
 the misery and the oppression we endure?
For we are lying in the dust prostrated,
 our body trampled in the dirt this day;
rise up, and come to rescue us, we beg you:
 redeem us in your steadfast love, we pray.

Psalm 45

To the choirmaster: according to Lilies.
A Maskil of the Sons of Korah; a love song.

1 A noble theme impels my heart to sing,
my tongue is like a skilful writer's pen,
as I address my verses to the king:
O fairest far among the sons of men!
Your lips speak grace to everyone who hears;
so God has blessed your reign for endless years.

2 Strap on your sword in glorious majesty,
ride forth for truth, humility and right;
the triumph of your victory all shall see
as your right hand wreaks havoc in the fight:
your arrows pierce the hearts of rebel foes,
the peoples fall to your unerring blows.

3 Your throne, O God, shall stand for evermore:
 your sceptre rules for all that's just and true,
 you love what is right and evil you abhor;
 therefore has God, your God, anointed you
 with oil of joy your fellows may not share:
 and all your robes are odours rich and rare.

4 Musicians play, princesses throng your throne;
 beside you stands your bride in gold adorned.
 Hear, daughter; now forget your father's home,
 the king desires you, bow to him, your Lord;
 then neighbouring lands will favour you, his queen,
 with honours, gifts and riches unforeseen.

5 Fair maidens wait, their princess to escort
 in cloth of gold, the king himself to wed;
 with joyful heart she's led inside his court:
 leave kinsmen and have royal sons instead!
 From age to age my song shall spread your fame;
 so shall the nations ever praise your name.

Psalm 46

To the choirmaster. A Psalm of the Sons of Korah.
According to Alamoth. A Song.

1 God is our shield and God our rock,
 present to help when troubles loom;
 we will not fear the seismic shock
 though mountains hurtle to their doom.
 Let oceans roar, let hills subside,
 the depths of earth unleash their power:
 the Lord of hosts is by our side,
 the God of Jacob, our strong tower. . . .

2 God's city finds within her walls
　water abundant from her stream:
　God dwells within, she never falls,
　his help will come with dawn's first beam.
　The nations rage, the kingdoms slide;
　he speaks, whose words the world devour:
　the Lord of hosts is by our side,
　the God of Jacob, our strong tower.

3 See what the Lord has wrought below:
　great desolations on the world!
　He stamps out war: he breaks the bow,
　and chariots in the fire are hurled.
　"Be still, and know I'm God worldwide,
　supreme above all earthly power!"
　The Lord of hosts is by our side,
　the God of Jacob, our strong tower.

Psalm 47

To the choirmaster. A Psalm of the Sons of Korah.

1 O clap your hands, all nations, cry
　with joy to God, declare his worth:
　how awesome is the Lord Most High,
　the great King over all the earth.

2 The nations conquered by his hand
　now all look up to us above;
　he chose our heritage, the land
　he gave to Jacob out of love.

3 The Lord's ascended! Hear the cry!
　The skies with clarion trumpets ring!
　Sing praise, sing praise to God on high,
　sing praise to our victorious King!

4 For all the earth is God's domain:
　sing joyful psalms, his praise make known!
　For God, who over all must reign,
　is seated on his holy throne.

5 The nations' princes join the throng
 of those who Abraham's God adore,
 for this world's powers to him belong:
 our God, supreme for evermore!

Psalm 48

A Song. A Psalm of the Sons of Korah.

1 Great is the LORD, supremely to be praised
 within God's holy city, set on high,
 Mount Zion, in resplendent beauty raised,
 the joy of all the earth, of every eye,
 the city of the great King: there he dwells,
 himself the Fortress of her citadels.

2 For when the kings had marshalled all their men
 and with their allied forces marched ahead,
 they saw her, were astounded at her – then
 in sudden terror turned about and fled:
 they shook, as women in their birth-pangs shake,
 and fell apart like ships the storm winds break.

3 What we had heard, our eyes at last have seen
 within the city of the LORD of hosts,
 the city of our God, by whom it's been
 secured for ever to the uttermost;
 and there your temple's hallowed courts we trod,
 reflecting on your steadfast love, O God.

4 Just as your name, O God, your praise no less
 spreads far afield to earth's remotest ends,
 and your right hand displays your righteousness
 in victory and deliverance that it sends;
 rejoice, Mount Zion, Judah's daughters too:
 the judgments of our God are just and true.

5 Walk round the city, see her walls of stone,
 her towers majestic soaring to the skies,
 survey her ramparts – make these glories known
 to generations that shall yet arise;
 for such is God, the God whom we adore,
 and he will be our guide for evermore.

Psalm 49

To the choirmaster. A Psalm of the Sons of Korah.

1 Hear this, all nations; listen, all you people,
 both low and high alike, both rich and poor:
 in song my mouth will utter words of wisdom
 as one of life's enigmas I explore.
 Why should I be afraid in times of trouble,
 when malice, treachery and deceit abound,
 when people put their trust in their great riches
 and boast about their wealth to all around?

2 The price to offer God for one's redemption
 is far beyond what we could ever pay –
 that we should live this present life for ever,
 and never see the grave and its decay.
 The wise die as do fools: the grave's their mansion,
 they leave behind their name and their estate;
 for all his wealth and honour, man is mortal:
 he's like the beasts – they share one common fate.

3 This is their path, the end of their bravado,
 and of the crowd who follow where they lead;
 like sheep they're driven down towards the graveyard
 to be the pasture on whom Death will feed.
 When morning breaks, the just will rule those shadows,
 now stripped of home and all they'd striven for;
 but God will ransom me from death's dominion
 and take me to himself for evermore.

4 So do not fear when someone's wealth increases
 and when his house enjoys illustrious days;
 he'll leave it all behind: his fame and fortune,
 self-satisfaction, other people's praise.
 He'll join the generation of his fathers
 in deepest darkness, their eternal state:
 the man of wealth who lacks true understanding
 is like the beasts – they share one common fate.

Psalm 50

A Psalm of Asaph

1 The Mighty One, the living God, the Lord,
 calls earth from east to west before his throne;
 from Zion's perfect beauty God shines forth:
 our God descends, to make his purpose known.
 Devouring fire precedes his sacred form,
 encircled by a vast tempestuous storm.

2 He summons both the heavens and earth to see
 his people judged at his divine assize:
 "Bring all my faithful people here to me,
 in covenant bonds with me by sacrifice."
 His justice let the very heavens declare,
 for God himself is giving judgment there.

3 "Hear, O my people Israel, I will speak
 as your accuser – God, your God, am I:
 it's not burnt offerings that I truly seek,
 that rise each day before my watchful eye;
 your herded bulls and he-goats I decline,
 for cattle, sheep and wildlife all are mine.

4 "Would I say if I'm hungry? Are goats' blood
 and slaughtered bulls the daily meals I take?
 Bring sacrifice to offer thanks to God:
 fulfil to God Most High the vows you make;
 and call on me when trouble clouds your days:
 I'll rescue you, and you shall give me praise."

5 But to the wicked God says: "Who are you
 to mouth my laws, yet brush my words aside?
 You're friends with thieves, and with adulterers too;
 your speech is evil, day by day you've lied.
 You sit around and smear your brother's name:
 the son of your own mother you defame!

6 "These things you've done, yet no reproof I sent;
 you thought that I was really like yourself;
 hear my rebuke, consider and repent,
 lest judgment strike, with no one there to help.
 Thanksgiving is the heart of purest praise:
 salvation is for such as walk my ways."

Psalm 51

To the choirmaster. A Psalm of David, when Nathan the prophet came to him, after he had gone in to Bathsheba.

1 In your grace, O God, have mercy,
 in your great love intervene:
 blot out these my grave transgressions,
 wash me, cleanse me from my sin.
 Well I know my sins: their memory
 haunts my conscience day and night;
 you alone have I offended,
 done what's evil in your sight.

2 You are just in passing sentence,
 holy in your solemn curse;
 I, in truth, was born a sinner,
 flawed, rebellious and perverse.
 Teach my heart the inner wisdom
 you desire that I should know;
 purge my soul of sin's defilement,
 wash me whiter than the snow.

3 Let the bones that you have broken
 now their songs of joy outpour;
 blot out all my sin and evil,
 on my failures look no more.
 God, create a heart within me
 steadfast, pure – completely new;
 don't withdraw your Holy Spirit,
 keep me ever close to you.

4 Make me glad in your salvation,
 make my heart obedient too,
 then shall I teach other sinners
 who shall hear and turn to you.
 O my Saviour God, absolve me
 from my part in sin and death;
 Lord, inspire my lips to praise you
 all the while you give me breath.

5 There's no offering I can bring you,
 none finds favour in your eyes,
 but a broken, contrite spirit
 you, O God, will not despise.
 Bless and prosper all your people,
 O transform us in your love,
 then shall we be living offerings
 to delight our God above.

Psalm 52

To the choirmaster. A Maskil of David, when Doëg the Edomite came and told Saul, "David has come to the house of Ahimelech."

1 Why, mighty hero, must you boast
 of cruelty and of crime,
 yet disregard God's steadfast love
 which lasts throughout all time?
 How razor-sharp your deadly tongue,
 what treachery you devise!
 You cling to evil, hate the good
 and love pernicious lies.

2 But God will tear you clean away
 from all the wealth you own,
 from home and family, life itself,
 to reap what you have sown.
 The righteous will look on in awe,
 and with a laugh will say:
 "We knew his trust was not in God-
 in wealth and force it lay."

3 But I am like an olive tree
 that thrives in God's domain,
 dependent on his steadfast love
 whose power can never wane.
 I will for ever give you praise
 for what your hand has done,
 hope in your name, and with your saints
 make all your goodness known.

Psalm 53

To the choirmaster: according to Mahalath. A Maskil of David.

 1 The fool has said it in his heart:
 "God can't exist – and never could!"
 With lives depraved in every part,
 in thought and deed, not one does good.

 2 Yet God looks downward from the skies
 upon our wayward human race,
 to see if anyone is wise,
 if any seek their Maker's face.

 3 They've turned whichever way they would,
 along corruption's path they run;
 they're all alike, not one does good:
 no, truly, not a single one.

 4 Can evildoers be so misled
 that they will never learn or care?
 My people they devour like bread
 and never call on God in prayer.

 5 There were your enemies petrified –
 the cause of which was never learned –
 their bones God scattered far and wide:
 you put to shame those God had spurned.

 6 From Zion let God come in power
 once more to set his people free,
 his people's fortunes to restore:
 how joyful then will Israel be!

Psalm 54

To the choirmaster: with stringed instruments. A Maskil of David, when the Ziphites went and told Saul, "David is hiding among us."

 1 God, save me by your sacred name
 and vindicate me by your might:
 God, hear my prayer, my words that claim
 Your help in my despairing plight.

2 I'm facing strangers bent on strife,
 their minds intent on shedding blood,
 remorseless men who seek my life
 and who have no regard for God.

3 But God is all the help I need,
 the Lord sustains me day by day:
 turn back their evil on their head
 and faithfully sweep them all away.

4 With glad and thankful heart I'll bless
 your name, O Lord, for it is good,
 delivering me from my distress,
 to view my enemies now subdued.

Psalm 55

To the choirmaster: with stringed instruments. A Maskil of David.

1 Listen to my prayer, O God,
 under trouble's crushing load:
 enemies all around rampage
 clamouring for me in their rage;
 terror overwhelms my heart,
 every instinct says, "Depart!"
 O for wings, that like a dove
 I could reach the hills above,
 or some distant wilderness,
 safe from all the storm and stress.

2 Lord, confuse their thoughts and plans,
 curb their wild marauding bands:
 constant violence, daily strife
 tear apart our city's life;
 fraud, oppression and deceit
 take control of every street.
 Trust has met a bitter end:
 see, the traitor, once my friend,
 leaves the way of faith we trod –
 now he courts the wrath of God. . . .

3 Still I call upon the Lord
 till my cry for help is heard;
 morning, noon and night I cry
 and he answers from on high:
 he will ransom me unharmed,
 though my enemies are well armed.
 From his everlasting throne
 God will make his verdict known,
 judging in such godless days
 those who will not change their ways.

4 Sacred bonds my friend will breach,
 feigning peace with smoothest speech,
 words that sound like soothing oil,
 yet are swords designed to kill.
 Cast your cares upon the Lord –
 trust his promise, prove his word!
 He, will ever bear you up,
 never to betray your hope;
 hardened sinners reap their due:
 I, O God, will trust in you.

Psalm 56

To the choirmaster: according to The Dove on Far-off Terebinths.
A Miktam of David, when the Philistines seized him in Gath.

1 O God, have mercy – men pursue
 and look to attack me all day long,
 but when afraid I trust in you
 to save me from that shameless throng.
 Your word I praise, from fear set free:
 what can mere mortals do to me?

2 Forever twisting what I say,
 to harm me is their one design;
 concealed, they watch my steps all day,
 resolved to end this life of mine.
 Shall they not reap what they have sown?
 O God, in anger cast them down.

3 My wanderings you will not forget,
 you keep account of all my tears;
 I call to God, the men retreat,
 the Lord is for me: yes, he hears.
 His word I praise, from fear set free:
 what can mere mortals do to me?

4 My vows, O God, I now must pay,
 to you my heartfelt thanks repeat;
 you've rescued me from death today
 and kept secure my faltering feet,
 that walking in the light you give
 to your great glory I may live.

Psalm 57

To the choirmaster: according to Do Not Destroy. A Miktam of David, when he fled from Saul, in the cave.

1 O God, from whom all mercy springs,
 on you my trusting soul I cast;
 conceal me underneath your wings
 until the raging storm is past.
 O God Most High, hear my distress:
 work out your perfect will for me
 in steadfast love and faithfulness
 and make my fierce pursuers flee.

2 At night I know they're crouching near
 like lions that hunger for their prey,
 their teeth as sharp as any spear:
 they seek my life by break of day –
 Exalt above the heavens, O God,
 your everlasting sovereign worth:
 then come in power and blaze abroad
 your glory over all the earth. . . .

3 They spread a net before my feet –
 my soul is crushed, all hope is fled;
 across my path they dig a pit –
 but they will stumble in instead.
 My heart is steadfast, and on fire
 with praise, O God, in soaring song!
 Awake, my soul! Let harp and lyre
 Awake – O I'll awake the dawn!

4 Before the world your name I'll bless
 and sing of you: how great your love!
 Your steadfast love and faithfulness
 transcend the very skies above.
 Exalt above the heavens, O God,
 your everlasting sovereign worth:
 then come in power and blaze abroad
 your glory over all the earth.

Psalm 58

To the choirmaster: according to Do Not Destroy. A Miktam of David.

1 Do you that rule and judge fulfil your trust
 to exercise true justice in your lands?
 No! What your hearts devise is all unjust:
 so many suffer violence at your hands.

2 From when they're born the wicked go astray;
 a venom like the viper's fills their throat;
 no influence, no appeal will change their way,
 they're like the cobra, deaf to every note.

3 Lord, tame these monsters, let their fangs be drawn;
 like water let them simply seep away,
 or like a stillbirth never see the dawn,
 but vanish from our world without delay.

4 The righteous will rejoice at last to see
 the wicked judged according to their worth;
 "So virtue is repaid," shall all agree,
 "there is a God who judges here on earth."

Psalm 59

To the choirmaster: according to Do Not Destroy. A Miktam of David; when Saul sent men to watch his house in order to kill him.

1 From my fierce enemies, O my God,
 protect me, and from their design:
 they lie in wait to shed my blood,
 for no offence, O Lord, of mine.
 They're set to attack me – come and see!
 You're Israel's God of hosts, the Lord:
 judge all who oppose you endlessly,
 let traitors get their due reward.

2 At night they're back: they prowl about
 and snarl like dogs to fuel our fear;
 pernicious words their tongues spew out,
 for no one else, they think, can hear.
 But you, O Lord, just laugh instead;
 my Strength, my Tower, for you I'll wait:
 in steadfast love God moves ahead
 and lets me look upon their fate.

3 But we forget as time goes by:
 don't kill them – slowly make them slide,
 O Lord our shield! They curse and lie:
 let them be caught in their own pride,
 consumed in wrath till they're no more,
 that everyone may understand,
 from here to earth's remotest shore,
 that God is King in Jacob's land.

4 At night they're back again, and bay
 like vicious dogs: they prowl about
 and snarl, impatient for their prey.
 But with the dawn my song rings out:
 your strength, your steadfast love I sing,
 in my distress my Tower above;
 my Strength, to you all praise I bring,
 my Tower, my God of steadfast love.

Psalm 60

To the choirmaster: according to Shushan Eduth.
A Miktam of David; for instruction; when he strove with Aram-naharaim and with Aram-zobah, and when Joab on his return killed twelve thousand of Edom in the Valley of Salt.

1 In wrath, O God, you've cast us off;
we're left in utter disarray,
we quake and reel at your reproof:
restore us, heal our land, we pray.
You've made us drink a bitter cup,
what desperate times you've brought us to;
and yet you've raised a banner up
for all who fear and trust in you.

2 Then save us with your powerful hand,
for in your holiness you swore:
"In triumph I'll bestow this land
on my belovèd evermore:
both east and west the land is mine
which Ephraim guards, where Judah reigns;
while Moab, Edom, Philistine
I'll break, or use for menial ends."

3 Who has resolve and strength enough
to lead me on to Edom's gate?
Can you, O God, have cast us off
and left our armies to their fate?
Against this enemy grant us strength,
mere human force is sure to fail;
but victory will be ours at length:
with you, our God, we shall prevail.

Psalm 61

To the choirmaster: with stringed instruments. A Psalm of David.

 1 Hear my cry, O God,
 listen to my prayer;
 from afar I call upon you,
 weak and in despair.
 Lead me to the rock
 that is higher than I;
 be a tower against my enemies:
 listen to my cry!

 2 Let me ever dwell
 with you, in your tent;
 there, beneath your wings, I shall be
 sheltered and content.
 For you've heard my vows,
 rescued me from shame,
 given me the heritage of
 those that fear your name.

 3 Grant the king long life;
 may he see your face,
 in your presence ever reigning,
 guarded by your grace.
 Then your holy name
 I will ever praise,
 and fulfil the vows I made you
 all my earthly days.

Psalm 62

To the choirmaster: according to Jeduthun. A Psalm of David.

 1 My soul in stillness waits for God alone,
 my rock, my one salvation, my defence:
 assailed I am, but never overthrown,
 though they would fell me like some tottering fence;
 they plan my end, deceivers and perverse,
 who mouths may bless, but in their hearts they curse. . . .

2 My soul, in stillness wait for God alone,
my shield against the evil they intend;
with such a hope I shan't be overthrown:
on him my life and honour both depend;
then trust in him in every circumstance:
pour out your heart to God, our sure defence.

3 Men high and low are merely wind and lies,
and as for wealth, ill-gotten or hard-earned,
don't set your heart on such a hollow prize;
once God has spoken, two things have I learned:
that power is yours, and steadfast love, O Lord,
and you will give to each their due reward.

Psalm 63

A Psalm of David, when he was in the Wilderness of Judah

1 O God, my God, I seek your face,
my soul at daybreak thirsts for you,
in this most weary wilderness
devoid of water, mist or dew;
so have I in your house of prayer
beheld your power and glory there.

2 Your steadfast love is more to me
than life – and so I sing your praise:
I'll bless you till I cease to be,
and in your name my hands I'll raise;
with richest fare you feast my soul,
O God, whom I with joy extol.

3 And on my bed awake at night
I muse on all your mercy brings,
for you're my help, and I delight
to sing beneath your sheltering wings;
my soul at sunrise clings to you,
and your right hand will bear me through.

4 Those hunting me will be subdued,
the nether world their souls' abode,
their bodies left as jackals' food;
the king, though, will exult in God,
whose faithful people will rejoice
as silence falls on falsehood's voice.

Psalm 64

To the choirmaster. A Psalm of David.

1 Receive, O God, my anguished prayer:
protect my life from those I dread,
from evildoers who now prepare
to bring their scheming to a head.

2 Their tongues they sharpen like a blade,
and aim with care their bitter lies;
well hidden, they are not afraid
to take the guiltless by surprise.

3 Resolved to have this evil done,
they talk of where to lay their snares,
presuming they are seen by none
and that success will soon be theirs.

4 "The perfect plan we have designed!" –
They dare to praise their loathsome art:
how devious is the human mind,
how dark and deep the human heart.

5 But God will take them by surprise:
their bodies will be stricken, torn,
destroyed by their recoiling lies,
and all will look on them with scorn.

6 Then shall all people, hushed and awed,
survey God's work and its result;
the just will glory in the Lord,
in him take refuge – and exult!

Psalm 65

To the choirmaster. A Psalm of David. A Song.

1 How right, O God, that all in Zion praise you,
 and that all vows to you should be fulfilled;
to you that hear our prayers all folk shall gather:
 when sins prevail, you take away our guilt.
How blessed the one you choose and draw towards you,
 to live near you and in your courts reside:
for with the goodness of your holy temple
 our hearts will be supremely satisfied.

2 By awesome deeds you answer us with justice,
 our Saviour God, the hope of all the earth,
who, armed with power, uphold the towering mountains
 which by your strength at first were brought to birth.
You still the seas, you calm the nations' turmoil,
 so those who live at earth's remotest ends
behold with awe the signs of your great glory:
 from east to west their song of joy ascends.

3 You tend the land, you water and enrich it;
 your flowing streams prepare it for the grain,
its furrows soaked, its ridges levelled smoothly,
 its increase blessed with gentle showers of rain.
Your goodness crowns the year with rich abundance:
 the drylands flower, the hills with gladness ring,
sheep fill the fields and golden grain the valleys:
 all nature joins to shout for joy and sing.

Psalm 66

To the choirmaster. A Song. A Psalm

1 Shout with joy to God, all nations,
 sing the glory of his name;
praise with loudest acclamations!
 His tremendous deeds proclaim!
All his enemies cowering, trembling
 bow beneath his mighty arm,
while all earth with joy assembling
 sounds his praise in song and psalm.

2 Come and see, with awe and wonder,
 see displayed the power of God:
 as he held the waves asunder,
 Israel crossed the sea dry-shod;
 praise him, then, with jubilation,
 who for ever rules by might,
 keeping watch lest any nation
 dare contest his sovereign right.

3 Bless our God who's stood beside us
 and not let our footsteps slide!
 In the fires of life you tried us
 till like silver purified:
 you sent fierce afflictions to us,
 conquerors trampled on our head,
 yet through flame and flood you drew us
 and to great abundance led.

4a Whole burnt offerings I shall render
 in your temple, as I vowed
 to my God, my sure defender,
 when by trouble I was bowed;
 fat burnt offerings I shall proffer,
 sacrifice of rams ablaze:
 bulls and goats to you I'll offer
 to declare my heartfelt praise.

OR

4b What thank-offering shall I render,
 my most solemn vows to pay,
 made to you, my sure defender,
 when I faced the evil day?
 Here I offer on your altar
 all I am and have and do;
 may my purpose never falter,
 all my life be spent for you. . . .

5 Come and listen, all who fear him,
 hear what God has done for me:
with my praises I drew near him
 and poured out my urgent plea;
had I cherished sin within me,
 God would not have heard my prayer:
praise him for the answer given me
 in his steadfast love and care.

Psalm 67

To the choirmaster: with stringed instruments. A Psalm. A Song.

1 God in mercy grant us blessing,
 lift on us his radiant face;
may all earth, his ways confessing,
 know the power of saving grace:
 let the peoples' voices raise,
 God, to you their hymns of praise.

2 Let them all with jubilation
 sing of your transcendent worth,
justly ruling every nation,
 sovereign Lord of all the earth:
 let the peoples' voices raise,
 God, to you their hymns of praise.

3 See the blessing God has granted
 on our labours in the field!
May his word in hearts implanted
 worldwide harvests duly yield:
 so shall all the nations raise
 to our God their hymns of praise.

Psalm 68

To the choirmaster: a Psalm of David. A Song.

1 Let God arise, his enemies all take flight,
let those who hate him flee before his ire,
like smoke disperse and vanish from our sight,
like wax that melts away before the fire;
but let the righteous sing with joyful voice:
in their victorious God let them rejoice!

2 Sing praise to God who rides the clouds on high:
he is the Lord, his name in triumph bless!
The orphans' father, widows he stands by,
this is our God who dwells in holiness:
the prisoners freed, the lonely given a home,
but rebels left the desert wastes to roam.

3 "O God, when Israel followed where you led,
when through the trackless wilderness you strode,
the earth shook and the clouds burst overhead
before the God of Sinai, Israel's God;
your rains refreshed your people's weary land,
the needy fed by your unstinting hand."

4 The Lord spoke and great numbers spread the news:
"The kings and their battalions flee in haste!
There's plunder left for all to pick and choose?
fine metalwork with gold and silver chased."
And so the Almighty swept them out of sight,
like snowfall turning dark Mount Zalmon white.

5 O great Mount Bashan, why with envy watch
the mountain where the Lord desires to dwell?
In thousands, chariots joined the Lord's long march
from Sinai to his holy citadel;
"Ascending, you led captives in your train,
receiving tribute, there henceforth to reign." ...

6 Bless him who bears our burdens day by day,
 our Saviour GOD who rescues us from death;
 inveterate foes who walk in evil's way
 he'll crush till they no longer draw their breath:
 brought back from heights or depths to which they'd fled,
 "Their blood will flow along your streets," he said.

7 See God's procession to his sacred seat:
 the singers first, then minstrels plucking chords,
 amid the tambourine-girls: "All repeat
 God's praise, O Israel, you that are the Lord's!"
 Young Benjamin next leads Judah's princes forth
 with princes from the peoples of the north.

8 "O God, reveal your might now, as before,
 your temple drawing kings with gifts to you;
 rebuke the hostile nations threatening war,
 till they submit and bring their tribute too!"
 Let Egypt's envoys come in suppliant mood,
 and Ethiopia's hands reach out to God.

9 O kingdoms of the earth let all arise:
 sing praises to the Lord, in him rejoice;
 sing praise to him who rides, the ancient skies,
 who thunders forth with his almighty voice.
 Proclaim his power, his grandeur glorify,
 who watches over Israel from on high.

10 How awesome is this God, our hearts know well,
 who reigns supreme from his most holy place,
 our great Creator God of Isra-el,
 the God of sovereign power, the God of grace,
 his people strengthening time and time again:
 God's name be blessed for evermore! Amen!

Psalm 69

To the choirmaster: according to Lilies. A Psalm of David.

1 Save me, O God! The water's rising round my neck:
 I'm sinking in the mire, beneath the flood;
I'm wearied, crying out for help, my throat is parched,
 my eyes tear-blinded, waiting for my God.
So many lying enemies look to end my days:
 must I restore now what I did not steal?
You know my folly and my guilt: may I not shame
 your people, O Lord GOD of Isra-el.

2 It is for your sake I have borne reproach and shame:
 my brothers look on me as though unknown;
for it is zeal for your house that's consuming me,
 and your revilers have become my own.
I wept and fasted and I was abused for that;
 when I wore sackcloth they derided me;
men sit and joke about me at the city gate,
 the butt of drunkards' songs and ribaldry.

3 But I beseech you now, O LORD, to answer me
 in all your steadfast love and faithfulness,
and save me from the mire, my enemies and this flood:
 don't let me be engulfed in the abyss.
LORD, answer me because your steadfast love is good,
 in mercy do not turn your face away;
come quickly, save your servant, for I'm in distress,
 and from my enemies ransom me, I pray.

4 You know my shame and my disgrace, my enemies too,
 my broken heart – in deep despair I sink;
I looked for pity or comforters, but none I found:
 they gave me gall and vinegar to drink.
So may the table set for them become a trap,
 a snare concealed upon their reckless path,
their eyes be darkened and their bodies drained of strength
 as they are overtaken by your wrath. . . .

5 Let their encampment be deserted evermore,
 with no one left to dwell there – derelict,
 for they are persecuting one whom you have struck,
 exchanging tales about those you afflict.
 Add guilt to their guilt, punishment to punishment;
 let no acquittal even be discussed,
 their names instead be banished from the Book of Life
 and never be inscribed among the just.

6 But I remain in dire affliction, racked with pain:
 O God, protect me, set me safe on high;
 and then in joyful song I'll praise God's holy name
 and with thanksgiving him I'll magnify.
 For that will better please the Lord than ox or bull
 with horns and hooves and every other part;
 on seeing this, the humble poor will all rejoice:
 and you now seeking God, do not lose heart.

7 For, look! The Lord hears those in need who cry to him:
 he will not scorn his people in their chains;
 let heaven and earth together praise him, and the sea
 and every living creature it contains.
 For God will rescue Zion, build up Judah's towns,
 and bring his people back to breathe its air;
 the offspring of his servants will inherit it,
 and those who love his name will settle there.

Psalm 70

To the choirmaster. A Psalm of David, to bring to remembrance.

1 O God make haste to save me,
 be quick, O Lord, I pray;
 let theirs be shame and failure
 who seek my life this day.
 Let those who want my downfall
 be shamed and put to flight:
 let them retreat dishonoured,
 who mock me in my plight.

2 May all who look to you, and
 for your salvation wait,
 rejoice in you, and ever
 declare, "Our God is great!"
 Yet I am poor and needy:
 be quick, O God, I pray;
 you are my help and saviour:
 O Lord do not delay.

Psalm 71

1 In you, O Lord, I shelter: never fail me,
 but in your righteousness deliver me;
 incline your ear to me, come down and save me:
 my Rock, my Fortress, keep me safe and free.
 You've issued the command for my deliverance,
 for you're my rock, my fortress, my defence;
 God, save me from the clutches of the wicked,
 from sheer injustice and malevolence.

2 For you're my hope, O Lord, and always have been,
 the Lord I've trusted from my early days,
 from birth – for from my mother's womb you took me:
 continually my voice shall sing your praise.
 To many I've become a kind of wonder,
 while you remain my refuge ever strong;
 your praises fill my mouth from dawn to sunset,
 declaring your great glory all day long.

3 Don't cast me off as old age overtakes me,
 do not forsake me as my strength gives way:
 my enemies are conspiring now together
 to engineer my end without delay.
 They say, "Now God's deserted him, we'll get him;
 there's no one there to come and set him free."
 O God do not remain far off, I beg you,
 but, O my God, come quickly, rescue me! . . .

4 May my accusers perish in dishonour,
 may they be covered in contempt and shame;
 but I'll maintain my hope in you forever:
 yet more and more your praise I will proclaim.
 All day your righteousness and your salvation
 I'll tell of – countless acts of grace I've known;
 I'll come and tell of your great deeds, O Lord GOD,
 your righteousness remembering, yours alone.

5 O God, since I was just a youth you've taught me
 I still declare the wondrous things you do;
 as I grow old and grey do not desert me
 till I teach this new generation too.
 Your righteousness, O God transcends the heavens:
 great things you've done – O God, who is like you?
 You've taken me through many bitter troubles,
 but from the depths you'll raise me up anew.

6 My honour you'll increase, and be my comfort;
 then with the harp your praises I will tell:
 for all your faithfulness I'll sing your praises,
 my God, the Holy One of Isra-el.
 My lips will shout for joy as I exalt you,
 this soul that you've redeemed, that you've reclaimed;
 yes, all day long your righteousness I'll speak of,
 for those who sought my downfall have been shamed.

Psalm 72

A Psalm of Solomon

 1 Give the King, O God, your judgment,
 crown him with your righteousness;
 rightly he will judge your people,
 and your poor with justice bless.
 See the hills bear peace and plenty,
 all the fruit of righteousness,
 as he shields the poor and needy
 and he crushes all who oppress.

 2 He'll endure throughout all ages,
 long as sun and moon remain;
 he will shower the land with blessing
 like the early springtime rain.
 In his days the just will flourish
 as perpetual peace abounds:
 may his kingdom span the oceans,
 reaching earth's remotest bounds!

 3 May the desert tribes pay homage
 and his enemies lick the dust,
 distant cities, isles and coastlands
 render tribute right and just,
 Eastern kings declare allegiance
 by the royal gifts they bring:
 may all kings fall down before him,
 every nation serve the King.

 4 For he saves the poor and needy,
 hears their cry and feels their fear;
 from the oppressor he redeems them:
 in his sight their blood is dear.
 May he live long! Gold be given him,
 bring the finest, bring the best;
 constant prayer for him be offered,
 all day long may he be blessed. . . .

5 May the land bring forth abundance,
 even on the mountain tops;
may the cities grow and flourish
 like the grass, the fields, the crops.
May his name endure for ever,
 and continue like the sun:
blessed by him be every nation,
 blessed be he by everyone.

Doxology

Let us bless the God of Israel
 bless the living God, the Lord,
who alone does acts of wonder,
 who alone may be adored.
Bless his glorious name for ever!
 Hail his just and gracious reign!
May his glory fill the *whole* earth
Evermore! Amen! Amen!

The prayers of David, the son of Jesse, are ended.

BOOK THREE: PSALMS 73–89

Psalm 73

A Psalm of Asaph

1 Truly God is good to Israel,
 good to those whose heart is pure;
as for me, my feet were faltering,
 not one step remained secure,
for I envied shameless sinners
 flaunting all their easy wealth,
so remote from human suffering,
 clear of pain, awash with health.

2 Therefore pride's their chain of office,
 violence their habitual dress;
from their heart springs endless evil,
 every kind of wild excess.
Scorn and malice are their language,
 death-threats are their stock-in-trade;
heaven itself their mouths contend with,
 through the earth their tongues parade.

3 So his people heed them, saying
 "How can God the Most High know?
Look at how the wicked prosper,
 how their wealth and influence grow!"
What's the good of godly living?
 Heart and hands I've cleansed in vain;
all day long am I afflicted,
 dawn brings further chastening pain. . . .

4 How such words betray your children?
 Yet how hard to comprehend,
 till I sought God's holy presence;
 then I clearly saw their end:
 set by you in slippery places,
 swift and fearful their demise,
 like a dream when one awakens,
 shadows, Lord, that you'll despise.

5 When my soul had grown embittered
 as my inner rage increased,
 I was foolish, knowing nothing,
 dumb before you like a beast.
 Yet I am at all times with you,
 my right hand by yours held fast;
 by your counsel I am guided,
 led to glory at the last.

6 Whom have I in heaven but you, Lord,
 or on earth, to hunger for?
 Flesh may fail, but God's my stronghold
 and my portion evermore.
 Perish traitors and deserters –
 better far to be the one
 near to you, Lord GOD my refuge,
 telling all that you have done.

Psalm 74

A Maskil of Asaph

1 O God, why have you cast us off for ever,
 in anger at the sheep within your fold?
 Remember us, the people that you ransomed,
 and Zion's mountain where you dwelt of old.
 Walk through and see the utter devastation
 your foes have brought upon your holy place:
 where once you met with us they raise their banners,
 and of its beauty they have left no trace.

2 They went at it like woodsmen wielding axes
 to clear a tangled mass of boughs and shrubs;
 they hacked away at all its crafted panelling,
 they smashed it with their hatchets and their clubs,
 and having set ablaze your holy temple
 they've levelled it completely to the ground,
 defiling your name's dwelling-place, resolving:
 "We'll crush them till no sign of them is found!"

3 Our holy places are reduced to ashes;
 no token of your favour can we see;
 no prophet brings us any word from heaven,
 and no one knows how long these things shall be.
 How long, O God, will you endure their taunting?
 Shall they blaspheme your name for evermore?
 Why now withhold your hand, why keep it hidden?
 Will you not save your people as before?

4 Yet you are God, my King from distant ages,
 victorious over every earthly power:
 you tamed the sea, you slew its angry serpent
 for creatures of the desert to devour.
 You opened streams, you halted flowing rivers;
 you made the sun and moon and stars appear,
 and you it was who set our planet's boundaries,
 and you designed the seasons of the year.

5 O LORD remember how the enemy's mocked you,
 how foolish people have reviled your name;
 respect your covenant: save us from their violence;
 do not abandon us to loss and shame.
 But may we in our poverty yet praise you,
 despite their jeers that echo day and night;
 amid the din and clamour of the wicked
 rise up, O God, maintain your sovereign right.

Psalm 75

To the choirmaster: according to Do Not Destroy.
A Psalm of Asaph. A Song.

1 O God, we give you thanks and praise,
 because your name is ever near,
 that name of wonder that we hear
revealed in all your works and ways.

2 "When comes the time that I ordain,
 my righteous judgment shall prevail;
 when earth and all its people quail,
its trembling pillars I sustain.

3 "'No longer boast,' I tell the proud;
 I tell the wicked: 'do not rise
 in wild revolt against the skies,
nor voice your high disdain aloud.'"

4 For neither from the east nor west
 come earthly honours or renown;
 but God the Judge puts one man down
and raises one above the rest.

5 For in the Lord's hand there's a cup
 that brims with foaming, well-mixed wine;
 and all the wicked and malign
shall drink that deadly potion up.

6 His name in songs of joy be praised,
 for Jacob's God is ever true:
 the wicked shall receive their due,
to honour shall the just be raised.

Psalm 76

To the choirmaster with stringed instruments.
A Psalm of Asaph. A Song.

1. In Judah God is well renowned,
 in all Israel his name is great,
 his chosen lair is Salem's ground,
 in Zion's den he'll watch and wait:
 he there destroyed the arms of war,
 the glint of steel is seen no more.

2. How glorious are you to behold
 returning from the hills of prey!
 The plundered warriors, once so bold,
 in death's disabling slumber lay:
 O God of Jacob, at your word
 no horse or charioteer has stirred.

3. What awe, what fear do you compel,
 for who can stand when you appear?
 From heaven your solemn verdict fell,
 the earth was dumb, transfixed with fear
 when you, O God, in judgment rose
 to save the oppressed from all their foes.

4. For human wrath will be transformed
 to praise your name and work for you.
 Then may his people serve the Lord
 and those around bring tribute too:
 in this world's rulers all alike
 what awe and fear his judgments strike.

Psalm 77

To the choirmaster: according to Jeduthun.
A Psalm of Asaph.

1 I cried out to God to help me
 in my turmoil and my grief;
all night long I pleaded with him,
 yet my soul found no relief.
I remembered God with sorrow
 and my groaning heart grew faint;
wearied, sleepless, I could scarcely
 raise my voice in lone lament.

2 Earlier days and years I turned to,
 when my songs rang through the night;
now the bitter thought possessed me:
 "Has God cast us off outright?
Is his steadfast love now ended?
 Is his promise null and void?
Have God's mercy and compassion
 in his anger been destroyed?"

3 Then I called to mind the marvels
 once performed by God Most High,
pondering on the Lord's great actions
 mortal power could not defy.
Holy is our God – no other
 works the wonders done by ours,
freeing Jacob's sons and Joseph's
 by his all-transcending powers.

4 When, O God, the waters saw you,
 terror-struck they turned and fled;
lightning, tempest, whirlwind, thunder
 filled the trembling world with dread.
Leaving in the sand no footprint,
 you took Israel through the deep,
and by Moses' hand and Aaron's
 led them like a flock of sheep.

Psalm 78

A Maskil of Asaph

1 My people, hear my teaching, hear each word:
 I'll bring you living lessons from of old,
 enigmas from the past that we have heard,
 that we have known, the things our fathers told.
 We will not rob our children of these facts,
 but tell that generation, every one,
 the glories of the Lord, his mighty acts,
 his power and all the wonders he has done.

2 He gave his holy law to Isra-el,
 with orders that our fathers should relay
 the same to their descendants, who should tell
 the coming generations in their day,
 that they might trust in God and not forget
 God's acts, nor from his clear commands depart –
 unlike their fathers, that rebellious set
 of faithless spirit and inconstant heart.

3 The men of Ephraim, all equipped with bows,
 turned back when once the battle-front they saw;
 they did not keep God's covenant, but they chose
 to live in disobedience to his law.
 They soon forgot what he had done, despite
 the truly wondrous acts to Israel shown,
 that he'd accomplished in their fathers' sight
 in Egypt's land, upon the plain of Zoan.

4 He split the sea to speed them on their way,
 he made the water stand up like a wall;
 he led them with a cloud above by day,
 at night his fiery pillar led them all.
 He split the desert rocks and slaked their thirst
 with water gushing as from deep below;
 from solid rock he caused his streams to burst
 and downward like a mighty river flow. . . .

5 And yet those rebels sinned against him still,
 against the Most High in that desert land:
 they tested God with their defiant will,
 demanding food they craved for from his hand;
 they spoke against him: "Can God spread a feast
 here in the desert, food that's good to eat?
 He struck the rock, great torrents were released:
 but can he give us bread or send us meat?"

6 On hearing this the Lord was full of wrath
 against the sons of Jacob, Israel's seed,
 because they showed their utter lack of faith
 in God to care for them in time of need.
 And yet he opened heaven's doors to rain
 his gift of manna down for them to eat;
 men ate the bread of angels, heaven's grain,
 enough and more until they were replete.

7 He drew the east and west winds by his power
 and rained down meat like dust upon the ground,
 birds plentiful as sand upon the shore:
 among their tents he dropped them all around.
 They gorged themselves, they sated their desire,
 but while the food still lingered in the mouth,
 God rose against them in his sacred ire
 and put to death the flower of Israel's youth.

8 In spite of all this, still his people sinned:
 despite his wonders they did not believe;
 their days he ended like a puff of wind,
 their years in mortal fear beyond reprieve.
 When God slew some of them, the rest would flock
 to him with anxious heart and tearful eye,
 remembering God indeed to be their rock
 and also their redeemer, God Most High.

9 But they approached him with the flatterer's art,
 they lied to him with every word they spoke;
 nor were they faithful to him in their heart:
 his holy covenant constantly they broke.
 Yet in compassion he'd forgive their sin:
 he'd spare their lives, his anger he'd restrain;
 he knew that flesh was all they'd ever been,
 a breath of wind that won't return again.

10 How often as they roamed that stark terrain
 they grieved him, always ready to rebel;
 they tried him sorely time and time again
 and vexed the Holy One of Isra-el.
 They did not keep in mind his powerful hand,
 that day they watched the oppressor overthrown,
 how he displayed his signs in Egypt's land,
 redemption's wonders on the plain of Zoan.

11 He turned their streams to blood, so all supplies
 of water were repellent to the taste;
 he sent them swarms of noxious biting flies
 and hordes of frogs that laid the country waste.
 His insects left their standing crops to fail,
 his locusts caused their produce to be lost,
 he tore their vines to shreds with pounding hail
 and withered all their sycamores with frost.

12 He gave their cattle over to the hail,
 their sheep and goats his lightning bolts destroyed.
 On them he let his burning wrath prevail
 through deadly angel forces he deployed;
 his fury did not spare a single one,
 but to the dreadful plague delivered them:
 he struck down every family's eldest son,
 the pride of Egypt in the tents of Ham.

13 His people like a flock of sheep he led
 across the trackless desert's stony ground;
 so guided safely they were not afraid,
 but in the sea their enemies all lay drowned.
 And then he brought them to that holy spot,
 the mountain his right hand had made his own;
 he dispossessed the nations, to allot
 their land for Israel's tribes to settle down.

14 Yet, rebels still, they tested God Most High:
 his godly laws they did not wish to know,
 but like their fathers were self-willed and sly,
 perverse and treacherous as a crooked bow.
 They made him angry with each hilltop shrine
 and jealous with the idols they had cast,
 which so provoked him and his wrath divine
 that he spurned Israel utterly at last. . . .

15 His dwelling-place at Shiloh he forsook,
 the tent in which he'd lived among mankind;
 his power, as he ordained, the enemy took:
 his glory into hostile hands consigned!
 He sent the sword to strike his people dead:
 across his heritage his fury swept,
 young men devoured by fire, girls left unwed,
 and priests cut down, for whom no widows wept.

16 And then as though from sleep the Lord awoke,
 and like a warrior roused from wine he came:
 he dealt his enemies' rearguard such a stroke
 that they were put to everlasting shame.
 And he repudiated Joseph's line,
 nor did he choose the tribe of Ephra-im;
 but Judah's tribe was now the choice divine,
 Mount Zion's height, so dearly loved by him.

17 He built his temple, lofty as the skies,
 established like the earth for evermore;
 he called his servant David to arise
 and leave the sheep that he'd been caring for,
 the ewes and lambs, with his young shepherd's art,
 to tend his Jacob – Israel, his own still!
 So David tended them with upright heart
 and guided them with all his shepherd's skill.

Psalm 79

A Psalm of Asaph

1 O God, your heritage has been invaded –
 the land you gave your people to possess;
 the nations have defiled your holy temple,
 Jerusalem they have made a wilderness.
 The bodies of your servants they've abandoned
 as carrion for the gathering beasts of prey;
 throughout the city blood they've spilt like water
 and left the dead unburied where they lay.

2 We've now become the scorn of all our neighbours,
 despised and mocked whichever way we turn;
 how long, O L<small>ORD</small>, how long will you be angry?
 For ever must your jealous anger burn?
 Pour out your wrath upon the pagan nations
 that neither know nor call upon your name;
 for they have swallowed up all Jacob's people
 and laid his homeland waste with steel and flame.

3 Don't hold our past iniquities against us:
 let your compassion quickly intervene;
 how low we're brought! Help us, O God our Saviour,
 and let the glory of your name be seen.
 Deliver us, absolve us for your name's sake:
 why should the nations say, "Where is their God?"
 Before our eyes, make known among the nations
 that you avenge your servants' outpoured blood.

4 O listen to the groaning of the prisoners:
 in your great power save those condemned to death;
 repay our neighbours sevenfold for the insults
 they've hurled at you, O Lord, with every breath.
 Then we your people, we the flock you shepherd,
 will give you heartfelt thanks for evermore,
 and generation tell to generation
 the praises of the God whom we adore.

Psalm 80

To the choirmaster: according to Lilies.
A Testimony of Asaph. A Psalm.

1 O hear us, Israel's Shepherd, as we pray
 for Joseph's sons, that like a flock you lead.
 Enthroned above the cherubim, display
 the radiance of your glory to his seed,
 Ephraim, Manasseh – and to Benjamin too.
 Stir up your strength and rescue us anew.
 O God, we plead, restore us: shine your face
 upon us, and redeem us by your grace. . . .

2 O Lord, the God of hosts, how long shall we
 endure your wrath against your people's prayers?
 You've fed them with the bread of misery
 and made them drink their fill of bitter tears.
 You've made our neighbours look on us with mirth,
 our enemies laugh at us for all they're worth:
 O God of hosts, restore us: shine your face
 upon us, and redeem us by your grace.

3 You brought a vine from Egypt long ago,
 drove out the nations, planting it where planned,
 then cleared the ground, enabling it to grow:
 it took deep root and filled the fertile land.
 It veiled the distant mountains with its shade
 and topped the cedars when its growth increased,
 while to the Western Sea its tendrils spread
 and reached the mighty River in the east.

4 But why have you now broken down its walls,
 so every passer-by can pluck its fruit?
 It's ravaged by marauding forest boars,
 and creatures of the field devour its root.
 Return, O God of hosts: look down and see,
 inspect this vine and view the damage done,
 the stock your right hand planted, yours to be,
 which you have raised as though it were your son.

5 They've burnt it down and levelled all the land:
 so may they perish at your deadly frown;
 your hand be on the man of your right hand,
 the son of man you've raised to be your own.
 Then we'll not turn from you to sin and shame;
 revive us and we'll call upon your name.
 Lord God of hosts, restore us: shine your face
 upon us, and redeem us by your grace.

Psalm 81

To the choirmaster: according to the Gittith. A Psalm of Asaph.

1. To God our strength sing gladly: come,
 to Jacob's God your praises bring;
 begin the song and strike the drum,
 praise him with each melodious string:
 at new moon let the trumpet sound,
 at full moon let it echo round.

2. This feast for Israel was decreed,
 an ordinance Jacob's God designed
 for Joseph and the chosen seed,
 once Egypt had been left behind.
 Rejoicing at the feast, I heard
 an unknown voice that spoke this word:

3. "I gave your burdened backs relief
 and freed you from your slavery's yoke;
 you called on me in fear and grief,
 and from the thundercloud I spoke;
 I tried you at 'the Streams of Strife':
 would you be loyal to me for life?

4. "My people, hear my warning now,
 from this, O Israel, never swerve:
 no alien god shall you allow
 among you to adore and serve;
 I am the Lord, your saviour still:
 open your mouth for me to fill.

5. "My people would not heed my voice,
 Israel rejected all I'd said,
 and so I left them to the choice
 their stubborn hearts had made instead.
 If only Israel would obey,
 my people take the path I say!

6. "Their enemies I'd soon overpower,
 so ending endless years of war;
 all those who hate the Lord would cower,
 their fate be sealed for evermore;
 with finest wheat I'd feed my flock,
 regaled with honey from the rock."

Psalm 82

A Psalm of Asaph

1 The gods of earth are in the hands
of God who reigns supreme on high;
in their assembly now he stands
and judges with impartial eye.

2 "How long will you betray the cause
of truth and justice in the land?
You let the wicked flout the laws,
and so they prosper by your hand.

3 "Support the weak and fatherless,
defend the rights of those in need;
deliver them from those who place
no limit on their rampant greed."

4 No knowledge and no sense they show,
no measured judgment can they make;
in utter darkness on they go,
and all the earth's foundations shake.

5 "Though I declared your godlike worth,
you'll die as kings and all men do."
Rise up, O God, and judge the earth,
whose nations all belong to you.

Psalm 83

A Song. A Psalm of Asaph.

1 O God, do not remain so quiet,
so silent and, O God, so still:
you see your enemies rage and riot,
they rear their heads, they flout your will;
against us devious plans they lay,
against your people, those you love:
"Let's wipe this Israel out," they say,
"all memory of her name remove!"

2　Agreed, they train on you their sights,
　　in league against you all combine:
　　the tents of Edom, Ishmaelites,
　　the men of Moab, Hagar's line,
　　and Gebal, Ammon, Am'lek too,
　　Philistia with the men of Tyre;
　　Assyria joins the retinue:
　　with Lot's descendants all conspire.

3　Deal with them as with Midian's men –
　　Sis'ra and Jabin, all but drowned
　　in Kishon's stream, at Ender slain
　　and left to rot upon the ground,
　　their captains like Oreb and Zeeb,
　　Prince Zebah and Zalmunn' as well,
　　who said, "Let's seize that favoured glebe,
　　'God's Pasturelands', from Isra-el!"

4　My God, make them like whirling dust,
　　like stubble wind-blown far and wide;
　　as fire consumes the forest fast,
　　as flames ignite the mountainside,
　　so with your tempest give them chase,
　　its terror be their fit reward,
　　emblazon shame on every face,
　　that they may seek your name, O Lord.

5　Let them be shamed for evermore,
　　from terror never be exempt,
　　that those who sought our end in war
　　may perish in complete contempt.
　　So let them know that you alone,
　　by name the Lord, of peerless worth,
　　are God Most High upon the throne,
　　the sovereign over all the earth.

Psalm 84

To the choirmaster: according to The Gittith.
A Psalm of the Sons of Korah.

1 O Lord of hosts, how lovely is your dwelling-place!
 I cry aloud, I long for your abode;
the joys of earth have left my soul unsatisfied:
 my heart and flesh desire the living God.
The sparrow's home is there, and there the swallow nests,
 that near your altars she may have her young:
O Lord of hosts, how blessed are those within your house,
 by whom your holy praises are for ever sung!

2 How blessed are those who have in you the strength they need,
 and in whose heart the pilgrim ways are found;
the desert wastes they make a land of water-springs,
 till early rains refresh the barren ground.
From strength to strength they journey on their pilgrimage,
 till each at last appears to God in Zion;
Lord God of hosts, O God of Jacob, hear my prayer:
 behold our shield, and bless your own anointed one.

3 How better, far, a single day within your courts
 than thousands spent in any other way;
I'd rather wait upon the steps beside your door
 than pitch my tent where wickedness holds sway.
For God the Lord is both a sun and shield to us:
 he gives us grace and crowns with glory too,
and nothing good withholds from those of upright life:
 O Lord of hosts, how blessed the one who trusts in you!

Psalm 85

To the choirmaster. A Psalm of the Sons of Korah.

1 You once showed favour to our land, O Lord;
 the fortunes of your people you restored:
 you pardoned them and covered all their sin;
 you turned from wrath and reined your fury in.

2 O Saviour God, restore us once again;
 your deep displeasure with us now restrain.
 Will you be always angry? Must you pour
 your anger on our children evermore?

3 Will you not turn and give us life anew,
 that we, your people, may rejoice in you?
 Show us again, O Lord, your steadfast love
 and grant us your salvation from above.

4 I'll listen to what God the Lord will say:
 peace to his saints, who keep from folly's way,
 who fear him – his salvation is at hand,
 that glory may again dwell in our land.

5 So steadfast love will meet with faithfulness,
 and righteousness and peace each other kiss;
 from earth shall faithfulness spring up on high,
 and righteousness look downward from the sky.

6 Indeed, the Lord will give us what is good:
 our land will yield the harvest that it should;
 and righteousness will hasten on ahead
 to make a pathway for his feet to tread.

Psalm 86

A Prayer of David

1 Lord, hear me, poor and humbled to the dust:
 protect your loyal servant's life, I pray;
 O save me, you're my God, in you I trust:
 have mercy, for I cry to you all day;
 and make your servant's soul again rejoice
 as, Lord, to you I lift my soul and voice.

2 For, Lord, you're good and ready to forgive,
 to all who ask you're rich in steadfast love;
 give ear to me, O Lord, I pray, receive
 my plea for mercy from your throne above.
 In trouble's darkening day to you I cry,
 for you will hear and answer from on high. . . .

3 Among the gods, O Lord, there's none like you:
 creative powers like yours not one can claim;
 the nations you have made, of every hue,
 shall come to praise and glorify your name,
 O Lord, for you are great and from your throne
 perform great wonders: you are God alone.

4 Teach me your way, O Lord, to make me true:
 give me a focused heart to fear your name;
 O Lord my God, my heart gives thanks to you:
 to glorify you is my constant aim.
 Your steadfast love towards me is so great,
 delivering me from Hades' sombre fate.

5 I'm facing proud assailants bent on strife,
 their hearts and minds intent on shedding blood,
 a band of ruthless men who seek my life
 and who have no regard for you, O God.
 But, Lord, you're slow to anger, full of grace,
 and rich in steadfast love and faithfulness,

6 So turn to me, be gracious in my need,
 bestow upon your servant strength divine,
 and save the faithful son of your handmaid.
 Assure me of your favour by a sign,
 that those who hate me may be shamed to see
 that you, O Lord, have helped and strengthened me.

Psalm 87

A Psalm of the Sons of Korah. A Song.

1 See the city he has founded
 on the sacred heights above:
 more than all the towns of Jacob,
 Zion is the Lord's great love.

2 Glorious things are spoken of you,
 God's own city here on earth,
 ever blessed by all who name you
 as their treasured place of birth.

3 "Rahab, Babylon both belong with
 those who know me, I'll declare;
 Tyre, Philistia, Ethiopia –
 saying, 'This one was born there.'"

4 And it shall be said of Zion,
 "Each of these was born in her",
 by the Most High built, established,
 safe, whatever storms occur.

5 Registering them all, the Lord writes,
 "Yes, this one was born there too."
 Singers, dancers, voice and heart cry:
 "All my wellsprings are in you!

Psalm 88

A Song. A Psalm of the Sons of Korah.
To the choirmaster: according to Mahalath Leannoth
A Maskil of Heman the Ezrahite

1 O Lord, my Saviour God, receive my prayer,
 as day and night I cry to you to save;
 my soul is troubled more than I can bear,
 my life draws ever closer to the grave.
 For I am like a man whose strength has fled:
 I'm seen as on the brink of the abyss,
 like one who's cast adrift among the dead,
 that you no longer help, nor even miss.

2 You've laid me in the depths of the abyss,
 in darkness deeper than the deepest caves;
 your wrath lies heavy on me, merciless:
 you overwhelm me with your pounding waves.
 You've made my close companions shrink away –
 shut in alone, by them I am abhorred;
 through blinding tears I call to you each day,
 as I stretch out my hands to you, O Lord. . . .

3 Do you do works of wonder for the dead?
 Do those departed rise to praise your name?
 Is knowledge of your steadfast love widespread
 where sheer oblivion wraps our lifeless frame?
 But I, O Lord, cry out to you each day:
 as dawn returns, in prayer I bow my knee;
 O Lord, why do you cast my soul away?
 O why do you conceal your face from me?

4 I've suffered since my youth, been close to death,
 afflicted by the terrors you've brought on;
 I've been engulfed by your incessant wrath:
 beneath your blows my life is almost gone.
 They swirl around me like a flood each day,
 encircling me entirely in the end;
 those near and dear to me you've driven away:
 the darkness has become my only friend.

Psalm 89

A Maskil of Ethan the Ezrahite

1-Praise (vv.1-18)

1 I'll sing the Lord's unfailing love for ever,
 his faithfulness on young and old impress;
 I know your steadfast love is built for ever,
 firm in the heavens you've fixed your faithfulness.
 You made a covenant, saying: "I have chosen
 my servant David, and to him I swore
 'For ever I'll establish your descendants
 and build your throne to stand for evermore.'"

2 The heavens, O Lord, extol your works of wonder,
 your faithfulness your holy ones declare;
 for who is like the Lord among the angels,
 who else in heaven can with the Lord compare?
 A God most feared by angels and archangels,
 and held in awe by those around his throne:
 Lord God of hosts, who has such power as you have,
 such faithfulness as all your deeds make known?

3 For you're the one who rules the surging oceans,
 rebukes the wind and waves till all is calm;
 your waters smothered Pharaoh and his warriors,
 your enemies fled before your powerful arm.
 The heavens and earth are yours, which you have founded,
 the north and south, the seas and all the land;
 your name is praised by Tabor and Mount Hermon,
 created by the strength of your right hand.

4 Your throne is built on righteousness and justice,
 your guards are steadfast love and faithfulness;
 how happy those who join the cry of worship
 and walk, O Lord, before your radiant face.
 All day they glory in your strength and justice,
 exalted by the favour you have shown;
 for to the Lord belongs our shield and ruler,
 our king himself to Israel's Holy One.

2-Covenant (vv.19–37)

5 Of old you spoke in visions to your prophets:
 "I've called a young man from his common toil;
 I've found and raised on high my servant David,
 and have anointed him with holy oil.
 I'll strengthen him and strike down all his enemies,
 my loyalty shall be with him constantly;
 and in my name he'll scale the heights as sovereign
 from distant Tigris to the Western Sea.

6 "He'll cry to me: 'my Father, God and Saviour!'
 and I'll make him my heir, my king supreme;
 my steadfast love I'll keep for him for ever:
 for ever stands my covenant firm for him.
 His royal line for ever I'll establish,
 his throne shall be as permanent as heaven;
 his children I shall punish if they spurn me,
 the law, the statutes and commands I've given. . . .

7 "But I'll not take from him my love unfailing,
 nor break the solemn promise I have made,
my holy covenant never will I violate,
 nor change a single word that I have said.
For I have sworn and will not lie to David:
 his line shall last as long as suns shall rise,
his throne established like the moon for ever,
 the faithful witness shining in the skies."

3-Bewilderment (vv.38–51)

8 But you in wrath have cast off your anointed,
 renounced your covenant and defiled his crown,
breached all his walls and laid his forts in ruins:
 despoiled by all, men scorn his lost renown.
You've made his enemies strong – they're all triumphant;
 you've turned the battle, left him weak and lame,
cast down his throne and thereby all his splendour,
 cut short his youth and covered him with shame.

9 How long, Lord? Will you hide yourself for ever?
 How long will your fierce anger burn like fire?
How short is life, how pointless our existence!
 Who can deny the grave its grim desire?
Lord, where's your steadfast love once sworn to David?
 You hear the stinging taunts the nations fling,
with which your enemies mock, O Lord, your servant,
 and mock the steps of your anointed king.

Doxology

All praise and blessing to the Lord for ever,
Amen! Amen! Let all his people sing.

BOOK FOUR: PSALMS 90–106

Psalm 90

A Prayer of Moses, the man of God

1 O Lord our God, in every age
 our home upon the earth!
 Before you built the mountain range
 or brought this world to birth,
 from countless eras seen by none
 to futures vast, unknown,
 you are the Everlasting One
 on your eternal throne.

2 "Turn back, O Man!" At your decree
 we all return to dust,
 and like a single day you see
 a thousand years go past;
 you sweep us, everyone, away:
 we vanish from the light,
 as grass springs up to flower by day,
 yet droops and dies by night.

3 Your wrath consumes us: all our sins
 are open to your eye,
 the years slip by, our end begins,
 we finish like a sigh.
 Though some may with their strength exceed
 our threescore years and ten,
 what is this fleeting life we lead
 but trouble, toil and pain? . . .

4 Yet who of us will pause to view
 your wrath with solemn thought,
and meditate in measure due
 your anger as we ought?
Instruct us in that vital art
 of counting up our days,
that wisdom may direct our heart
 to walk in all your ways.

5 Turn back, O Lord! How long? Relent,
 restore us with your love!
As years of humbling you have sent,
 now raise our hearts above.
So may your servants see your grace,
 our children know its power,
your favour all our works embrace
 both now and evermore.

Psalm 91

1 Shelter safely in the shadow
 of the Almighty, God Most High;
call the Lord your rock and fortress
 God on whom your hopes rely.
Kept by him from mortal danger,
 saved from hazards well concealed,
you will find his wings a refuge
 and his faithfulness a shield.

2 Fear, then, neither days of violence,
 nor the terror of the night,
nor the plague that stalks in darkness,
 nor the scourge at noonday light;
though a thousand fall beside you,
 it will not endanger you:
you will only watch and witness
 as the wicked get their due.

3 If you make the Lord your refuge,
 God Most High your lifelong home,
no disaster will befall you,
 near your tent no trouble come.
Neither will his angels let you
 strike your foot against a stone;
you will tread on lion and serpent,
 trample every evil down.

4 "Since you set your heart upon me,
 I will keep you safe from them,
covering you with my protection,
 for you know and trust my name.
Call on me and I will answer,
 I'll be with you in distress,
grant you freedom, life and glory,
 saved for ever by my grace."

Psalm 92

A Psalm. A Song for the Sabbath.

1 How good, O Lord, to praise your name
 to raise my thanks to heaven's height,
by day your steadfast love to acclaim
 and all your faithfulness at night,
with harp and lyre's harmonic art
 to join as one the voice and heart.

2 O Lord, I glory in your acts
 and in the wonders of your hands,
creation's wealth of startling facts:
 how deep are your designs and plans!
And yet the senseless, shallow mind
 to such amazing truths is blind.

3 Although the wicked sprout like grass,
 eternal doom is their reward;
 but you, enthroned on high, surpass
 all powers for evermore, O Lord:
your enemies will be swept aside,
 the wicked scattered far and wide. . . .

4 To me you've given an ox's strength
 and poured fresh oil upon my head,
I've seen my enemies yield at length
 and heard their fury as they fled:
like desert palms the righteous grow
 and tower like cedars in the snow.

5 In God's own courts they've taken root,
 they flourish in the Lord's domain;
in old age still they're bearing fruit,
 their sap, their vigour they retain,
his goodness their eternal song:
 "My Rock, in whom there is no wrong."

Psalm 93

1 The Lord is King! His majesty
and strength adorn him like a robe;
the world was built by his decree
and still his power secures our globe.

2 Your throne established long ago,
before creation came to be,
for ever rules this earth below:
you are from all eternity.

3 The seas have raised their fearsome voice
with pounding waves and surging tide;
the Lord on high can hush their noise,
his power can make their rage subside.

4 Your holy name, O Lord, we bless:
your sacred laws are firm and sure,
and they declare that holiness
befits your house for evermore.

Psalm 94

1 O Lord, the God of vengeance, hear these cries:
 O God, the God of vengeance, now shine forth!
 O righteous Judge of all the earth, arise,
 repay the proud according to their worth!
 How long shall wicked men, O Lord, how long
 shall they rejoice and triumph in the wrong?

2 They mouth contemptuous words without a blush,
 these evildoers who brag and boast all day;
 your own, O Lord, your heritage they crush,
 and widows, strangers, orphans too they slay:
 "The Lord," they say, "will never see the deed,
 the God of Jacob simply pays no heed."

3 Take heed yourselves! It's time you fools were wise!
 You think he's deaf, the one who made the ear?
 You think he's blind, the one who formed your eyes,
 who disciplines both men and nations here?
 The Lord our teacher knows our every thought,
 and knows that human thinking comes to nought.

4 "How blessed, O Lord, the one you discipline,
 with whom your law's instruction you have shared,
 to grant in troubled times your peace within,
 until the ungodly's fate has been prepared."
 His heritage the Lord will not desert,
 but bring true justice to the upright heart.

5 "Who'll stand for me against these wicked men?
 Without the Lord I'd soon have breathed my last;
 For when I said, 'My foot is slipping', then
 in steadfast love, O Lord, you held me fast.
 When cares flood in and start to take their toll,
 your consolations lift and cheer my soul."

6 Can wicked rulers be allied with God,
 who frame their laws to back their lawless ways?
 They join against the just to shed their blood,
 but God's my rock of refuge in these days;
 and he'll repay them via their wickedness:
 yes, these the Lord will utterly suppress.

Psalm 95

1 O come, let us sing
 to our great God and King,
 and rejoice in our Rock of salvation, the Lord;
 let us all seek his face,
 giving thanks for his grace,
 and in song now acclaim him with joyful accord.

2 The Lord is supreme,
 all the gods bow to him;
 in his hand are the caverns and depths of the earth,
 all the mountains are his,
 he created the seas
 and his hands shaped the dry land that he'd brought to birth.

3 Come in and bow down,
 let us kneel at the throne
 of the Lord our Creator, and worship him there;
 for our God, this is he,
 and his people are we,
 yes, the sheep that he pastures and keeps in his care.

4 Today if you hear
 his command strong and clear,
 "Do not harden your hearts in this critical hour,
 as when Israel rebelled
 after all they'd beheld –
 testing me, though they'd witnessed my work and my power.

5 "For forty years tried
 to the limit, I cried:
 'They have hearts ever wandering, unfaithful, unblessed,
 and my ways they know not.'
 So I swore in my wrath:
 'None of this generation shall enter my rest.'"

Psalm 96

1 O sing a new song,
 O sing to the Lord;
 O sing, all the earth,
 his name be adored!
 Tell forth his salvation
 as day follows day;
 among all the peoples
 his wonders display.

2 For great is the Lord,
 most worthily praised,
 more awesome than gods
 the nations have raised.
 The Lord made the heavens,
 so great is his might,
 and dwells amid majesty,
 beauty and light.

3 Ascribe to the Lord,
 all peoples on earth,
 due glory and strength,
 due honour and worth;
 let all the earth seek him,
 with offerings draw near,
 in holiness worship
 and bow down with fear.

4 Proclaim to all lands:
 "The Lord reigns today!
 This earth shall be freed
 from change and decay:
 his justice is coming!"
 O heavens, rejoice,
 and oceans, re-echo
 with thunder-like voice! . . .

5 Then forest and field
 for gladness will sing
 to welcome the Lord,
 their Maker and King,
 for by his true judgment
 at last shall be weighed
 all lands and all peoples,
 the world that he made.

Psalm 97

1 The Lord is King! With joyful sound
 let all the earth in him delight,
 whom cloud and deepest dark surround,
 whose throne is justice, truth and right.

2 Before him fires of judgment go,
 his lightnings blaze his advent forth,
 the mountains melt like wax and flow
 before the Lord of all the earth.

3 His righteousness the heavens proclaim,
 his glory all the peoples see;
 the pagan world is put to shame:
 to him all gods must bow the knee.

4 His people hear; with joy they cry
 to see the judgments he ordains,
 for he, the Lord, is God Most High,
 and far above all gods he reigns.

5 Let everyone who loves the Lord
 hate evil, as his word commands;
 his faithful people he will guard,
 delivering them from wicked hands.

6 So light will shine upon the just,
 and joy on hearts kept clear of blame,
 who gladly make the Lord their trust
 and ever praise his holy name.

Psalm 98

A Psalm

1 O sing a new song,
 O sing to the Lord,
his wonders declare
 with joyful accord!
His might and his mercy
 have saved us from shame,
and brought him the victory:
 all praise to his name!

2 His power to redeem
 the Lord has made plain,
the nations now see
 his righteousness reign;
his covenant with Israel
 the Lord has recalled,
and all earth has seen
 the salvation of God.

3 Then sing, all the earth,
 rejoice in the Lord,
break forth into song,
 his praise be outpoured!
With strings and with trumpets
 make music and sing,
acclaiming in triumph
 the Lord God, the King!

4 Let islands and seas
 resound with delight,
the rivers clap hands,
 the mountains unite
to sing to their Maker,
 the Lord who comes forth
to judge with true justice
 all peoples on earth.

Psalm 99

1 The Lord is King – let all the peoples tremble –
 the cherubim his throne – Earth, quake with fear! –
in Zion great, supreme above all peoples:
 his awesome, holy name let all revere!

2 The King loves justice, this he has established:
 in Jacob what is just and right he's done;
exalt the Lord our God and bow in worship
 before the footstool of the Holy One!

3 When priests and seers like Moses, Aaron, Samuel
 cried to the Lord, their prayers he would accept,
and speaking from the cloudy pillar gave them
 his holy laws and statutes which they kept.

4 O Lord our God, you answered their petitions:
 you punished sins, but sinners you restored;
draw near and worship at his holy mountain,
 exalt him: holy is our God the Lord!

Psalm 100 (1)

A Psalm for the thank offering.

1 With joyful shouts acclaim the Lord,
 all people everywhere!
Bow down to him in glad accord,
 with songs of joy draw near!

2 Acknowledge God the Lord to be
 the one true God indeed!
He made us all; his sheep are we
 that in his pasture feed.

3 As you approach his temple steps
 your thankfulness proclaim;
come in with praises on your lips
 and bless his holy name.

4 Rejoice because the Lord is good,
 his steadfast love is sure;
 his faithfulness has always stood
 and shall for evermore.

Psalm 100 (2)

A Psalm for the thank offering

1 Shout for joy!
 Rejoice in the Lord, every nation!
 Shout for joy!
 In his praise unite;
 serve the Lord with all jubilation,
 come before him, singing with delight.

2 Know that he,
 the Lord, is our God and he made us;
 know that he
 is the God who reigns,
 who in joy and praise has arrayed us:
 we are his, the flock he feeds and tends.

3 Bless his name
 and enter his gates with thanksgiving!
 Bless his name,
 fill his courts with praise;
 sovereign Lord of all that is living:
 sing his praises all your earthly days.

4 For the Lord
 is good, showing mercy and favour;
 for the Lord's
 loyal love is sure;
 and his truth and faithfulness ever
 shall unchanged from age to age endure.

Psalm 101

A Psalm of David

1 Of loyal love and justice,
 O Lord, shall be my song;
my heart pursues perfection:
 for you, O Lord, I long!
May my whole life be blameless,
 and pure my every aim;
be far from me all evil,
 all crookedness and shame.

2 The whispering voice of slander
 shall do its work no more,
the haughty eyes and proud heart
 no more shall I endure;
I look for faith and honour
 in those at court with me:
the one whose life is blameless
 my minister shall be.

3 For I will never welcome
 deceivers and their lies:
and none who utters falsehood
 will stand before my eyes;
before our court shall evil
 receive its due reward
and wickedness give place to
 the city of the Lord.

Psalm 102

A prayer of one afflicted, when he is faint and pours out his complaint before the Lord

1 "Lord, hear my prayer, I cry to you to help me:
 hide not your face in my most troubled day;
O listen when I call and answer quickly:
 with fevered frame my days just burn away.
My heart is sick, my voice reduced to groaning,
 forgetting food, I'm mostly skin and bone;
I'm like a wandering ostrich in the desert:
 adrift and lost, I lie awake alone.

2 "And all day long my enemies hurl their insults,
 they use my name to curse amid their jeers;
instead of bread I seem to feed on ashes,
 and what I drink is mingled with my tears.
Your wrath and fury bring all this upon me,
 for you have picked me up and thrown me out;
my days are darkening like the shades of evening:
 I wither like the grass in time of drought.

3 "But you, O Lord, you sit enthroned for ever:
 from age to age continues your renown;
you will arise and will have pity on Zion:
 the appointed time indeed is coming soon.
For we, your servants, love her stones, her rubble:
 your name, O Lord, all lands, all kings will fear."
He'll build up Zion and appear in glory,
 and not despise his stricken people's prayer.

4 Record this, that a future generation
 may praise the Lord: he looked from heaven on high
upon this earth to hear the prisoners' groanings
 and bring release to those condemned to die.
So will the Lord's name be proclaimed in Zion,
 when kings and people throng to bring him praise –
My strength he's broken, cutting short my life-span:
 "My God, don't take me halfway through my days!

5 "Your years extend throughout all generations:
 you laid the earth's foundation in time past;
you formed the heavens, you will see them perish,
 like clothes they'll fade and fall apart at last.
You'll change them like a garment and discard them;
 but you're the same, for ever you'll endure,
the children of your servants shall continue,
 their offspring in your presence dwell secure."

Psalm 103

A Psalm of David

1 Bless the Lord, let all within me
 praise and bless his holy name,
 mindful of his endless mercies:
 who removes my guilt and shame,
 and who heals me and redeems me,
 crowns with grace and steadfast love,
 fills my life, my youth renewing
 like an eagle high above.

2 He brings justice to the victims
 underneath the oppressor's heel;
 he made known his ways to Moses
 and his deeds to Isra-el;
 for the Lord is all compassion,
 slow to anger, rich in grace:
 he will not rebuke forever,
 nor forever hide his face.

3 So we sinners are not dealt with
 on our merits by the Lord,
 nor our acts of disobedience.
 given their well-deserved reward;
 like the heavens that tower above us
 his great love is measureless,
 far as east from west removing
 all our sins and wickedness.

4 Creatures of the dust, our frailty
 well our heavenly Father knows:
 short-lived as the meadow flowers are,
 withered once the dry wind blows;
 but his love for those who fear him
 steadfast through the ages stands,
 pledged to those who keep his covenant
 and who live as he commands.

5 Bless the Lord enthroned in heaven:
 all are subject to his sway;
 bless the Lord, you mighty angels,
 listening, ready to obey;
 bless the Lord his heavenly forces,
 waiting to fulfil his word;
 bless the Lord, his whole creation:
 all within me, bless the Lord!

Psalm 104

1 Bless the Lord, my soul! What greatness
 Lord, your splendour testifies,
 wrapped in light, your dazzling vesture:
 like a tent you spread the skies,
 lay your palace on their waters,
 ride on clouds where you desire,
 make the winds your message-bearers
 and your servants flames of fire.

2 You set earth on firm foundations
 evermore its place to keep,
 mantling all its mountain ranges
 with the waters of the deep;
 at your thunder these retreated,
 sinking downwards to remain
 in the bounds you set – and never
 shall they cloak the earth again.

3 You release the springs in torrents,
 down they flow from every hill,
 where the herds of wildlife water
 and the donkeys drink their fill;
 nearby in the leafy woodland
 choirs of songbirds come to nest:
 as your rains descend from heaven,
 with your bounty earth is blessed. . . .

4 You produce the grass for cattle
 and the plants by which we're fed,
oil and wine you give to cheer us
 and for strength our daily bread;
Lord, you water well your forests:
 there aloft the storks reside,
and beyond them in the mountains
 ibex roam and hyrax hide.

5 You made sun and moon to measure
 times and seasons, night and day:
darkness draws the forest creatures
 hungry for their heaven-sent prey;
sunrise sees them stealing homeward
 to the shelter of their dens:
man sets out to reach his workplace,
 toiling till the daylight ends.

6 Lord, how many are your wonders!
 You in wisdom made them all;
Earth is filled with your creations,
 living things both large and small.
How the vast expanse of ocean
 teems with life of every sort:
there the great ships sail the sea-ways,
 there Leviathan loves to sport.

7 And when hunger comes upon them
 these all look to you on high;
from your open hand they gather
 all the good things you supply.
Hide your face and they are fearful,
 stop their breath and they're no more;
breathe anew and life is kindled,
 Earth replenished as before.

8 Glory to the Lord for ever!
 May his works be his delight,
at whose glance the earth is shaken,
 at whose touch the peaks ignite.
May I ever praise and please him,
 my delight, my God adored,
and this earth be purged of evil:
 O my soul, O bless the Lord!

Psalm 105

1. Give thanks to God the Lord, call on his name,
 the wonders he has done make known abroad;
 sing praise to him, his holy name acclaim:
 rejoice in heart, all those who seek the Lord!
 At all times seek the Lord – his strength, his aid;
 his wondrous works be sure to recollect,
 his miracles, the judgments that he made,
 O Abraham's sons and Jacob's, his elect.

2. He is our God, his judgments fill the earth;
 his covenant he remembers evermore –
 millennia pass, but still it holds its worth –
 which he with Abraham made, to Isaac swore,
 confirmed to Jacob as a statute too,
 to Israel as an everlasting pledge:
 "The land of Canaan I will give to you
 to be your own appointed heritage."

3. A tiny handful, strangers in the land,
 forever wandering to another spot,
 he let no one oppress them, kings he warned:
 "These are my anointed prophets – touch them not!"
 Then calling down a famine on the land,
 he left his people destitute of bread;
 but Joseph, for relief that God had planned,
 sold into slavery, had been sent ahead.

4. His feet were fettered and his neck was chained,
 until what God predicted came to be;
 when tested as the Lord's word had ordained,
 the ruler of the peoples set him free.
 He made him lord of all that he possessed,
 to train his courtiers and enlighten them;
 then Israel came to Egypt as a guest:
 so Jacob settled in the land of Ham. . . .

5 The Lord made Israel's numbers grow so great
 that they outmatched their enemies' power and wealth,
 whose hearts he turned from welcome into hate,
 to oppose his servants by deceit and stealth.
 He sent his servant Moses and he picked
 his brother Aaron: they, at his command,
 announced his signs by which he would inflict
 thick darkness on those rebels and their land.

6 He turned their waters everywhere to blood,
 and left the fish in pools and rivers dead;
 frogs overran the country like a flood,
 and Pharaoh even found them in his bed;
 he spoke the word and flies came down in swarms,
 and lice in thousands spread at his command;
 he gave them hail for rain, and thunderstorms
 whose lightning bolts sent panic through the land.

7 He wrecked their vines and figs and trashed their trees;
 he spoke, and countless locusts all around
 descended on whatever they could seize,
 devouring every green thing in the ground.
 He struck down all the first-born in the land,
 each family's pride: enriched with silver and gold,
 his people Israel he brought out as planned,
 and there were none who stumbled, young or old.

8 How glad was Egypt once they'd gone away,
 for dread of Israel now had reached its height;
 he spread a cloud to cover them by day,
 and gave them fire to be their light by night.
 They asked for meat, and flocks of quails he brought,
 and bread from heaven abundant he bestowed;
 he pierced the rock, a stream came gushing out,
 which through the desert like a river flowed.

9 For he recalled his promise all along
 which to his servant Abraham once he gave:
 he brought his people out with joyous song,
 his chosen ones, who sang his power to save;
 the nations' lands he now made Israel's own,
 the fruit of others' toil their huge award,
 that they might keep the statutes he made known,
 and do the laws he taught them. Praise the Lord!

Psalm 106

1 Give thanks to God the Lord, how good he is:
his steadfast love endures for evermore;
his mighty acts surpass our power to praise:
how blessed are those who love and do his law.
"Remember me, O Lord, when in your grace
you come and save your people: save me too,
to see the joy that fills your chosen race
and with your heritage exult in you.

2 "What wickedness have we been guilty of!
Our fathers quite forgot your wondrous deeds
in Egypt – your abundant steadfast love –
and turned against you at the Sea of Reeds."
Yet for his name's sake, his great power to show,
he stilled the sea and opened up dry land;
he led them by that sandy path, and so
redeemed his people from their enemy's hand.

3 The waters closed, their enemies drowned, each one:
then they believed his words and sang his praise,
yet, all too soon forgetting what he'd done,
ignored his counsel in the ensuing days.
When seized with craving in the wilderness
they put their God and Saviour to the test;
he gave them what they asked for, in excess,
with sickness in return for their request.

4 Some, jealous of both Aaron he'd ordained
and Moses too, were judged: the ground gave way,
engulfing Dathan and Abiram's band,
whilst fire consumed the rest who'd gone astray.
They made a calf at Horeb, bowing down
before a molten image they had cast,
and thus exchanged their glorious God, their Crown,
for the image of an ox that chews the grass. . . .

5 They soon forgot their Saviour God, who'd done
such signs in Ham, such wonders by the Sea;
he said he would destroy them, every one –
had not his chosen, Moses, made his plea:
by standing in the breach he there deterred
God's wrath from striking all his people dead.
They spurned the land of promise, scorned his word,
complained and disobeyed what he had said.

6 "I'll crush you in the wilderness," he swore,
"your children through the nations' lands I'll spread."
Then Israel yoked themselves to Baal-of-Peor
and ate the pagan offerings to the dead.
In wrath he sent a plague; then Phinehas rose
and intervened, the plague was checked – and this
was credited to him, and to all those
belonging to his line, as righteousness.

7 At Meribah they angered him again,
and Moses suffered on account of them:
embittered by the Israelites' disdain,
he uttered thoughtless words that brought him blame.
They failed to root the pagan peoples out,
although the Lord had given a clear command,
but mingled with the nations round about
and learned to share the customs of the land.

8 They served their idols, which became a snare,
and offered sons and daughters to a god –
to demons, rather! – sons and daughters fair
they sacrificed, they shed their spotless blood.
To Canaan's idols these were sacrificed;
the land was stained by all the blood they spilt,
and they defiled themselves too, being enticed
to play the whore and so increase their guilt.

9 The Lord was therefore angry with his own,
abhorred them, placed them under others' rule:
beneath their heathen enemies they lay prone
in strict subjection, hated, pitiful.
He came and saved them time and time again,
but they remained rebellious nonetheless,
forever sinking lower in their sin –
yet when they cried, he noted their distress.

10 His covenant he remembered for their sake,
relenting in his steadfast love immense;
he made all those who held them captive take
due pity on them in their impotence.
"Lord, save us, gather us from east and west,
your holy name to thank and praise again."

Doxology

May Israel's God, the Lord, be ever blessed:
and so let all the people say, "Amen!"

BOOK FIVE: PSALMS 107–150

Psalm 107

1 To God the Lord give thanks, how good he is:
 his steadfast love endures for evermore;
 let his redeemed unite in song to praise
 the Lord who's saved them from the oppressor's power,
 who's gathered them from countries round about,
 has drawn them from the east and from the west,
 and from the north and south has called them out:
 let their redeemer's name be ever blessed.

2 Some wandered in the barren wilderness,
 condemned it seemed for evermore to roam;
 they found no way that led towards a place
 where they could settle and create a home.
 With little food, and water sources rare,
 their spirits sank, their strength grew less and less;
 then to the Lord they cried in their despair,
 and he delivered them from their distress.

3 For he enabled them at last to find
 a way that led directly to a town;
 and so they left the weary sands behind
 and reached a spot where they could settle down.
 For steadfast love, then, let them thank the Lord,
 and for his wonders done for mortal men,
 the thirsty satisfied, their life restored,
 and with good things the hungry filled again.

4 And those left long in darkness like the dead,
 to prison walls and bitter torment chained,
 for they'd rebelled against what God had said,
 the counsel of the Most High they'd disdained –
 he broke their hearts with toil they scarce could bear,
 they fell and lay there in their helplessness;
 then to the Lord they cried in their despair,
 and he delivered them from their distress.

5 He rescued them from darkness grim as death,
 he broke their chains, he burst their bonds apart,
 restoring to their bodies life and breath
 and, with their freedom, joy and peace of heart.
 For steadfast love, then, let them thank the Lord,
 and for his wonders done for mortal men:
 the gates of bronze are shattered by his word,
 the iron bars resist his hand in vain.

6 Those fools indulging in rebellious ways,
 in every kind of passion, greed and lust,
 discovered how iniquity repays
 its victims with affliction fit and just.
 They loathed all kinds of food, and soon drew near
 the gates of death, through their obscene excess;
 then to the Lord they cried in their despair,
 and he delivered them from their distress.

7 He sent his word with all its healing power,
 determined in his faithfulness to save;
 he came in mercy at the eleventh hour
 and saved them from destruction and the grave.
 For steadfast love, then, let them thank the Lord,
 and for his wonders done for mortal men:
 thank-offerings let them bring with one accord
 and sing his acts of grace in joyful vein. . . .

8 Some sailed the sea-lanes, merchants of the world,
 who saw the Lord's great wonders in the deep;
 at his command a furious storm unfurled,
 to heaven they rose, plunged downwards in a heap,
 they staggered, tripped and reeled – like drunks they were?
 they shook with terror at their hopelessness:
 then to the Lord they cried in their despair,
 and he delivered them from their distress.

9 He spoke the word to make the storm winds cease,
 to hush the waves whose power had been so vast;
 he cheered their hearts to see the waves at peace
 and brought them to their haven, safe at last.
 For steadfast love, then, let them thank the Lord,
 and for his wonders done for mortal men;
 among his people be his praise outpoured,
 amid the elders praise be their refrain.

10 He turns the springs and streams to barren sand,
 he makes a fruitful place a salty waste,
 so wicked were the people in that land;
 but drylands with new watersprings are graced:
 he lets the hungry build a city there,
 they sow, they plant, they soon have food and wine;
 their numbers soar beneath his kindly care,
 nor does he let their flocks and herds decline.

11 Brought low, afflicted – he who scorns the great
 leaves such to roam the desert's sand and rocks,
 but lifts the needy from their sorry state
 and makes their families multiply like flocks.
 The upright see and how their hearts rejoice!
 The wicked, stunned, look on without a word.
 Whoever's wise, give careful heed to this:
 observe the steadfast love of God the Lord.

Psalm 108

A Song. A Psalm of David.

1 My heart is steadfast, and on fire
with praise, O God, in soaring song!
Awake, my soul! Let harp and lyre
awake – O I'll awake the dawn!
Before the world your name I'll bless
and sing of you: how great your love!
Your steadfast love and faithfulness
transcend the very skies above.

2 Exalt above the heavens, O God,
your everlasting sovereign worth:
then come in power and blaze abroad
your glory over all the earth.
And now in grace reveal that power,
to rescue those you hold so dear;
give help, give victory in this hour,
and answer me – in mercy, hear!

3 Upon your promised word we stand,
for in your holiness you swore:
"In triumph I'll bestow this land
on my belovèd evermore:
both east and west the land I claim
which Ephraim guards, where Judah reigns;
while Moab, Edom, Philistine
I'll break, or use for menial ends."

4 Who has resolve and strength enough
to lead me on to Edom's gate?
Can you, O God, have cast us off
and left our armies to their fate?
Against this enemy grant us strength,
mere human force is sure to fail;
but victory will be ours at length:
with you, our God, we shall prevail.

Psalm 109

To the choirmaster. A Psalm of David.

1 O God, the God I praise, do not keep silent,
 for wicked lying lips without a pause
 pour out their falsehoods, uttering words of hatred,
 attacking my good name for no good cause.
 In answer to my kindness they accuse me,
 whilst I bring them in prayer to you above;
 so they reward the good I do with evil,
 and hatred is their answer to my love.

2 They say: "Appoint a wicked man against him
 at his right hand, that he may stand accused;
 when he is tried, let 'Guilty!' be the verdict,
 his prayers for his acquittal be refused.
 His days be few, another take his office,
 his wife and family lose their earthly head,
 his children leave their ruined home and wander
 to all parts, begging for their daily bread.

3 "May creditors and strangers seize his assets,
 his orphans' needs let everyone ignore;
 destruction be the fate of his descendants,
 their name be blotted out for evermore;
 the Lord recall his fathers' sins for ever,
 his mother's sins before him ever stand,
 their sins remain before the Lord for ever,
 their names and memory perish from the land.

4 "For, never showing kindness to the needy,
 he drove the broken-hearted to their death.
 He never blessed – may blessing be far from him!
 A curse on him – he cursed with every breath!
 He put on cursing like a coat each morning
 let cursing saturate his bones like oil,
 let it be like a cloak wrapped tight about him,
 tied round him like a rope he can't uncoil."

5 Thus may the Lord repay my false accusers,
 whose voices would destroy me if they could;
 But God my Lord, for your name's sake support me,
 and save me, for your steadfast love is good.
 I'm now reduced to poverty and hardship,
 my stricken heart will fail me soon enough;
 I'm fading as the shadows fade at evening,
 I'm like a locust quickly shaken off.

6 My legs have lost their strength from days of fasting,
 my body's thin, my whole physique is gaunt;
 they hurl their insults at me when they see me,
 they wag their heads at me with every taunt.
 Help me, O Lord my God, I here implore you,
 save me according to your steadfast love;
 and let them know that your own hand has done it,
 that you, O Lord, have acted from above.

7 Then let these people curse me – you will bless me:
 so shame my assailants, make your servant glad;
 may deep dishonour clothe my false accusers,
 wrapped in their shame, as in a mantle clad.
 My mouth will thank the Lord and all shall hear it:
 amid the assembled throng his name I'll praise,
 for he stands at the right hand of the needy
 against the accusers sworn to end his days.

Psalm 110

A Psalm of David.

1 The Lord said to my Lord:
 "Sit here at my right hand,
 until I put beneath your feet
 your enemies in this land."
 The Lord extends from Zion
 the sceptre you shall wield:
 assume your rule at his command
 and see your enemies yield. . . .

2 Your people make themselves
 an offering free and glad,
 the day you lead your forces out
 in holy splendour clad.
 As morning's fertile womb
 bears cool, refreshing dew,
 your youth shall flow in all its strength,
 untiring, ever new.

3 The Lord has sworn an oath
 which he will never break:
 "You are a priest for evermore
 like King Melchizedek."
 The Lord's at your right hand:
 his day of wrath draws near
 when he will crush rebellious kings
 to end their proud career.

4 His judgment will descend
 upon the nations soon,
 the bodies of their royal dead
 across the earth be strewn.
 By water from the brook
 his strength will be restored;
 and so he'll hold his head aloft,
 the Conqueror and the Lord.

Psalm 111

1 I'll praise the Lord with all my heart,
 to heaven my song of thanks ascends,
 in company with my upright friends
 and in the assembly taking part.

2 How great his works – how vast their range
 of mind – engaging laws and facts;
 how grand his providential acts:
 his righteousness will never change.

3 He helps us to recall to mind
 the works of wonder he has done,
 the great salvation he has won:
 the Lord is merciful and kind.

4 All those who fear his name he feeds:
 his covenant firm for ever stands;
 his people, given the nations' lands,
 beheld the power behind his deeds.

5 His actions prove him just and true;
 his precepts all are tried and sure,
 like rock, laid down for evermore,
 to be observed our whole life through.

6 In mercy their Redeemer came
 to set his captive people free,
 a timeless covenant to decree –
 and holy, awesome is his name.

7 The reverent fear of God the Lord
 is where the path of wisdom starts,
 the way of truth for minds and hearts:
 for ever be his name adored!

Psalm 112

1 Happy is he who fears the Lord,
 who holds his sacred name in awe,
 delighting greatly in the law
 commanded in his holy word.

2 His line will flourish on this earth,
 with riches and with honour blessed;
 for evermore shall all attest
 his righteousness and godly worth.

3 In darkest days he shines as light,
 a loyal, good and generous friend,
 prepared to share and freely lend,
 his dealings always just and right. . . .

4 The righteous man remains assured,
 nor will the memory of him fade;
 if news is bad, he's not afraid:
his heart is firm, he trusts the Lord.

5 Yes, unafraid: his heart is sure
 he'll look in triumph on his foes,
 while constant righteousness he shows
in showering gifts upon the poor.

6 So shall his head be lifted high:
 the wicked watch with rage and spite
 and slowly vanish into night,
their hopes extinguished like a sigh.

Psalm 113

1 Come, all his servants, praise the Lord,
his name let every one adore;
yes, praise his name with one accord
from henceforth and for evermore:
from dawn to sundown, east to west,
the Lord's most holy name be blessed.

2 The Lord transcends all earthly powers,
his glory soars above the sky:
what other god compares with ours,
the Lord enthroned supreme on high,
who has to stoop to set his eyes
upon our lowly earth and skies?

3 He lifts the poor and brings them from
the humblest depths to sit with kings;
he gives the barren wife a home
which soon with children's laughter rings:
despair is banished, hope restored –
What god is like him? Praise the Lord!

Psalm 114

1. When Israel freely walked away
 from Egypt and her alien tongue,
 Judah he chose to dwell among,
 Israel became his realm that day.

2. The sea looked on aghast and fled,
 the Jordan flowed uphill instead;
 the mountains leapt like startled rams,
 the hills as well like frisky lambs.

3. What made the frightened sea withdraw,
 the river flow upstream in awe,
 the mountains leap like startled rams,
 and hills as well like frisky lambs?

4. Earth, shake with fear before the Lord,
 the God of Jacob who draws near,
 who speaks, and from the rock are poured
 life-giving waters pure and clear.

Psalm 115

1. No, not ours, O Lord, the glory:
 glory be to your great name,
 for your steadfast love unchanging
 and your faithfulness the same.
 Why should all the nations ask us
 "Where's your God?" and shake with mirth?
 Our God is in heaven, and *he* does
 all he pleases here on earth.

2. Gold and silver are their idols,
 from the maker's mould they come,
 mouth and ears and eyes endowed with,
 yet they're blind and deaf and dumb;
 hands they have that cannot handle,
 feet that never stir the dust:
 like them shall be all who make them,
 all who place in them their trust. . . .

3 Israel, trust the Lord your Saviour,
 trust in him, your help and shield
 priests and people, you who fear him,
 look to see his power revealed;
 for the Lord does not forget us,
 we shall see his blessing fall:
 he will bless us, priests and people,
 all who fear him, great and small.

4 May the Lord increase his people,
 grant each generation growth
 under his perpetual blessing,
 who made earth and heaven both.
 Heaven is his, the earth he's given us,
 here to serve him all our days,
 not in silence like a graveyard
 but alive with endless praise.

Psalm 116

1 I love the Lord, because in my despair
 he heard my cry;
 henceforth, while life shall last, I'll lift my prayer
 to him on high.
 Around me death had coiled its tightening cord;
 I called upon his name: "O save me, Lord!"

2 The Lord is gracious, righteous too is he:
 God longs to bless;
 the Lord protects the meek – he rescued me
 from dire distress.
 Return, my soul, to your habitual rest,
 for with the Lord's great goodness you've been blessed.

3 Yes, you, O Lord, have brought me back from death,
 From grief and shame,
 to walk before you while I draw my breath,
 and fear your name.
 I clung to you in faith, when fiercely tried –
 deceived by all on whom I had relied.

4 What can I pay for all his grace to me,
 or offer up?
 I'll call upon his name and take his free
 salvation's cup;
 so to the Lord I'll pay my sacred vows
 before his people gathered in his house.

5 The death of every saint to him is dear:
 your servant, Lord
 my solemn thanks to you I offer here,
 loosed from death's cord;
 so to your name, O Lord, I'll pay my vows
 before your people gathered in your house.

Psalm 117

1 Praise the Lord, you nations all: *Hallelujah!*
 evermore his name extol;
 every land, your voices raise
 in the global hymn of praise!

2 Great indeed his steadfast love,
 freely given us from above;
 and his faithfulness is sure:
 evermore it shall endure.

Psalm 118

1 *Give thanks to God the Lord, for he is good;*
 his steadfast love for ever shall endure.
 Let Israel say with heartfelt gratitude:
 "His steadfast love endures for evermore."
 Let all the priests of Aaron's house proclaim:
 "His steadfast love for ever shall endure."
 Let those who fear the Lord repeat the same:
 "His steadfast love endures for evermore." . . .

2 In deep distress to God the Lord I cried:
he answered when I called and set me free;
I will not fear, the Lord is on my side:
what harm can mortal man then do to me?
The Lord is on my side: by him empowered
I'll look in triumph on my enemies' fate;
it's better to take refuge in the Lord
than trust in any man, however great.

3 All nations hemmed me in on every side,
but in the Lord's great name I drove them back;
they swarmed like bees, like blazing thorns they died,
for in his name I broke up their attack.
So nearly was I thrown down by that throng:
the Lord, though, helped me more than hold my own;
the Lord is all my strength and all my song,
and has become my Saviour, he alone.

4 Hear how the joyful songs of victory mount
from where the righteous camp upon the land;
I shall not die, but live, and I'll recount
the mighty victory of the Lord's right hand.
The Lord has disciplined me rigorously,
but he has not cut short my earthly days:
fling wide the gates of righteousness for me
to enter in and give him thanks and praise.

5 This is the gateway to the God of heaven,
through which the righteous come before his throne;
"I thank you for the answer you have given:
you have become my saviour, you alone."
The stone the builders spurned has now been laid:
the cornerstone! This wonder God has done!
This is the day the Lord himself has made:
rejoice in it and triumph, everyone!

> 6 "Save us, we pray, O Lord, grant us success;
> bless him, O Lord, who's coming in your name."
> The Lord is God, on us he's shone his face:
> we offer up our lives, his rightful claim.
> "You are my God, I'll give you thanks and praise,
> my God whom I exalt, whom I adore."
> *Give thanks to God the Lord, how good he is!*
> *His steadfast love endures for evermore.*

Psalm 119

EIGHT Hebrew words refer to God's written word in Psalm 119. In English some vary between translations. Others involve a small range of English words of similar meaning.

1. *torah* is the classic word for law, individual laws and the great body of law given by God in the Pentateuch. These five books are also called 'the law'. The word also means 'teaching', 'instruction'.

2. *'edoth* is rendered 'testimonies' in AV, RV, RSV, NASB, ESV. (The NIV gives 'statutes'.) The word speaks of the law witnessing to God's holy character. In Exodus 25:16-22 the Ten Commandments are called 'the testimony'. The chest in which they were kept is 'the ark of the testimony'. This English word omits the concept of law. I have followed NRSV, NLT and the Jewish *Tanakh* (1985) by using the word 'decrees' and adding 'divine' to convey their witness to God's holiness.

3. *miswoth* are 'commands', 'commandments', orders to be obeyed.

4. *piqgudim* are 'precepts'. Related to a verb meaning 'to visit', 'to inspect', 'to make lists', it emphasises the detailed character of God's laws.

5. *huggim* are 'statutes'. From the verb 'to engrave', it stresses the permanence of God's laws.

6. *mishpatim* are 'judgments' in AV, RV, NASB, meaning 'just rulings' in disputes. It is rendered variously as 'justice', 'rules', 'rulings', 'ordinances' which are *just* and *righteous*, hence also 'just laws' and 'righteous laws'.

7. *dabar* and *'imrah* both mean 'word', and also 'promise'. Eight times below they appear together in the same pair of verses: 41-42, 49-50, 57-58, 81-82, 139-40, 147-48, 161-62, 169-70.

1-ALEPH (1-8)

1 How blessed are those who lead a blameless life,
 according to the law the Lord has given,
 who daily follow his divine decrees
 and seek with all their heart the God of heaven.

2 Such people do not practise what is wrong,
 but they continue walking in his ways;
 to all of us you've given a clear command
 to keep your precepts carefully all our days.

3 O that my ways were steadfast, fully set
 on keeping all your statutes day and night;
 then would I surely not be put to shame,
 with your commandments firmly kept in sight.

4 I'll praise and thank you with an upright heart
 as I absorb your rules of righteousness;
 I'll keep your statutes, that is my resolve:
 don't ever leave me, lost and comfortless.

2-BETH (9-16)

1 How may a young man keep his pathway pure?
 By holding fast to what your word demands;
 with my whole heart have I sought after you:
 let me not wander from your clear commands.

2 Your word I've treasured up within my heart
 to keep from sinning and offending you;
 all praise and blessing be to you, O Lord;
 help me to learn your statutes through and through.

3 With my own voice to others I repeat
 the righteous rulings that your lips declare;
 I follow your divine decrees with joy,
 as one possessing wealth beyond compare.

4 Upon your precepts I will meditate,
 and on your paths my eyes I'll firmly set;
 your statutes are my ever dear delight:
 your word I'll not neglect, I'll not forget.

3-GIMEL (17-24)

1 Be generous to your servant: let me live
and always keep to what your word ordains;
unveil my eyes that I may search and see
the wondrous things your sacred law contains.

2 I'm just a passing visitor on earth:
do not hide your commandments from my eyes;
at all times I'm consumed with longing for
the righteous judgments that you formalise.

3 You reprimand and you condemn the proud
who stray from your commandments with such ease;
remove from me all scorn and all contempt,
for I observe all your divine decrees.

4 Although the powers that be contrive my fall,
upon your statutes will your servant dwell;
and your divine decrees are my delight,
they are my constant counsellors as well.

4-DALETH (25-32)

1 My soul lies clinging to the very dust:
restore my life according to your word.
I told you of my ways, you answered me:
help me to learn the statutes you record.

2 Make me discern the path your precepts mark,
that on your wonders I may meditate.
My soul is anguished, sorrow wears me down:
revive me by your word on which I wait.

3 The way of falsehood far remove from me:
grant me your law's instruction by your grace;
I've made the way of faithfulness my choice,
I give your righteous judgments pride of place.

4 I cling to your divine decrees, O Lord:
let not the shame of failure cover me;
I'll run the way that your commandments point,
for you enlarge my heart, you set it free.

5-HE (33-40)

1. Teach me, O Lord, the way your statutes show,
 that I may keep it till my dying day;
 give me true insight to observe your law,
 with all my heart to follow and obey.

2. Lead me along the path of your commands,
 for there I find my true delight indeed;
 so turn my heart to your divine decrees
 and not to envy, discontent and greed.

3. Direct my eyes away from worthless things,
 renew my life to walk in your ways here;
 fulfil your promise to your servant given
 that I may live for you with awe and fear.

4. Remove from me the censure which I dread,
 for perfect are the judgments you express;
 how precious are your precepts to my heart!
 Renew my life, then, in your righteousness.

6-WAW (41-48)

1. And may your steadfast love reach me, O Lord,
 your promise of salvation which I've heard;
 and I will answer him who's taunting me,
 for I am ever trusting in your word.

2. And do not take that true word from my mouth:
 my hope is in your rulings just and sure;
 so shall I keep your law continually,
 throughout this earthly life, for evermore.

3. And I will walk in freedom here below:
 to keep your precepts has become my aim,
 so I will speak of your divine decrees
 in front of kings and not be put to shame.

4. And your commandments are my great delight,
 I love them more than I could ever state;
 and so to them will I reach out my hands,
 and on your statutes I will meditate.

7-ZAYIN (49-56)

1. Remember me, your servant, and your word
 which gives me hope amid the storm and strife;
 in my affliction, here I find my strength:
 the promise you have made has given me life.

2. The arrogant bombard me with their jeers,
 but I have not departed from your law;
 when I recall your judgments from of old,
 O Lord, what strength and hope from them I draw!

3. The wicked leave me shocked and scandalised
 that they forsake the law you have bestowed;
 your statutes have become the songs I sing
 wherever I have lodged upon life's road.

4. My mind recalls your name at night, O Lord,
 and I observe your law, yes, come what may;
 this comfort has accompanied my life:
 that I have kept your precepts day by day.

8-HETH (57-64)

1. The Lord is my sublime inheritance:
 I promise I shall keep the words you've said;
 with all my heart I beg you, grant me grace
 according to the promise you have made.

2. I have again reflected on my ways
 and turn my steps to your divine decrees;
 I hasten to obey all your commands,
 without delay to keep and practise these.

3. The wicked strive to drag me away from you,
 but I do not forget your holy law;
 on midnight's stroke I rise to give you thanks
 for your just rulings, all without a flaw.

4. A friend am I to those in awe of you,
 to all who keep your precepts day by day;
 your steadfast love, O Lord, fills all the earth:
 help me to learn your statutes and obey.

9-TETH (65-72)

1. How good to me, your servant, you have been,
 according to your promised word, O Lord;
 teach me good judgment, make me truly wise:
 to your commands my faith is firmly moored.

2. Before I was afflicted I had strayed,
 but now I keep your holy word each day;
 how good you are, and all you do is good:
 help me to learn your statutes and obey.

3. The arrogant are smearing me with lies,
 I keep your precepts, though, with all my heart;
 but theirs are hearts unfeeling, cold and coarse:
 my joy is in your law, in every part.

4. How good for me affliction proved to be,
 that I might learn your statutes given of old;
 the law you spoke is better far to me
 than countless coins of silver and of gold.

10-YODH (73-80)

1. Your hands have made me and established me:
 give me true insight, your commands to learn;
 may those who fear you see me and rejoice,
 because it's to your word in hope I turn.

2. I know, O Lord, your judgments all are right:
 in faithfulness have you afflicted me;
 may I be strengthened by your steadfast love,
 as your word told your servant I would be.

3. Let your compassion come, that I may live,
 because your word is truly my delight;
 expose the arrogant who've slandered me,
 whilst I dwell on your precepts day and night.

4. May those in awe of you return to me,
 all those well versed in your divine decrees;
 may my heart keep your statutes blamelessly,
 lest I be shamed through disregarding these.

11-KAPH (81-88)

1 My soul is aching for your saving power,
 upon your word alone my hope I place;
 my eyes ache, watching for your promised help:
 I ask, "When will you send your strengthening grace?"

2 Though withered like a wineskin in the smoke,
 your statutes I shall constantly recall.
 How long, then, must your servant still endure?
 When will my enemies feel your judgment fall?

3 The arrogant dig pitfalls on my path,
 perverse opponents of your holy laws.
 All your commandments well deserve our trust:
 help me! They're hounding me for no good cause.

4 They've nearly made an end of me on earth,
 yet from your precepts I've not turned away.
 Now in your steadfast love preserve my life,
 that your divine decrees I may obey.

12-LAMEDH (89-96)

1 For evermore, O Lord, your word endures:
 fixed firmly in the heavens there it stands.
 Your faithfulness goes on from age to age,
 like earth itself established by your hands.

2 And still they stand, according to your will,
 for all things serve you, all before you bow.
 Had not your law been daily my delight,
 my suffering would have brought my end by now.

3 Your precepts nevermore shall I forget,
 since by them you've restored my life to me;
 because I'm yours, deliver me, I pray,
 for I consult your precepts constantly.

4 The wicked lie in wait to finish me,
 but I will ponder your divine decrees.
 Our finest works are limited at best,
 but your commandment's broader far than these.

13-MEM (90-104)

1 O how I love the teaching of your law!
 It is my meditation through the day.
 And I'm made wiser than my enemies are,
 for your commands are with me all the way.

2 I have more insight than my teachers have,
 for your divine decrees engage my thought.
 I've more discernment than my elders have,
 for I observe the precepts you have taught.

3 From every evil path I've steered away,
 that I may keep your word consistently.
 From your just laws I have not turned aside,
 for you yourself have been instructing me.

4 How sweet to me are all the words you speak,
 they're sweeter far than honey on my tongue!
 Your precepts teach me how to understand,
 and therefore I hate every path that's wrong.

14-NUN (105-12)

1 Your word's a lamp to guide my faltering feet,
 a light that shines upon my path ahead.
 I've sworn and have confirmed a solemn oath
 to keep the righteous laws that you have made.

2 See how severe, O Lord, my suffering is:
 restore my life according to your word.
 Accept, O Lord, my sacrifice of praise
 and help me learn the judgments you record.

3 I take my life forever in my hands,
 but don't forget the law that you have made.
 The reprobate have set a trap for me,
 but from your precepts I have never strayed.

4 My heritage is your divine decrees,
 the timeless treasures that rejoice my heart.
 I set my heart to keep your statutes now,
 forever until soul and body part.

15-SAMEKH (113-20)

1. I hate the wavering and divided mind,
 but love the sacred law that you've conferred.
 You are my hiding-place, you are my shield:
 my confidence and hope are in your word.

2. Depart from me, you men of evil life!
 To keep my God's commandments is my aim.
 Sustain me as you promised, and I'll live:
 and do not let my hope dissolve in shame.

3. Uphold me, that I may remain secure
 and view your statutes as a peerless prize;
 for you reject all those who stray from them:
 their specious arguments are simply lies.

4. The wicked of the earth you treat as dross,
 so your divine decrees I love, each clause.
 My body trembles in its fear of you;
 I stand in awe of all your righteous laws.

16-AYIN (121-28)

1. My actions have been always just and right;
 let my oppressors' will not be allowed.
 Assure your servant of your good intent
 and save me from the oppression of the proud.

2. My eyes ache, watching for your saving power,
 to see your righteous promise now come true.
 Deal with your servant in your steadfast love,
 and help me learn your statutes through and through.

3. I am your servant: give me insight, then,
 that I may know all your divine decrees.
 Now is the time for you to act, O Lord,
 for people break your law just as they please.

4. I therefore love and value your commands
 above all gold, the finest and the best;
 I therefore reckon all your precepts right,
 and every path of falsehood I detest.

17-PE (129-36)

1. How wonderful are your divine decrees!
 So my soul keeps them with the utmost care;
 the unfolding of your words gives light within,
 true insight to the simple and sincere.

2. With open mouth I pant for your commands,
 with all my heart and soul I long for them.
 Then turn to me and grant such grace to me
 as you extend to all who love your name.

3. Direct my steps according to your word:
 let nothing wrong or wicked master me.
 Redeem me from the oppressors of this world,
 that I may keep your precepts constantly.

4. Look on your servant with a shining face,
 and help me learn your statutes and obey.
 My eyes shed endless streams of bitter tears,
 because your law is broken night and day.

18-TSADE (137-44)

1. True righteousness belongs to you, O Lord,
 and just are all the judgments you express;
 you have appointed your divine decrees
 in righteousness and utter faithfulness.

2. I feel consumed by fury and by grief:
 my enemies quite forget the words you've said;
 your promises are fully tried and proved:
 your servant loves them and by them I'm led.

3. Though I myself am lowly and despised,
 I don't forget the precepts given by you.
 For evermore your righteousness is just,
 the teaching of your law for ever true.

4. Distress and anguish have become my lot,
 yet what delight do your commandments give!
 For ever your divine decrees are just:
 give me true insight so that I may live.

19-QOPH (145-52)

1 With all my heart I cry; respond, O Lord,
 and from your statutes I will never swerve.
 I cry aloud for you to rescue me,
 that your divine decrees I may observe.

2 I rise before the dawn and cry for help,
 for it's upon your word my hope is set;
 before the night-watch I'm awake again,
 that on your word my heart may meditate.

3 Lord, in accordance with your steadfast love
 and with your justice, hear and give me life:
 I see my persecutors closing in,
 so distant from your law, these men of strife.

4 But you are ever close at hand, O Lord,
 and your commands all true, of that I'm sure.
 Long have I known from your divine decrees
 that you have founded them for evermore.

20-RESH (153-60)

1 Look on my suffering and deliver me:
 your law I've not forgotten or ignored.
 Defend my cause, thereby redeeming me,
 and give me life according to your word.

2 Salvation is remote from wicked men,
 for they neglect your statutes' every clause;
 but your compassion is immense, O Lord:
 so give me life, for just are all your laws.

3 How many are the enemies hounding me,
 but I've not veered from your divine decrees.
 The sight of traitors makes me sick at heart:
 they flout your word by living as they please.

4 See how I love your precepts! Give me life
 according to your steadfast love, O Lord;
 your word is truth itself, and all your rules
 of justice are for evermore assured.

21-SIN & SHIN, (161-68)

1 The powerful hound me, though without a cause,
 but my heart trembles only at your word;
 and in your word do I indeed rejoice,
 like one who finds a massive treasure hoard.

2 Deceit and falsehood I abominate,
 but how I love the teaching of your law!
 Seven times a day I praise you for your rules,
 your judgments framed without a single flaw.

3 Abundant peace have those who love your law
 they won't be made to stumble on life's way;
 I set my hope on your salvation, Lord,
 and live my life as your commandments say.

4 My soul obeys all your divine decrees:
 I love them more than words could signify;
 I keep your precepts and divine decrees,
 for all my ways lie open to your eye.

22-TAW (169-76)

1 May my cry come before you now, O Lord:
 give me the insight promised by your word;
 and let my plea come now before your throne:
 deliver me according to your word.

2 Let my lips overflow with thanks and praise
 for teaching me the statutes given by you;
 let my tongue sing the wonders of your word,
 because all your commands are right and true.

3 May your hand be prepared to bring me help,
 because your precepts I embrace by choice;
 for your salvation how I long, O Lord,
 and in your law's instruction I rejoice.

4 Let my soul live that it may sing your praise,
 and let your justice help this wandering sheep;
 yes, I have wandered: seek your servant out,
 for you commands I don't forget to keep.

Psalm 120

A song of Ascents

1. In anguish to the Lord I cry,
 my desperate prayer is heard:
 "Save me, O Lord, from lips that lie
 and each deceitful word."

2. What just reward will he command
 for such deceitful speech?
 A warrior's sharpened arrows and
 hot burning coals for each.

3. Too long a time I've lived among
 these men who peace abhor:
 however peaceable my tongue,
 when I speak, they're for war.

Psalm 121

A song of Ascents

1. Up to the hills I lift my eyes and ponder:
 from where shall help arise?
 From God the Lord, who made the mountains yonder
 and all the earth and skies.

2. He'll hold you fast and keep your feet from stumbling:
 unwearied watch he keeps;
 for Israel's guard, of course, is never slumbering:
 he neither tires nor sleeps.

3. He keeps you safe: the Lord's unseen resources
 are there to shield each one:
 he shades you from the moon's mysterious forces
 and from the noonday sun.

4. The Lord will keep you from all harm or danger,
 guarding you with his power
 in all your ways, at home or where a stranger,
 now and for evermore.

Psalm 122

A Song of Ascents. Of David.

1 What joy to hear the pilgrims say
 "Will you come up with us,
to keep the Lord's appointed feast
 and worship at his house?"

2 Within the city gates we stand,
 delighted now to see
Jerusalem's one compact design,
 her perfect unity.

3 To her all Israel's tribes go up,
 by his divine decree,
to thank and bless his holy name:
 the tribes the Lord set free.

4 For there the thrones of judgment stand
 where justice may be sought,
the thrones of David's promised line
 in David's royal court.

5 Pray for Jerusalem's peace:
 "May those who love you share your peace;
within your walls and palaces
 prosperity increase."

6 Now for my friends' and family's sake
 "Peace be with you," I'll say;
the Lord our God's own house is there,
 so for your good I'll pray.

Psalm 123

A Song of Ascents.

1 I look up to you on high
where you reign beyond the sky:
just as servants understand
they must watch their master's hand,
as a maid will look to see
what her lady's wishes be,
we look to the Lord alone
till he makes his mercy known.

2 O have mercy on us, Lord:
far too long have we endured
jeers and laughter from the proud
voicing their contempt aloud,
far too long our souls have borne
all their insults, all their scorn:
Lord, we look to you alone
till you make your mercy known.

Psalm 124

A Song of Ascents. Of David.

1 If the Lord had not been with us,
 on our side – let Israel say –
if the Lord had not been with us
 when the men attacked that day,
then a wave of frenzied slaughter
 would have struck without delay,
like a mighty wall of water,
 and have swept us all away.

2 Bless the Lord, who did not let us
 be devoured like jackals' prey;
we escaped the snare they set us,
 like a bird we flew away.
And we know our help is ever
 in his very name, the Lord,
Maker of the earth and heaven:
 ever be his name adored!

Psalm 125

1 Immoveable as Zion's mount,
 for evermore assured
amid the storms of life, are those
 whose trust is in the Lord.

2 Just as the encircling mountains hold
 Jerusalem so secure,
the Lord surrounds his people now
 and shall for evermore.

3 The wicked won't extend their rule
 across the land for long,
or else the righteous too might turn
 their hands to doing wrong.

4 Do good, O Lord, to those whose hearts
 on uprightness are set;
but those who turn to crooked ways
 will share the sinners' fate.

5 All those who trust in you, O Lord,
 stand firm through good or ill;
we pray you, evermore bestow
 your peace on Isra-el.

Psalm 126

1 When the Lord restored our fortunes,
 life was like a dream come true:
every mouth was filled with laughter,
 filled with joy the whole day through.

2 Then they said among the nations,
 "What great things the Lord has done!"
Yes, the Lord's done great things for us,
 great the joy of every one!

3 Lord, again restore our fortunes,
 as when desert waters spring.
Those who sow in tears of sorrow
 reap with joy, they shout and sing.

4 He who, carrying seed for sowing,
 goes with tears like one who grieves
shall return in triumph singing,
 carrying home his golden sheaves.

Psalm 127

A Song of Ascents. Of Solomon.

1 Unless the Lord is building too,
 you toil in vain: the house will fall;
unless the Lord is keeping watch,
 they guard in vain the city wall.

2 In vain you rise before the sun
 and stay up late to earn your keep,
the daily bread of anxious toil:
 he gives his loved one rest and sleep.

3 Now, children are a heritage,
 the Lord's reward to man and wife:
like arrows in a warrior's hand
 are sons of early married life.

4 How blessed, how happy is the man
 who has his quiver full of them;
when facing enemies in this world
 such men will not be put to shame.

Psalm 128

A Song of Ascents.

1 Happy are those who fear the Lord
 and walk in all his ways;
your toil will bring its full reward
 and blessing crown your days. ...

2 Choice as a vine adorned with fruit
 shall be your loving wife,
 and every child an olive shoot
 that gladdens earthly life.

3 Thus shall the man who fears the Lord
 be blessed in all his ways;
 from Zion's God be blessing poured
 upon you all your days.

4 So may your eyes delight to see
 Jerusalem faring well,
 your children's children yet to be,
 and peace on Isra-el.

Psalm 129

A Song of Ascents.

1 From early youth – let Israel say –
 from early youth I've been assailed;
 and yet, if scarcely held at bay,
 my enemies have not yet prevailed.

2 As though with ploughs my back was scored:
 with furrows long they ploughed their prey,
 but in his righteousness the Lord
 has cut their tethering cords away.

3 May Zion-haters, every one,
 be put to shame and overthrown,
 like rooftop grass beneath the sun,
 dried up before the blade is grown.

4 At harvest time it's just ignored,
 and passers-by will not exclaim:
 "Be yours the blessing of the Lord!
 We bless you in his sacred name."

Psalm 130

A Song of Ascents.

1 Lord, from the depths to you I call:
 Lord, hear my urgent cry!
O turn your ears to hear my voice
 which pleads with you on high.

2 If you, O Lord, record our sins,
 O Lord, who could be spared?
But with you is forgiveness found,
 that you may be revered.

3 Now for the Lord my spirit waits,
 my hope is in his word;
more than the watchmen wait for dawn
 my soul waits for the Lord.

4 O Israel, hope then in the Lord!
 His steadfast love is free,
and pays in full to ransom us
 from all iniquity.

Psalm 131

A Song of Ascents. Of David.

1 Lord, you have weaned my heart from pride,
 my eyes from scorn are free;
no longer am I occupied
 with thoughts too high for me.

2 Contented now, and reconciled,
 secure from all alarms,
my heart is quiet as a child
 safe in its mother's arms.

3 O set your hope on Israel's God,
 all you that know his name:
now and for ever trust the Lord,
 eternally the same.

Copyright © 1978 Christopher Idle

Psalm 132

A Song of Ascents.

1 Lord, we pray, remember David,
 all the hardships he endured,
how he swore an oath, invoking
 Jacob's Mighty One, the Lord:
"I will leave myself no leisure,
 neither rest nor sleep afford,
till I find a dwelling place for
 Jacob's Mighty One, the Lord."

2 In the fields of Jaar we found it –
 found his ark and worshipped there:
"Come, O Lord, in power amongst us,
 grant what now we ask in prayer:
righteousness to clothe your priests in,
 joy to make your people sing."
And for David's sake, your servant,
 smile on your anointed king.

3 God the Lord once swore to David
 words he never will disown:
"One of your direct descendants
 I will place upon your throne;
if your sons observe my covenant
 and decrees that I've made known,
their sons also shall for ever
 reign as kings upon your throne."

4 For the Lord has chosen Zion:
 "There I'll dwell for evermore,
I will bless her with abundance,
 feed her hungry and her poor,
clothe her priests with my salvation,
 make her saints rejoice and sing,
shame her foes, and ever strengthen
 David's glorious son, my king!"

Psalm 133

A Song of Ascents. Of David.

1 How wonderful a thing
 it is to live in peace!
 What joy it is to sing
 of such a life as this,
 when brothers, sisters all agree,
 and live in love and unity.

2 It's like the oil once poured
 on Aaron's hallowed head
 as high priest of the Lord,
 from where its perfume spread
 down through his vesture to his feet
 and breathed on all its fragrance sweet.

3 It's like Mount Hermon's dew
 descending in the night,
 concealed from human view,
 on Zion's sacred height:
 for there the Lord on high will pour
 his blessing: life for evermore.

Psalm 134

A Song of Ascents.

1 Come, bless the Lord, his servants all,
 with joy observe this sacred rite,
 as in the temple of the Lord
 you stand to serve him through the night.

2 Lift up your hands towards the shrine
 and bless the Lord as daylight dies;
 the Lord from Zion bless you each,
 the Maker of the earth and skies.

Psalm 135

1 Praise him, you servants of the Lord,
sing praises to his holy name,
and serving in his holy courts
his praises in his house proclaim!
The Lord is good: O praise the Lord,
sing praises to his name, rejoice!
For by the Lord was Jacob called,
his treasured Israel, his by choice.

2 I know the Lord is great indeed,
above all other gods supreme;
in heaven, on earth and in the deep
he does whatever pleases him.
He makes the distant storm clouds rise,
releases rain and lightning bolts,
and sends the wind across the skies
from his celestial storage vaults.

3 His power it was, as he'd foretold,
that struck all Egypt's first-born down:
the beasts asleep in field and fold,
the men and boys in every town.
He wrought his signs at Egypt's heart,
on Pharaoh and his underlings;
and many nations fell apart
as he cut down their mighty kings.

4 Sihon and Og his hand struck dead
and all of Canaan's kingdoms fell;
he gave their land to be instead
the heritage of Isra-el.
For ever, Lord, your name endures,
as timeless, Lord, as your renown;
his people's freedom he secures
on whom he pours his mercy down.

5 The gold and silver gods that come
 from human hand and human mind
 have mouths, but they're forever dumb,
 and eyes, but they're forever blind;
 they've ears, but cannot hear through these,
 their mouths emit no living breath:
 their makers and their devotees
 become like them in life, in death.

6 O house of Israel, bless the Lord!
 O house of Aaron, bless the Lord!
 O house of Levi, bless the Lord!
 All you that fear him, bless the Lord!
 From Zion may the Lord be blessed
 who lives among us all our days:
 throughout Jerusalem be addressed
 to him, the Lord, eternal praise!

Psalm 136

1 Give thanks to God, the Lord our God,
 give thanks to him, for he is good,
 his steadfast love is ever sure;
 give thanks to him, the God of gods,
 give thanks to him, the Lord of lords,
 his love is steadfast evermore.

2 Give thanks to him, for he alone
 performs great wonders from his throne,
 his steadfast love is ever sure;
 whose wisdom brought the heavens to birth
 and on the waters spread the earth,
 his love is steadfast evermore.

3 To him who made and set in place
 the shining orbs of outer space,
 his steadfast love is ever sure;
 the sun to rule the hours of light,
 the moon and stars to rule the night,
 his love is steadfast evermore. . . .

4 To him whose power, as he had said,
 struck all of Egypt's first-born dead,
 his steadfast love is ever sure;
 and rescued Israel from that land
 with outstretched arm and powerful hand,
 his love is steadfast evermore.

5 To him who cut the sea in two
 and ushered Israel safely through,
 his steadfast love is ever sure;
 but when the waters closed again
 he swept in Pharaoh and his men,
 his love is steadfast evermore;

6 who for his wayward people traced
 a path through Sinai's desert waste,
 his steadfast love is ever sure;
 who struck such awesome rulers down,
 yes, slaughtered kings of great renown,
 his love is steadfast evermore;

7 King Sihon of the Amorites,
 then Og who ruled the Bashanites,
 his steadfast love is ever sure;
 and made their land from age to age
 his servant Israel's heritage,
 His love is steadfast evermore.

8 He saw us in captivity
 and from our enemies set us free,
 his steadfast love is ever sure;
 by him all creatures' food is given:
 give thanks to him, the God of heaven,
 his love is steadfast evermore.

Psalm 137

1. To Babylon's distant waters brought,
 in exile there we lay;
 with tears on Zion's hill we thought
 and wept the hours away:
 neglected on the willows hung
 our tuneless harps, while every tongue
 bewailed the fatal day.

2. For there did our unpitying foe
 a joyful song demand,
 as once in Zion used to flow
 in measure broad and grand:
 but now what songs of joy have we,
 our home despoiled, no longer free,
 and in a foreign land?

3. Jerusalem! If I should forget
 to think about you still,
 then let my mouth be dumb, and let
 my right hand lose its skill –
 if I do not remember you,
 the highest joy I ever knew:
 Jerusalem's sacred hill.

4. Remember, Lord, that hostile sound
 when Edom's voices cried:
 "Tear all her stonework to the ground,
 and trample on her pride!"
 Remember, Lord, and let the foe
 the terrors of your vengeance know,
 that vengeance they defied!

5. And you, great Babylon, you shall fall
 a victim to our God;
 your monstrous crimes already call
 for heaven's chastising rod:
 how blessed the one who shall suppress
 for ever that barbaric race
 that shed his people's blood.

Adapted from William Cowper (1731-1800)

Psalm 138

A Psalm of David.

1 I give whole-hearted thanks to you,
 before the gods your praise I sing,
 towards your holy temple bow
 and to your name my thanks I bring:

2 that name which tells of steadfast love,
 in which your faithfulness is heard,
 for you have magnified above
 all else your name and sacred word.

3 The day I called to you in prayer,
 when life seemed out of all control,
 you answered me in my despair
 and with new courage filled my soul.

4 Let all the kings on earth give praise,
 O Lord, to hear the words you state,
 and sing in wonder at your ways:
 "The glory of the Lord is great!"

5 For though he sits enthroned on high,
 the Lord sees where the lowly are
 and listens to their humble cry,
 but views the haughty from afar.

6 Though I may walk a troubled path,
 you keep me safe – alive and free;
 your hand will check my enemies' wrath,
 your right hand will deliver me.

7 O Lord, your purposes are sure,
 fulfilling for me all your plans:
 your love is steadfast evermore –
 don't leave the work of your own hands.

Psalm 139

To the choirmaster. A Psalm of David.

1 You, O Lord, have searched and known me,
 you know when I sit or rise;
every thought and deed lies open
 to your all-perceiving eyes.
You have laid your hand upon me,
 guarded me before, behind;
knowledge so sublime, so towering
 far transcends an earthly mind.

2 Where could I elude your Spirit
 ever present everywhere?
In the heavens, or deep in Hades?
 You are with me even there.
Eastward, westward, still you guide me,
 from your grip I cannot stray;
nor will darkness hide me from you:
 night to you is clear as day.

3 For you made my inmost being,
 wove me in my mother's womb,
God all-wise, who ordered for me
 all my days until the tomb.
How profound, how vast, how precious
 all the workings of your will:
countless marvels, endless mercies!
 When I wake, I'm with you still.

4 God all-holy, judge the wicked –
 violent, godless and malign!
How can I not hate such evil?
 All your enemies, Lord, are mine.
Search my heart., O God, and know me,
 test my anxious thoughts, I pray;
take away my sins and lead me
 on the everlasting way.

Psalm 140

To the choirmaster. A Psalm of David.

1. Deliver me, O Lord, I pray
 from violent men who seek my life,
 whose hearts plan evil day by day,
 forevermore fomenting strife:
 their tongues they sharpen – serpent-like
 and with envenomed lips they strike.

2. As they, O Lord, perfect their plans,
 keep me beneath your constant care,
 protected from their violent hands,
 from all the traps that they prepare,
 the entangling nets the proud have spread
 as snares along my path ahead.

3. "O Lord, you are my God," I've said:
 Lord, listen to my cry for grace;
 O Lord, my Lord, now shield my head
 as when their last attack took place:
 obstruct, O Lord, their pride and greed,
 don't let their evil schemes succeed.

4. But let them reap what they have sown,
 condemned for all their poisonous lies,
 by burning coals to be struck down,
 cast into pits, no more to rise;
 let slanderers vanish from the land,
 undone by evil they had planned.

5. The Lord, I'm certain, will secure
 full vindication for the oppressed,
 and I am absolutely sure
 that every wrong will be redressed:
 the just will surely sing your praise
 within your presence all their days.

Psalm 141

A Psalm of David.

1 O Lord, come quickly, hear my urgent cry!
Like incense may my prayer ascend on high,
and may my hands uplifted as I pray
be like the offering at the close of day;
but set a guard, O Lord, to keep my lips
from foolish words, from harsh or harmful slips.

2 Nor ever let my heart be led astray
to do the evil things the wicked say
and so become involved with evildoers:
let me not fall for their pretentious lures;
but let the godly strike me with goodwill
for my reproof – let me not take it ill.

3 My prayers oppose the evils of their world,
and when their leaders from their heights are hurled,
the wicked will perceive a wiser way
and gladly hear the pleasing words I say;
for as the plough breaks up the iron-hard ground,
our scattered bones at She-ol's mouth are found.

4 My eyes are looking, O Lord GOD, to you
in whom I trust to bear me safely through;
protect me from the traps that they have made
and from the snares these evildoers have laid;
let them instead be caught in their own nets,
while I myself escape their deadly threats.

Psalm 142

A Maskil of David, when he was in the cave. A Prayer.

1 I cry out loudly to the Lord,
 I lift my voice, I plead,
I cry for mercy from on high
 in my despairing need.
I pour out all my anguished thoughts,
 before him all I lay:
"When I am growing faint within,
 it's you who know my way."

2 Along the road I have to take
 they've hidden a trap for me;
I look towards my right and watch:
 no friendly face I see.
There is no refuge anywhere,
 and no one cares to know –
I cry out, "You're my refuge, Lord,
 my portion here below.

3 "O listen to my cry for help,
 my wretched state you see:
from my pursuers save my life,
 for they're too strong for me;
release me from my prison here,
 your name to thank and bless:
the just will gather round, for you
 will deal with me by grace."

Psalm 143

A Psalm of David.

1 Hear me, O Lord, in my distress,
 give ear to my despairing plea!
In faithfulness, in righteousness
 O hear my prayer and answer me.

2 I claim no favour as of right;
 you are the God I serve and trust,
 yet judge me not: for in your sight
 no living soul is counted just.

3 My fierce oppressor hunts me down:
 I shrink in darkness like the dead;
 my spirit fails, all hope is gone,
 my heart is overwhelmed with dread.

4 Days long since vanished I review,
 I see the wonders of your hands,
 and I stretch out my hands to you,
 for you I thirst like desert sands.

5 Lord, answer me without delay!
 My spirit faints – don't hide your face;
 in you I trust, let this new day
 bring word of your unfailing grace.

6 Lord, from my enemies save me still:
 in you my refuge I have found;
 teach me, O God, to do your will,
 and lead my feet on level ground.

7 For your name's sake, Lord, hear my plea:
 in steadfast love my life preserve!
 From all my enemies set me free
 to live and love the God I serve.

Psalm 144

1 The Lord God be blessed! He's my rock ever sure,
 who trains me to fight and equips me for war:
 my stronghold, my saviour, my shield and my tower,
 subduing the nations by his sovereign power.

2 O Lord, what is man that you notice him there,
 the son of man that you accord him your care?
 For we're like a breath and our few earthly years
 fly swift as a shadow that just disappears. . . .

3 O Lord, bow your heavens and come down as fire,
 drive back my opponents and foil their desire;
 reach down with your hand as the flood-waters rise:
 save me from those aliens, their treachery and lies.

4 O God, with the harp I will sing a new song
 to you, to whom *all* royal victories belong;
 as David your servant you save from the sword,
 save me from this alien, unscrupulous horde.

5 In youth be our sons like young trees, strongly made,
 as graceful our girls as a carved colonnade,
 our granaries be filled with the year's varied yields,
 our flocks in their thousands increase in our fields.

6 Our cattle too prosper: may we and our heirs
 have peace in our towns, no distress in their squares;
 how happy the people on whom are outpoured
 such blessings from God – for their God is the Lord!

Psalm 145

A Song of Praise. Of David.

1 O Lord! My God and King,
 I'll ever bless your name,
 your praises daily sing,
 your name each day acclaim:
 beyond our power to contemplate,
 how great the Lord, his praise how great!

2 Your great historic deeds
 from age to age are taught:
 your glory far exceeds
 the scale of human thought;
 so generous is the God we bless,
 so faithful in his righteousness!

3 The Lord is full of grace,
 his kindness has no bounds,
 his anger he delays,
 his steadfast love abounds;
to every creature he has made
the Lord's compassion is displayed.

4 Your glory they declare,
 and with your saints make known
 to people everywhere
 what wonders you have done:
your kingdom, glorious in its power,
through all the ages shall endure.

5 He makes the fallen rise;
 all living things he feeds:
 to him they lift their eyes,
 his hand supplies their needs;
the Lord is just in all his ways
and kind, as all his work displays.

6 The Lord is near to all
 who come in simple prayer;
 he hears his people's call,
 the wicked he'll not spare:
let every living soul adore
his holy name for evermore.

Psalm 146

1 O praise the Lord! My soul, in song
 declare his all-surpassing worth;
 I'll praise the Lord my whole life long,
 I'll praise my God while on this earth.

2 Give not the great and good your trust,
 mere men who have no power to save:
 they breathe their last, return to dust,
 their plans go with them to the grave. . . .

3 How happy then to find one's aid
and hope in Jacob's God, the Lord:
the heaven and earth and sea he made,
and always keeps his promised word.

4 The Lord brings justice to the oppressed,
he feeds the hungry in their need,
with sight restored the blind are blessed
and prisoners from their chains are freed.

5 The Lord lifts up all those bowed down,
he loves the righteous and the true,
he cares for strangers in the town,
the widows and the orphans too,

6 but he subverts all wicked ways –
The Lord will reign, and be adored,
O Zion, all your earthly days,
throughout all ages. Praise the Lord!

Psalm 147

1 O praise the Lord! Sing praises!
 How good to praise our God!
How fitting and how pleasing
 to sing his praise aloud!
The Lord rebuilds Jerusalem,
 seeks Israel's banished sons,
binds up their wounds and comforts
 the broken-hearted ones.

2 The stars of heaven he numbers
 and gives a name to each;
his power and mind outmeasure
 all human thought and speech.
The Lord sustains the humble,
 but casts the wicked down:
give thanks to him, declaring
 in song his great renown.

3 The sky with clouds he covers,
 supplies the earth with rain
and makes the grass spring freely
 across the hills again.
He knows his creatures' hunger:
 he feeds both beast and bird,
for in God's very throne-room
 the ravens' cry is heard.

4 No human power or prowess
 delights the Lord above;
his joy are those who fear him
 and trust his steadfast love.
Extol the Lord, O Zion,
 who's made your peace complete,
has blessed your sons and gives you
 your fill of finest wheat.

5 To earth he sends his order,
 it flies there in a flash:
he spreads the sparkling snowfield
 and scatters frost like ash;
he flings the hurtling hailstones,
 his ice grips all below;
he sends his word and melts them:
 again the waters flow.

6 His word by revelation
 to Jacob he makes known,
his statutes and his judgments
 to Israel's tribes alone.
To none among the nations
 does he such grace accord:
they do not know his judgments –
 O praise him! Praise the Lord!

Psalm 148

1 Praise the Lord from heaven,
 praise him in the heights!
 Praise him, all his angels!
 Praise him, stars and lights!
 Praise him, skies and waters
 which for ever stand
 in creation's order
 at his sole command!

2 From the earth sing praises:
 creatures in the seas,
 lightning, hail and snowstorms,
 mountains, hills and trees!
 Praise him, beasts and cattle,
 all created things,
 young and old together,
 peoples and their kings!

3 Praise the Lord of glory,
 praise his peerless worth!
 Praise his name exalted
 over heaven and earth!
 Praise him, all his people,
 by his power restored,
 drawn to know and love him!
 Praise him! Praise the Lord!

Psalm 149

1 Sing praise to the Lord!
 O sing a new song!
 O praise him amid
 the saints' gathered throng!
 Israel, praise your Maker,
 and, Zion, your King!
 With harp and with timbrel
 make music and sing!

2 In those who are his
 the Lord takes delight;
the oppressed he perceives
 and lifts from their plight;
in grace and in glory
 the saints all rejoice,
with songs in the night, and
 God's praise in their voice.

3 By wielding his sword
 new victories they win:
they conquer the hordes
 of darkness and sin,
whose rulers to justice
 are brought at long last:
his saints then shall glory
 as judgment is passed.

Doxology

Then sing to the Lord!
 O sing a new song!
to his name alone
 our praises belong!
Praise God our Redeemer,
 his name be adored!
Praise God all-victorious!
 Sing praise to the Lord!

Psalm 150

1 Praise the Lord! His glories show *Hallelujah!*
 in his temple here below;
 angels round his throne arrayed,
 praise him in the heavens he made!

2 Earth to heaven, and heaven to earth,
 tell his wonders, sing his worth!
 Let the trumpets' fanfare blaze,
 drums and dance declare his praise! . . .

3 Praise him with the harp and lute!
 Praise him with the strings and flute!
 Praise him with the cymbals' sound:
 let their praises echo round!

4 Every instrument that plays,
 join the global hymn of praise!
 All that breathes, the Lord adore!
 Praise the Lord for evermore!

2

Valuing and Using the Psalms

LOST TREASURE?

The Book of Psalms has been described as 'an anatomy of all the parts of the soul'.[1] Indeed it is the uniquely inspired songbook of the Bible, which represents experiences of every kind and the emotions of the soul from deep depression to exultant joy – from 'lament to laughter'.

On my desk is a little old hymn-book, 6 x 3.5 inches, 1819. Title page, preface, list of contents, index, 12 pages in all. Then, 276 pages of text. Nothing else, no names, no tunes, no dates, just the words: 65 Psalms, 218 Hymns and 34 Spiritual Songs.

The hymns are addressed to God 'in one or more of his sacred and co-equal Persons, either of Praise or Prayer', concluding with 'occasional' hymns for morning, evening, harvest, the Lord's Day, etc. The spiritual songs are reflection, exhortation, spiritual experience, such as 'A debtor to mercy alone' and 'There is a fountain filled with blood'.

Like Spurgeon's *Our Own Hymn-Book*, pride of place is given to versions of the Psalms, in keeping with the universal Church's age-long use of them in worship. The 65 pieces include versions of such well-known Psalms as 19, 23, 51, 84, 100, 121, 130, 148 and 150. The words are clear and simple, sometimes from Isaac Watts or his imitators or a mixture of sources, all unacknowledged in that early era of hymn-books.

1. John Calvin, *Calvin's Commentaries* (Grand Rapids USA, Baker Books) vol.4, p.xxxvii

Why did evangelical Christians value the Psalms and use them in worship in the 18th and 19th centuries? Why are they less used among us today?

To answer the second question first, they have fallen out of use for at least two major reasons. One, we read our Bibles less and know them less well than our forebears in those times. Many had one or two or a mere handful of books in the house, certainly not dozens, nor were they besieged by the plethora of media whose demands today we frankly cannot altogether avoid. They read and re-read their Bibles – the Authorised Version with its sonorous, memorable phraseology – and that included the Psalms with their Old Testament background (e.g. 'A Psalm of David, when he changed his behaviour before Abimelech; who drove him away and he departed', Ps 34 title). They did not need to leaf through 1 Samuel to check the reference! And they appreciated their New Testament fulfilment ('At present we do not see everything in subjection to him. But we see him who for a little while was made lower than the angels, namely Jesus, crowned with glory and honour' – Heb 2:8-9). They knew the Psalm reference, and when reading or singing the Psalm knew its Christian significance. They read the Psalms with a Christian mind, perhaps more easily than we do today; and could use them intelligently in public worship.

A second factor might have been the great changes that have occurred in the English language since the end of the 19th century, possibly in conjunction with a growing sense of distance from the great Scottish Psalter of 1650 with its (now) uncomfortable verbal gymnastics. People might well have concluded that metrical Psalms were no longer singable, despite the survival of 23 and 100 in our hymnals. Indeed, we still have survivors from Tate and Brady of 1696 (34, 42), Isaac Watts (36, 72, 90, 92, 98, 117, 122, 146), John Newton (19), James Montgomery (72) and H. F. Lyte (67, 84, 103). These, however, are sung as hymns without much awareness of their scriptural base, and in most cases cover only part of the Psalm.

Congregational Praise (1951) contained a section of sixteen extracts from the Scottish Psalter, nearly all comprising four or five common metre stanzas. Only 23 and 93 appeared in full. Dr Martyn Lloyd-Jones, the long-serving minister at London's Westminster Chapel, regularly included one as the second hymn on Sunday mornings.

What, then, is so special about the Psalms that they once enjoyed a regular place in evangelical worship? Does it matter that they are neglected and comparatively little known in many quarters today – quite apart, of course, from their eminent status as part of the God-breathed Scriptures?

I should like to highlight three particular features that render them so important: their presentation of God, their doctrinal value and their range of spiritual experience. My threefold analysis made for convenience defies, of course, that essential union of these factors, found in varying degrees in virtually every Psalm. The presentation of God involves doctrine, as does spiritual experience. Doctrine springs from God's being and character, and our grasp of these truths affects how we live. Experience is our response in our varying circumstances to what we know of God, and to his dealings with us. So that I may not appear to be exaggerating the importance of this part of Holy Scripture, let me point out a remarkable statistic: the Index of Biblical References in the McNeill-Battles edition of Calvin's Institutes contains far more references to the Psalms than to any other Old Testament book – in fact more than the next two, Genesis and Isaiah, put together. It even contains more than any New Testament book except Romans; otherwise only Matthew comes anywhere close.

HERE IS YOUR GOD!

God is, of course, the great object of our worship. The Hebrew word for Psalms, *tehillim*, means 'praises'. God is presented in all his greatness and majesty, the utterly fit object of our worship:

> *Great is the LORD and greatly to be praised* (48:1)

> *For the LORD is a great God,*
> *and a great King above all gods.* (95:3)

> *For great is the LORD, and greatly to be praised;*
> *he is to be feared above all gods.* (96:4)

> *O LORD my God, you are very great!*
> *You are clothed with splendour and majesty* (104:1)

> *and they shall sing of the ways of the LORD,*
> *for great is the glory of the LORD.* (138:5)

> *Great is the LORD, and greatly to be praised,*
> *and his greatness is unsearchable.* (145:3)

Hence his kingly power, i.e. his sovereignty, over this world and all that is:

> *For God is the King of all the earth;*
> *sing praises with a psalm!*
> *God reigns over the nations;*
> *God sits on his holy throne.* (47:7-8)
>
> *The Lord reigns.* (93:1; 96:10; 97:1; 99:1)
>
> *Our God is in the heavens;*
> *he does all that he pleases.* (115:3)
>
> *Whatever the Lord pleases, he does,*
> *in heaven and on earth,*
> *in the seas and all deeps.* (135:6)

He reigns over history, most obviously that of his people Israel (78, 105, 106), but also over the human race and its fortunes (33:10-17). He rules over armies (48:4-7; 76:3-6) and over that least manageable of all our earthly circumstances, the weather (48:7; 77:17,18; 107:23-30). Remember the hapless Canaanites and their state-of-the-art war machine that suddenly turned into a disastrous liability (Judg 4:3)? Deborah's song tells us how the Lord defeated them (Judg 5:19-21).

> *He it is who makes the clouds rise at the end of the earth,*
> *who makes lightnings for the rain*
> *and brings forth the wind from his storehouses.* (135:7)

He moves people into and away from positions of honour and influence:

> *For not from the east or from the west*
> *and not from the wilderness comes lifting up,*
> *But it is God who executes judgment,*
> *putting down one and lifting up another.* (75:6-7)

He will even bring humanity worldwide to bow to him:

> *All the nations you have made shall come*
> *and worship before you, O Lord,*
> *and shall glorify your name.* (86:9)

Francis Schaeffer's favourite hymn, I am told, was the famous version of Psalm 100, 'All people that on earth do dwell,/Sing to the LORD with cheerful voice', in truth a great missionary Psalm. (Have you ever sung Psalm 100 on a missionary Sunday?)

The Psalms also present God as holy, like Isaiah naming him the 'Holy One of Israel' (71:22; 78:41; 89:18). His holiness speaks of his 'otherness', far exalted above all his creation, including his image-bearer, mankind, so that he is not part of the universe in any sense, or in any degree. He is 'exalted in the earth' (46:10), his name and word are 'exalted above all things', 'the LORD is high' (138:2,6), exalted in his strength (21:13), he has 'set [his] glory above the heavens' (8:1).

His holiness also includes his utter moral perfection: 'God is light,' says the New Testament, 'and in him is no darkness at all' (1 John 1:5). So the Psalmist asks:

> LORD, who may dwell in your sanctuary?
> Who may live on your holy hill?
> He whose walk is blameless
> and who does what is righteous,
> who speaks the truth from his heart. (15:1-2, NIV)

The question repeated in 24:3 is given the answer, 'He who has clean hands and a pure heart.' Yet God also displays his holiness in the redemption of his people: 'Your way, O God, is holy ... You with your arm redeemed your people' (77:13,15). So his holy name is a cause for praise (30:4) and for trust (33:21). It is also a cause for 'blessing', that is to say that we are to speak well of our God; as the *Oxford English Dictionary* explains the word, 'to hold or call holy; to exalt as holy (see Isa 6:3, Rev 4:8), divine, gracious', and a little later, 'with an added notion of thanksgiving or acknowledgement of gracious beneficence or goodness.'[2] Perhaps the most comprehensive presentation of God's holiness is found in Psalm 99, which brings together both God's otherness and his moral perfection. When preaching, leading Bible studies or in personal devotions, you might think about using it to focus on the holiness of God.

That brings us to God's goodness. Not only are we urged to 'bless' the LORD, as in the opening verse of Psalms 34, 103, 104, 134 and 145; the last concludes,

2. OED 2nd edition, vol.2, p.281.

'let all flesh bless his holy name for ever and ever.' Why? 'For the LORD is good' (100:5), 'for he is good' (136:1), 'he ... gives food to all flesh' (136:25). In fact he gives liberal blessings to 'the children of mankind ':

> *They feast on the abundance of your house,*
> *And you give them drink from the river of your delights.* (36:7-8)

Enjoy Psalm 104 as a lyrical celebration of God's goodness to his created world: 'you water the mountains ... you cause the grass to grow for the cattle and plants for man to cultivate ... The young lions roar for their prey, seeking their food from God ... These all look to you, to give them their food in due season.'

Surprisingly God's goodness to his creation is ascribed to his 'steadfast love' (36:7; 136:25), the word used for God's covenant love, rendered variously in the NIV, most happily as 'love unfailing', and in the AV sometimes as 'mercy', sometimes by the beautiful old word 'lovingkindness'.[3]

So we are to give thanks to God because 'he is good' (106:1; 107:1; 118:1; 136:1). We are told that the LORD's name is good (54:6), and we are invited in 34:8 to 'taste and see that the LORD is good!' That is the same word 'good' as we find throughout Genesis 1 of the Creation before the Fall. Even in old age his people repeat, 'there is no unrighteousness in him' (92:15). In him there is no darkness, no shadow-side.

Because he is good, he is faithful. The great revelation of his name, given to Moses in Exodus 34:6, is repeated a number of times in the Psalms:

> *The LORD is merciful and gracious,*
> *Slow to anger and abounding in steadfast love.*

It is recalled in 86:5, 15; 103:8; 145:8. His faithfulness is immense, it extends to the clouds (36:5), so we may 'trust in him, and he will act' (37:5).

The Psalms tell us of God's eternity:

> *Of old you laid the foundation of the earth,*
> *and the heavens are the work of your hands.*
> *They will perish, but you will remain ...*
> *you are the same, and your years have no end.* (102:26-27)

3. For a good brief discussion of the word, see J. I. Packer, *18 Words* (Fearn UK: Christian Focus, 2007) ch.7. Formerly *God's Words*.

Isaac Watts' famous version of Psalm 90, 'O God, our help in ages past' captures that simply and perfectly in its third stanza: 'From everlasting thou art God, /To endless years the same' (90:2).

Not only is he the eternal living God, he is also the true God. He is contrasted with 'the gods of the peoples which are 'worthless idols'. The Lord is the Creator, the God of splendour and majesty, strength and beauty (96:5-6). Idols, after all, are 'the work of human hands' (115:4; 135:15), dumb, blind, deaf, static. Don't make the mistake of thinking that the Lord, like them, cannot see what is going on in your life:

> *He who planted the ear, does he not hear?*
> *He who formed the eye, does he not see?* (94:9)

On the contrary, he sees everything: 'the Lord looks down from heaven; he sees all the children of man ... and observes all their deeds' (33:13, 15). He sees into the heart of the unbeliever: 'the Lord looks down from heaven ... to see if there are any who understand, who seek after God' (14:2). In a word he is omniscient:

> *You know when I sit down and when I rise up;*
> *you discern my thoughts from afar.*
> *You search out my path and my lying down*
> *and are acquainted with all my ways.*
> *Even before a word is on my tongue,*
> * behold, O Lord, you know it altogether.* (139:2-4)

Though we read that he looks down from heaven, and have earlier noted that his holy 'otherness' means that he is utterly distinct from all that he has created, he is nevertheless present amid the whole creation, omnipresent. From Exodus to 2 Chronicles the emphasis is on his special presence amid his covenant people Israel in the tabernacle and later in the temple. David sang:

> *O Lord, I love the habitation of your house*
> *and the place where your glory dwells.* (26:8)

In one of the best-known Psalms the writer mourns his exile from God:

> *My soul thirsts for God, for the living God.*
> *When shall I come and appear before God?* (42:2)

Yet Solomon understood this, even as the temple was being dedicated: 'But will God indeed dwell on the earth? Behold, heaven and the highest heaven cannot contain you; how much less this house that I have built!' (1 Kings 8:27). Jonah found out that there was no escape from God. This is not a theme that occurs frequently in the Psalms. 'Through all the changing scenes of life' the Psalm ascribes the delivering presence of God to 'the angel of the Lord [who] encamps round those who fear him' (34:7). But it is given most memorable expression, again in Psalm 139:

> *Where shall I go from your Spirit?*
> *or where shall I flee from your presence?*
> *If I ascend to heaven, you are there!*
> *If I make my bed in Sheol, you are there!*
> *If I take the wings of the morning*
> *and dwell in the uttermost parts of the sea,*
> *even there your hand shall lead me,*
> *and your right hand shall hold me.* (139:7-10)

Proverbs 8:22-31 gives a singular representation of wisdom as God's 'supreme agent' in the work of creation: 'this is simply a poetic way of describing God as "the only wise God".'[4] The Psalms portray God's wisdom in all that he does, without naming it, except once. They speak of his 'thoughts': 'You have multiplied, O Lord my God, your wondrous deeds and your thoughts towards us; none can compare with you!' (40:5, see also 139:17). It is the beautiful Psalm on God as Creator and Sustainer, which alone gives us:

> *O Lord, how manifold are your works!*
> *In wisdom you have made them all.* (104:24)

God's holiness and goodness are manifested also in his righteousness. 'righteousness and justice are the foundation of his throne ... The heavens proclaim his righteousness' (97:2,6), 'for the Lord is righteous; he loves righteous deeds' (11:17), 'He loves righteousness and justice' (33:5). God is the guarantor of all moral norms: we do not live in a universe that is morally neutral, or even perverse and malevolent, where the human race decides what is right and wrong by force or by majority vote. God our Creator is law-giver and Judge, meting

4. Eric Lane, *Proverbs* (Fearn UK: Christian Focus, 2000) p.71.

out justice to his image-bearers: 'For you will render to a man according to his work' (62:12), 'God is a righteous judge, and a God who feels indignation every day (7:11), 'the heavens declare his righteousness, for God himself is judge!' (50:6).

But to the honest person such a judge is an intolerable thought: 'Enter not into judgment with your servant, for no one living is righteous before you' (143:2). How does the Old Testament get over that? Have the Psalms any hope to offer the sinner aware of his condition, such as New Testament believers enjoy in the grace of our Lord Jesus Christ? The answer, of course, is Yes, though it looks forward in time to it, hinting, sketching, promising. Perhaps it looks rather more than that to those who enjoy the perspective of New Testament revelation.

The hope arises amazingly from God's justice and is encapsulated in that most precious word, *hesed*, steadfast love, which we glanced at earlier. 'He loves righteousness and justice; the earth is full of the steadfast love of the LORD' (33:5); 'Gracious is the LORD, and righteous; our God is merciful' (116:5). His covenant name may be pleaded, 'O God, save me, by your name ... I will give thanks to your name, O LORD, for it is good' (54:1, 6). David under deep conviction of sin, aware that his sins could be met under the law by nothing other than the death sentence, cried out to God for mercy on the basis of his steadfast love:

> *Have mercy on me, O God, according to your steadfast love;*
> *according to your abundant mercy blot out my transgressions.* (51:1)

Yes, the day would come, and for some already was, when 'steadfast love and faithfulness meet; righteousness and peace kiss each other' (85:10). How could this be? The Jewish sacrifices gave the clue, but not the full story. This much was grasped by David; in a most remarkable Psalm:

> *Blessed is the one whose transgression is forgiven,*
> *whose sin is covered.*
> *Blessed is the man against whom the* LORD *counts no iniquity,*
> *and in whose spirit there is no deceit.* (32:1-2)

I need not remind readers that it is from these verses, together with Genesis 15:6, that the Apostle Paul spells out the pivotal doctrine of justification by faith alone in Romans 4.

There is, of course, much more to say on the multi-faceted presentation of God in the Psalms. He is Saviour of his people (106:21), Shepherd (23:1) and Guide (77:20), and as we have seen with respect to his steadfast love, he is a God of grace in 106, 107, 136 – among the longer Psalms; and a faithful God (89, an even longer Psalm). Such thoughts delight the Psalmist:

> *It is good to give thanks to the* LORD,
> *to sing praises to your name, O Most High;*
> *To declare your steadfast love in the morning,*
> *and your faithfulness by night.* (92:1-2)

But we cannot conclude this brief survey without returning to God's greatness, majesty and kingly power, manifestations in time and in eternity of his glory. The Psalmist urges us to 'declare his glory among the nations', and calls on all people to ascribe glory to the LORD, bring him an offering, worship him and tremble before him (96:3,7-9). He prays, 'may the glory of the LORD endure for ever' (104:31). Scarcely a prayer that is necessary, you might think; yet it is necessary for us, and indeed all who love God, to harbour that desire and pray fervently. Psalm 29 calls him 'the God of glory' (v.3), and calls on all creation to cry 'Glory! to God' (vv.1-2); and as his power is demonstrated in the more extreme forces of the created order, 'in his temple all cry, "Glory"'(v.9). Turn to that Psalm when this planet's most awesome natural forces are unleashed, and also make this your daily prayer: 'may the whole earth be filled with his glory!' (72:19).

As we have seen, the presentation of God in the Psalms has many implications for doctrine. Some of these implications will now be considered.

GOD AT WORK

So far in our review of the doctrine of God in the Psalms we have said nothing about God as Trinity. He is, after all, love. As such he is not a solitary monad as in Islam. From all eternity to all eternity the God of the Bible is Trinity: Father, Son, Spirit. There is perfect love in the three Persons. It took the Church some centuries to talk through the doctrine that God is truly three and truly One, even with such a passage as John 14:15-26 to make the unity of the three Persons plain, and Luke 3:21-22 to confirm the diversity. The New Testament writers, we know, had the advantage of being taught by the greatest of all interpreters

of the Hebrew Scriptures (Luke 24:44-48). There are hints of God's plurality in Genesis 1:26 and Isaiah 6:8, as well as in the commonest Hebrew word for God, the plural *elohim*.

The Letter to the Hebrews (1:5) picks up three key passages from the Psalms (the first from 2:7) in its opening chapter, referring them to Christ: 'You are my Son, today I have begotten you'. From Psalm 45:6-7 these astonishing words were addressed to an earthly monarch, and prophetically to Christ (Heb 1:8):

> *Your throne, O God, is for ever and ever,*
> *the sceptre of uprightness is the sceptre of your kingdom.*
> *You have loved righteousness and hated wickedness;*
> *therefore God, your God, has anointed you*
> *with the oil of gladness beyond your companions.*

And from Ps 102:25, 'You, LORD, laid the foundation of the earth in the beginning.' In the first of these passages God's anointed is called his Son, the second distinguishes the one addressed as God from God who has anointed him; and the third applies the work of creation to Christ.[5] In the long quotation above and in Ps 2:2 the figure in question is God's anointed, or in Hebrew 'Messiah', in Greek 'Christ'. A. M. Hodgkin's classic, *Christ in all the Scriptures*, gives eleven recommended pages to the Son's presence in the Psalms.

The Holy Spirit is there, as he is in Genesis 1:2 and Isaiah 61:1. In Psalm 139:7 his inescapable presence is a cause of awe and wonder, in 51:11 his withdrawal is something to contemplate with fear and trembling. Thus in embryo do we find the doctrine of the triune God.

The first two Psalms were clearly positioned as the gateway to the whole collection. The first, a beautiful short poem, presents the value of God's written Word and the wisdom of delighting in and benefiting from this divine source of spiritual health and strength. At much greater length, right in the middle of our Bibles, is the massive Psalm 119, a meditation on God's word in all its various aspects as law, testimonies, precepts, commandments and more. Written as a giant acrostic, all eight verses of each section start with the same letter of the Hebrew alphabet, *aleph* for the first section, *beth* for the second, and so on,

5. 'LORD' does not appear in 102:25 in our Bibles. Hebrews quotes from the Greek Septuagint of c.270 BC. Its addition for clarity is perfectly legitimate: the whole Psalm is addressed to God the LORD.

thus illustrating by its form the completeness of God's word: it is all there from A to Z, we might say. It is no easy text to appreciate in all its fulness; in that respect it mirrors in microcosm the Bible itself. Wilberforce knew it by heart and would rehearse it on his long walk to the House of Commons. Spurgeon comments: 'He never repeats himself ... It contains no idle word ... It is loaded with holy sense, and is as weighty as it is bulky.' Psalm 19 celebrates the glory of God revealed in sun, moon and stars, then turns to the perfection and sheer goodness of his self- revelation in his Word written. These three Psalms provide a comprehensive summary of the Old Testament's view of Holy Scripture.

The second Psalm is one of a number that are clearly messianic, marked out by the key word, 'anointed':

> *The kings of the earth set themselves,*
> *and the rulers take counsel together,*
> *against the* Lord *and against his anointed.* (2:2)

How foolish! The Lord will terrify these violent rebels, install his Son as his anointed King, give him the world and summon rebels to make peace with his Son, to take refuge in him. We are familiar with it, at least, by Peter's use of it in prayer towards the end of Acts 4, where he links it explicitly with Messiah's atoning sacrifice at Golgotha.

Psalm 110 starts with bewildering words:

> *The* Lord *says to my Lord:*
> *"Sit at my right hand,*
> *until I make your enemies your footstool."*

Whatever can that mean? Exactly the question that Jesus asked the Pharisees in his last days on earth in his pre-glorification body; that silenced them (Matthew 22:43-46). Peter was able to tell the answer to the great crowd gathered on the Day of Pentecost (Acts 2:34-36). Hebrews 1 concludes its survey of Old Testament Scriptures by quoting from that opening verse. This most extraordinary Psalm repays prolonged study and meditation. It is an ideal Psalm to sing before a sermon on the exaltation of Christ. Or on any Lord's Day.

Those two messianic Psalms are essential in any selection of Psalms, as are the opening Psalm on Scripture and the glorious doxology that closes the

Psalter.[6] Other prominent messianic Psalms include 8 (see Heb 2:6-9); 22 on his atoning death (see John 19:24); 16 on his resurrection (see Acts 2:25-32); 118 on his exaltation (see Acts 4:10-12) as both foundation and head of the Church (see 1 Pet 2:4, 7); 72 on his worldwide rule (= Isaac Watts, 'Jesus shall reign where'er the sun'); 45 on the marriage of the King's son and his beautiful bride (see Rev 21). Many other Psalms that speak of severe suffering (e.g. 69, 116) are generally taken to betoken the rejection, suffering and deliverance of Messiah. Might they have been part of our Saviour's meditation as he endured that dreadful cross, despising the shame (Heb 12:2)?

The theme of covenant runs through the Psalms. The divine name, the LORD, is of course God's covenant name. We shall return to this subject shortly; here I should like to highlight Psalm 132, which tells of the recovery of the Ark of the Covenant which had somehow been neglected, lost or forgotten and which King David brought from Kiriath-Jearim (= 'the fields of Jaar' in the Psalm) to Jerusalem (1 Chron 13:1-8; 15:25-28):

> *Behold, we heard of it in Ephrathah;*
> *we found it in the fields of Jaar.*
> *"Let us go to his dwelling-place;*
> *let us worship at his footstool."* (132:6-7)

The Psalm moves on to celebrate the covenant promise, which the LORD gave King David (2 Samuel 7:12-16), a key moment in the history of Israel:

> *The LORD swore to David a sure oath*
> *from which he will not turn back:*
> *"One of the sons of your body*
> *I will set on your throne.*
> *If your sons keep my covenant*
> *and my testimonies that I shall teach them,*
> *their sons also for ever*
> *shall sit on your throne."* (132:11-12)

The vast majority of the rest of the Hebrew Scriptures follow in one way or another from the covenants of Exodus and 2 Samuel 7. Every year many millions hear the fulfilment of this latter read in church in Luke 1:32.

6. All four are in the little old hymn-book on my desk.

What of an afterlife? Many of the Psalms do not see beyond the silence of the grave, as in this cry to God:

> "What profit is there in my death,
> if I go down to the pit?
> Will the dust praise you
> Will it tell of your faithfulness?" (30:9)

But we have seen a farther perspective in the case of Messiah in 16:10: 'You will not abandon my soul to Sheol, or let your holy one see corruption.' There is also a hint at the end of Psalm 23, also in 17:15:

> *As for me, I shall behold your face in righteousness;*
> *when I awake, I shall be satisfied with your likeness.*[7]

And in another popular Psalm:

> *You guide me with your counsel,*
> *and afterwards you will receive me to glory.* (73:24)

Perhaps the most striking example is in the little known Psalm 49, very much a tract for these times of material loss and financial uncertainty:

> *Like sheep they are appointed for Sheol;*
> *death shall be their shepherd,*
> *and the upright shall rule over them in the morning.*
> *Their form shall be consumed in Sheol, with no place to dwell.*
> *But God will ransom me from the power of Sheol,*
> *for he will receive me.* (49:14-15)

Here 'receive' is the same Hebrew word as in 73:24 above, and it is found in Genesis 5:24, 'Enoch walked with God, and he was not, for God took him.'[8]

Peter reminds his Christian readers that the Hebrew prophets (which includes the Psalmists, Acts 2:30) did not always understand their prophecies, and that was, in part at least, because they were 'serving not themselves but you' (1 Pet 1:10-12).

7. 'A variety of strong expressions in the Psalms support the view that awake is used here of resurrections, as it undoubtedly is in Isaiah 26:19; Daniel 12:2.' Derek Kidner, *Psalms 1-72* (Leicester UK: IVP, 1973) p.90.
8. See Derek Kidner, *Psalms 73-150* (Leicester UK: IVP, 1975) p.263.

God's covenant name, the LORD, has already been mentioned several times. It appears countless times in the Psalms, while the word 'name', referring to the LORD, occurs just short of 100 times. His name, YHWH, rendered in some versions as Yahweh and in some as Jehovah, is the name by which he revealed himself to his people. It speaks of his self-existence and eternity (Exod 3:14) and of his moral perfection and love (Exod 34:6-7):

> *The LORD is gracious and merciful,*
> *slow to anger and abounding in steadfast love.*
> *The LORD is good to all,*
> *and his mercy is over all that he has made.* (Ps 145:8-9)

By this name he bound himself in covenant to his people. When he is addressed by his covenant name, the Psalmists are appealing to him on the basis of his promised grace. Well over half the Psalms address him or refer to him as the LORD in their opening verse. Typical are 'Give ear to my words, O LORD' (5:1), 'Oh come, let us sing to the LORD' (95:1), 'Not to us, O LORD, not to us, but to your name give glory' (115:1). He is the object of his people's trust:

> *The LORD is a stronghold for the oppressed,*
> *a stronghold in times of trouble.*
> *And those who know your name put their trust in you,*
> *for you, O LORD, have not forsaken those who seek you.* (9:9-10)

He rescued his people when they rebelled against him, doing this 'for his name's sake' (106:8), and acts similarly towards the individual:

> *He restores my soul.*
> *He leads me in paths of righteousness*
> *for his name's sake.* (23:3)

In some Psalms his name is mentioned or appealed to time and again (29, 116, 135). In others, however, there is a single, dramatic appeal, a call from the depths of adversity (74:18, 77:11) and a more measured appeal in 90:13. If we are not aware of such moments, we shall miss something of supreme importance to the writers.

THE PSALMS AND SPIRITUAL EXPERIENCE

It is important to consider revival in the Psalms, a topic that overlaps with our third major division, spiritual experience. So far I have not mentioned the structure of the Psalter, its overall division into five books. How this came about is unknown, nor are the pattern and its purpose clear. However, the third Book, Psalms 73-89, is largely about revival in one respect or another: 'Will you not revive us again, that your people may rejoice in you?' (85:6). Some refer obviously to the destruction of Jerusalem and its temple by the Babylonians in 587 BC and the ensuing exile of all but a few (2 Kgs 25:8-12). The writers wonder what has happened to the promises of God, to his covenant with his people, to his power and to his concern for his reputation. Very likely, such texts were written by one or more of the exiles in profound, prolonged shock in Babylon, as clearly was the poignant, despairing lament 'By the waters of Babylon' (Ps 137).

The group begins with a ' classic ' on personal revival, Psalm 73. Overwhelmed by the seeming power and wealth of the world, the Psalmist seriously wonders if his godly living has been 'all in vain' (73:13). But, on going 'into the sanctuary of God' his perspective is corrected, restoring his joy in God and trust for the future.

> *Whom have I in heaven but you?*
> *And there is nothing on earth that I desire besides you.* (73:25)

Psalm 77 is the lament of the believer who feels deserted by God. It might be an individual response to the sack of Jerusalem:

> *Has his steadfast love for ever ceased?*
> *Are his promises at an end for all time?* (77:8)

Such a reference is not explicit; the application and use of the Psalm are clearly wider. His solution is to recall 'the years of the right hand of the Most High' (77:10) in brief and graphic detail.

Psalm 79 has meant much to me for over forty years. Here is a heart cry to the God of the covenant to rein in his rampant anger with his people:

> *How long, O LORD? Will you be angry for ever?*
> *Will your jealousy burn like fire?* (77:5)

Rather he calls on God to pour out his anger on the pagan people around who wrought such destruction – and forgive his people's 'former iniquities' (77:8), for the sake of his reputation in the world (77:10,12). Psalm 74 is a longer, perhaps earlier plea (he recalls the destruction of the beautiful interior of the temple), lamenting the nation's apparent abandonment (74:9) and calling on the covenant God:

> *Remember this, O Lord, how the enemy scoffs,*
> *and a foolish people reviles your name...*
> *Have regard for the covenant.* (74:18,20)

Have not these cries of spiritual anguish much to teach us in the dark days through which the Church is passing in the UK? Psalm 83 prays in terms of the godless oppressors, and the mighty Psalm 89 wrestles and pleads with God at great length over his apparent abandonment of the Davidic covenant (89:3-4), and pleads like Psalms 74 and 79:

> *How long, O Lord? Will you hide yourself for ever?*
> *How long will your wrath burn like fire?* (79:46)

Here indeed is a powerful lesson for our own prayer ministry today.

Psalms 75 and 76 review God's judgment in favour of his people in the past, the latter quite possibly inspired by Sennacherib's ignominious retreat (2 Kings 19). Psalms 78 and 81 review God's patience with his difficult people in times past. Psalms 80 and 85 are sustained prayers for revival:

> *Restore us, O Lord God of hosts!*
> *Let your face shine, that we may be saved!* (80:19)

I strongly believe we should use such Psalms to fuel our private prayer and our prayer meetings in these times, that God will 'revive us again' (85:6):

> *Arise, O God, defend your cause;*
> *remember how the foolish scoff at you all the day!*
> *Do not forget the clamour of your foes,*
> *the uproar of those who rise against you, which goes up continually!* (74:22-23)

Let us finally consider something of the range of spiritual experience presented in the Psalms. Many pastors, I know, use them frequently in counselling.

I can give but a few indications, hoping that, like me, people will draw strength from the particular texts they have found for themselves, or been pointed to.

First must come the penitential Psalms. Traditionally, 6, 32, 38, 51, 102, 130 and 143 have been so named. Of these, I would call 130, 51 and 32 indispensable, in that order. Psalm 130 is the cry of the sinner lost in sin in general and aware that God is Judge:

> *Out of the depths I cry to you, O LORD!*
> *O Lord, hear my voice!*
> *If you, O LORD, should mark iniquities,*
> *O Lord, who could stand? (130:1-3)*

Psalm 51 is for those convicted of specific sin or sins, which must draw down the judgment of God:

> *For I know my transgressions,*
> *and my sin is ever before me.*
> *Against you, you only, have I sinned*
> *and done what is evil in your sight,*
> *so that you may be justified in your words*
> *and blameless in your judgment. (51:3-4)*

The particular sin(s) strike(s) the Psalmist so profoundly that he realises that sin itself is in him from the very beginning, and that his only hope is God's cleansing and renewal. Psalm 32 emphasises the destructive power of sin here and now, under nothing less than God's hand:

> *For day and night your hand was heavy upon me;*
> *my strength was dried up as by the heat of summer. (32:4)*

These are confessional texts for all of us at some time, as well as being invaluable for serious gospel preaching.

A number of Psalms might be called Wisdom Psalms, rarely containing that word, but echoing some of the concerns of Proverbs and Ecclesiastes. We are reminded that

> *The fear of the* LORD *is the beginning of wisdom;*
> *all those who practise it have a good understanding. (111:10)*

The following closely linked Psalm speaks of the blessings that come to 'the man who fears the LORD' (112:1): prosperity, integrity, stability and generosity – not an extravagant health-and-wealth 'gospel', but a description of godly character. Psalm 113 presents the blessing of family life, as does 128. Other Wisdom Psalms include 39, that of a man conscious of God's chastening, and pleading:

> *Look away from me, that I may smile again,*
> *before I depart and am no more. (39:13)*

Psalm 49 exposes materialism for its folly and dehumanising effects: 'when he dies he will carry nothing away; his glory will not go down after him ... [He] is like the beasts that perish' (49:17,20). Instead, as we saw above, the writer looks to God to ransom his soul, an insight left unexplained.

Many conditions find expression in prayer: waiting on God (62), yearning for him (42, 43), thirsting for him (63); seeking God when feeling spiritually alone (12, 14), perhaps deserted by God (13) or feeling oppressed and weary under circumstances and God's dealing with one (6).

Then there are all the Psalms in books 1 and 2, i.e. Psalms 3–70, which call upon God for help time and again: 3, 7, 16, 17, 18, 22, 31, 35 and so on. Why so many? Is it not frankly a bit monotonous, overdone? A modern Christian song contains these simple lines:

> I call out to you again and again.
> I call out to you again and again.

That is one lesson taught by such Psalms: we may and we must call out to God again and again. 'Pray continually' (1Thess 5:17 NIV).

Psalm 25 contains instruction and example on that, sometimes, difficult subject of guidance, notably 25:8-10,12-15. Psalm 30 warns of and illustrates the danger of self-assurance in easy times. Psalm 37 with its echoes of Job and Proverbs treats at greater length than Psalm 62 the wisdom of waiting on God patiently; it has on a number of occasions restored my inner peace in the face of stubborn evil:

> *Fret not yourself because of evildoers;*
> *be not envious of wrongdoers!*
> *For they will soon fade like the grass*
> *and wither like the green herb.*
> *Trust in the* LORD, *and do good;*
> *dwell in the land and befriend faithfulness.*
> *Delight yourself in the* LORD,
> *and he will give you the desires of your heart.* (37:1-4)

So far I have said very little about Psalms 120-134, known as the Songs of Ascents, which contain some of the most popular Psalms. Alec Motyer calls them 'the Pilgrims' Songbook', in his recent publication of masterly addresses of some thirty years ago.[9] I simply urge all my readers to acquire and benefit from it themselves.

I have provided an overview of the pastoral riches of some of the Psalms. All believers need to find for themselves those texts that minister to their condition, perhaps also to their temperament. Some will become precious over the years, others may come as a helpful surprise in later life or new circumstances. These will generally be most suitable for private devotion, though some – e.g. the penitential Psalms, and those helping us to seek God, like Psalm 42 – may be of value in public worship.

Those of most obvious value in public worship are, to use the modern phrase, 'worship songs', in older English 'hymns': those which worship God our Creator, law-giver, Redeemer, Judge. Psalm 145 and the great concluding doxology in 146-150 are suitable for opening or closing public worship, as are 92, 93, 95-100. Psalm 103 is for all seasons. Those on God's word written (1, 19 and 119's 22 sections) can have their place. The harvest Psalms (65, 67 and 147), family Psalms (113, 127, 128) and evening Psalm 134 will all be found relevant and useful. Messianic Psalms are of immense value, but need to be familiar, or explained, to the worshippers.

9. Alec Motyer, *Journey: Psalms for pilgrim people* (Nottingham UK: IVP, 2009). Equally recommended is his *Treasures of the King: Psalms from the life of David* (Nottingham UK: IVP, 2007).

THE PSALMS IN PUBLIC WORSHIP

To introduce the Psalms into public worship, start with just perhaps three or four out of 46, 93,103, 121, 139, 145, sung to familiar tunes. Metre and familiarity alone do not make a tune suitable. The party game of singing flippant words, nursery rhymes or the like, to a heavy, solemn tune or vice versa for comic effect is, alas, all too often replicated by Evangelicals in a mismarriage of Psalm text or hymn and tune – perhaps not to comic effect, but sufficient to kill off the words. Take time to learn any new tune properly, repeating it a couple of times midweek before its re-appearance. See your accompanist understands and knows the words.

Keep a record and build a repertoire of 25 or so Psalms to sing twice a year each. The following 52 may provide a helpful quarry: 1, 8, 15, 16, 19, 24, 30, 32, 33,34, 42, 46, 47, 48, 51, 62, 63, 66, 67, 72, 73, 80, 84, 85, 90, 91, 92, 93, 95, 96, 97, 99, 100, 103, 110, 111, 115, 117,121, 122, 126, 127, 128, 130, 133, 135, 139, 145, 146, 147, 148, 150. The most personal and popular of all you sing already.

Try one a week, alternately morning and evening. Don't copy the keen young pastor who introduced two or three Psalms per service. You can guess the result.

Some, including some fine evangelical leaders, sing nothing else. With great respect we must disagree with them. Christians love to sing the praise of the Lord Jesus Christ.

In AD 112 Pliny the younger reported to the Emperor Trajan that Christians were 'accustomed to meet before daybreak, and to recite a hymn antiphonally to Christ, as to a god'.[10] Long before, in the New Testament itself, we find evidence of Christian hymns. The great passage about Christ's humiliation and exaltation for our redemption (Phil 2:5-11), is clearly a hymn and has been versified in English a number of times. So is 1 Timothy 3:16,[11] the basis of Vernon Higham's most successful hymn, 'Great is the gospel of our glorious God.'[12]

When Paul writes to Corinth he observes, 'Each one has a hymn' (1 Cor 14:26). Charles Hodge comments, 'this can hardly mean one of the Psalms.'

10. Henry Bettenson, *Documents of the Christian Church* (Oxford: OUP, 1943) p.4.
11. '...the hymn from which Paul now quotes six lines.' William Hendriksen, *I & II Timothy & Titus*, (London UK: Banner of Truth, 1960) p.137.
12. Although it must be said that in purporting to paraphrase or draw on 1 Tim 3:16, he ignores the incarnation, which is the foundation of the Apostle's words: 'manifested in the flesh...'

True, the Greek is *psalmon*, the word used in the Septuagint for the Book of Psalms; but as Hodge explains, it means 'a song of praise to God'.[13] Dictionaries tell us the root of the word is to pluck a stringed instrument, coming in time to mean to sing to it. James recommends the cheerful believer, 'let him sing praise' – *psalleto* (Jas 5:13). He might mean psalms, but he could certainly mean hymns. Paul and Silas were singing hymns (the verb is *hymnoun*) in prison (Acts 16:25), no doubt for their own benefit (Eph 5:19), but also for others within earshot. Did the jailer hear some before he went to sleep? (Acts 16:29-30)

Limiting ourselves to the Psalms really means restricting our sung worship to pre-Christian revelation – in principle, at least, to that of the synagogue. It would be missing so much divine light: 'For the law was given through Moses; grace and truth came through Jesus Christ' (John 1:17). The cumulative revelation of the Scriptures comes to its glorious fulness in his advent, life, death, resurrection, ascent to glory, intercession and second advent. Shall we believers not sing with delight to and of our beloved Saviour? And sing to and of our all-glorious, self-revealed triune God?

Rightly we sing Trinitarian hymns like Watts's 'We give immortal praise', Bonar's 'Glory be to God the Father' and of course Thomas Ken's doxology 'Praise God from whom all blessings flow'. Rightly too we praise our Saviour with 'Join all the glorious names', 'We sing the praise of him who died', 'Love's redeeming work is done', 'How sweet the name of Jesus sounds'. It is no discourtesy to the Psalmists (nor to the Holy Spirit who inspired them) to sing of what they could only dimly foresee. So in heaven our praise will far surpass that of our present 'poor lisping, stammering tongue'.

We must see our selection of hymns balances the Trinitarian and the Christocentric. Anglicans tend to emphasise the former, Independents the latter. We must certainly take care to neglect neither or our worship will not be truly Christian.

The Psalms nevertheless have distinct value in Christian worship. Their divine inspiration and use in the New Testament, as well as in Christian theology, make that crystal clear. No wonder Spurgeon placed his selection of Psalm versions as the first 150 numbers in *Our Own Hymn-Book*. Others have followed his wise example, the most recent being *Praise!*

13. *A Commentary on the First Epistle to the Corinthians* (London UK: Banner of Truth, 1958) p.300.

They set an example and standard for our hymns. They blend perfectly the sense of awe at the greatness and majesty of God with a sense of delight in him and boldness in addressing him. We too easily err in one direction or the other: overwhelmed by holiness and majesty, or over-intimate in cosying up to the God of grace. 'We have made God too familiar to us – we have made him ... our "buddy" and our "pal".'[14]

The Psalmists also question him, sometimes bewildered, sometimes agonised. But they never forget that he is God. Psalm 73 is an example. In their anxious questioning they are, far more often than not, concerned for his glory.

They are honest before him in confessing their condition and need as sinners and in seeking forgiveness with a truly contrite heart. There are no glib excuses, no downplaying the gravity of sin, no cheap grace. The language is always measured, appropriate, adult, thought through, well written, even in the shortest like Psalms 117 and 131.

The Psalms also demonstrate a proper balance between the subjective and the objective, between being about me, my needs and my feelings; and being about God, his grace and his glory. The subjective emphasis of Christian hymns and songs today is nothing new. It goes back through Wordsworth and the Romantic Movement to Jean-Jacques Rousseau (1712-78) as a counterweight to the rise of European rationalism. The increasing use of 'heart' for the seat of the emotions rather than the centre of one's being, together with two centuries' emphasis on the importance of the individual, affects us all.

They do not ignore the individual, far from it. Just under half contain 'I', 'me', or 'my' in the opening verse. Yet what a vast picture of God they present! Psalm 23 is an extreme case: 17 references to 'me' in its six short verses, but it starts with Israel's covenant God, the Lord, and concludes in 'the house of the Lord for ever'. In between it speaks of his lifelong provision, his 'goodness and mercy', that last word meaning his steadfast covenant love (*hesed*).

Those who oppose the use of hymns in Christian worship point out that human compositions may contain error. Too right! Over the last sixty years we Evangelicals have dropped our guard and allowed dubious or unsound hymns into our books and worship. And that includes those who consider themselves as Reformed. For all his brilliance and fire, Charles Wesley needs careful watching; *Christian Hymns* rescued 'Spirit of faith, come down' by

14. Robert Reymond, *What is God?* (Fearn UK: Christian Focus, 2007) p.180.

changing one word. Yet it is amazing how much error Evangelicals tolerate in their hymns that they would never sanction in the pulpit. Watts, Newton and Montgomery are the most reliable of the classic hymn-writers. But don't just take my word for it (Acts 17:11).

Finally, the Psalms can help with the question of appropriate language for Christian worship. God's wonder and glory can be as properly expressed in modern versions of the Bible as in older ones. We do not need antique language to worship God. The sonorous language of the AV is indeed magnificent and memorable, designed for declamation in public, after the Elizabethans had brought our language to its finest flowering. Its lineal descendants, the RV, ASV, RSV and ESV, retain noble expression despite the steady decline of English. But the simpler *New Living Translation* (2000 AD), made by an army including men from Westminster, Reformed, Calvin and Covenant Seminaries, shows how plain modern English can properly present the majesty and glory of God.

I understand why some address God in dated language, the old familiar 'thou' creating a sense of distance and respect. But like Gothic arches, vestments and plainsong, that is aesthetic, not spiritual. Those who preach God from the Scriptures in all his power, infinitude, holiness, wisdom, love, supported by the Psalms and soundly biblical hymns, will find they can address God properly in today's language. Look at Professor Robert Reymond's prayers offered before and after each lecture published in his *What is God?* referred to above.

All who know the Psalms appreciate that they offer no encouragement to a mystifying trend in some circles towards the trivial and even the childish in worship. The child-like (Ps 131:2; Matt 18:3-4) has been confused with the infantile. 'Brothers, do not be children in your thinking. Be infants in evil, but in your thinking be mature' (1 Cor 14:20). Yet today students and grown men are singing the 'nursery rhymes' of the church.

The trend goes back 60 years or more. The last two or three decades have brought a wave of lively music in popular style with thin content, trivial even, at times erroneous, whose meagre material has to be re-sung ad nauseam to make up for its brevity. The music should not be the real issue, though in some places it is shamelessly exploited to work up a mood or atmosphere. No wonder some Evangelicals tragically leave so-called evangelical worship for the solemnity of Anglo-Catholic or even Roman worship – which is no substitute for profound Reformed worship.

Are our theological colleges properly training students to conduct worship according to biblical standards? And doing it by example in daily chapel services? Reformed churches must avoid this steep decline and set high standards of public worship, without being dull or old-fashioned. There is, after all, much good material. Our leading 20th-century hymn-writers, Margaret Clarkson, Timothy Dudley-Smith, Christopher Idle and Martin Leckebusch, have written nearly 1,000 hymns, which pastors ought to know and use. And pastors must be responsible for the content of everything that is sung in their churches.

Modern Psalm versions can be found in *The Psalter Hymnal* (1987) of the Christian Reformed Church, USA and in *Sing Psalms* (2003) of the Free Church of Scotland. *Praise!* (2000) starts with a complete set of Psalms. Timothy Dudley-Smith's collected hymns, *A House of Praise* (OUP, 2003), contain 40 complete versions, Christopher Idle's *Light upon the River* has complete texts of 60 Psalms. Some of these last two collections and some of my own will be found in *The Book of Praises* (1986), now available from Evangelical Press. Some of Timothy Dudley-Smith's, Christopher Idle's, Emma Turl's and of mine can be found on the website **www.jubilate.co.uk** of Jubilate Hymns Ltd and also in the hymnbook *Praise! Lament and Laughter* offers metrical versions of the whole Psalter.

When the preaching of the gospel has prospered, bringing into being churches vibrant with spiritual life, men and women have taken great delight in praising their Maker and Redeemer through these scriptural hymns. May God be pleased in his sovereign grace to look on our land with mercy and again pour out his Holy Spirit in revival.

3

Metres and Music

ABBREVIATIONS

DSM = 66 86 x 2 (Double short metre)

CM = 86 86 (Common metre)

DCM = 86 86 x 2 (Double common metre)

LM = 88 88 (Long metre)

DLM = 88 88 x2 (Double long metre)

	Metre	Tune	Composers and sources
1	88 88 88	Greenhill	John Barnard
2	88 88 88	Castle Hedingham	Gill Berry
3	88 88 88	Ad astra	Henry G. Ley
4	LM	Cromer	J. Ambrose Lloyd
5	DCM	St Matthew	W. Croft
6	76 76	Lily	Irish Folk Melody
7	DLM	Merthyr Tydfil	Joseph Parry
8	DCM	Ladywell	W. H. Ferguson
9	DCM	Evangel=Seraph	G. W. Fink
10	DCM	Halifax	Handel, arranged Charles W. Douglas
11	DCM	Hands of the poor	Alfred V. Fedak

	Metre	Tune	Composers and sources
12	CM	Burford	Chetham's *A Book of Psalmody*
13	87 87 x2	Llanymawddwy	David G. Preston
14	10 10	Insipiens	David G. Preston
15	LM	Cross Deep, Bow Brickhill	Barry Rose, Sydney Nicholson
16	DCM/CM	Kingsfold/Godre'r Coed	English traditional melody/ Matthew Davies
17	10 10 10 10 D	new tune needed	
18	66 66 88	St Godric	J. B. Dykes
19	DLM	Radiant City	Thomas Pavlechko
20	10 10 10 10	Rock Harbor	Alan MacMillan
21	10 10. 10 10. 10 10	Anirts	Robert Gower
22	12 10 12 10 D	Above the voices of the world	Phil Burt
23	CM	Crimond	Jessie Irvine
24	DSM	(St) Ishmael	Charles J. Vincent
25	88 88 88	St Matthias	W. H. Monk
26	LM	Bishopsteignton	Linda Mawson
27	98 98 x 2	Crugybar, Llwynwern	*Moliant Seion* 1883, E. T. Davies
28	DSM	Dinbych	Joseph Parry
29	55 55 65 65	Old 104th	Ravenscroft's *Psalter* 1621
30	66 66 88	Andrew, Eastview	David McCarthy, J. V. Lee
31	11 10 11 10 x2	Above the voices of the world	Phil Burt
32	88 88 x2	Rhyd-y-groes	T. D. Edwards
33	DCM	Evangel=Seraph	G. W. Fink
34	88 88 88	Isaac=Mozart	Mozart
35	12 10 12 10 x2	Above the voices of the world	Phil Burt
36	10 10. 10 10. 10 10	Anirts	Robert Gower
37	66 66 88	Eastview, St Godric	J. V. Lee, J. B. Dykes
38	DCM	Shepherds' Pipes	Annabeth McClelland Gay
39	10 10. 10 10. 10 10	Unde et memores	W. H. Monk
40	DLM	Rhyd-y-groes	T. D. Edwards
41	10 10. 10 10. 10 10	Ravendale	John Wilson
42	77 77 x 2	Aberystwyth	Joseph Parry

METRES AND MUSIC

	Metre	Tune	Composers and sources
43	77 77 X 2	Aberystwyth	Joseph Parry
44	11 10 11 10 X 2	Above the voices of the world	Phil Burt
45	10 10. 10 10. 10 10	Northleach	John Barnard
46	DLM	Jerusalem	Hubert Parry
47	LM	Church Triumphant	J. W. Elliott
48	10 10. 10 10. 10 10	Anirts	Robert Gower
49	11 10 11 10 X 2	Above the voices of the world	Phil Burt
50	10 10. 10 10. 10 10	Song 24	Orlando Gibbbons
51	87 87 X 2	In Memoriam (Roberts)	Caradog Roberts
52	DCM	Shepherds' Pipes	Annabeth McClelland Gay
53	LM	Halladale	Donald M. MacDonald & Isobel Gordon
54	LM	Plaistow, Brynteg	*Magdalen Chapel Hymns*, c. 1760, J. A. Lloyd
55	7 7 X 5	Whyteleafe	John Crothers
56	88 88 88	Ad astra	Henry G. Ley
57	DLM	Dawn, St Patrick	David G. Preston, Irish traditional melody
58	10 10 10 10	Cadboll Road	Isobel Gordon
59	DLM	Rhyd-y-groes	T. D. Edwards
60	DLM	Merthyr Tydfil	Joseph Parry
61	55 85 X2	new tune needed	
62	10 10. 10 10. 10 10	Unde et memores	W. H. Monk
63	88 88 88	Isaac=Mozart	Mozart
64	LM	Otterspoor	Ron Klusmeier
65	11 10 11 10 X 2	Londonderry Air	Irish melody
66	87 87 X 2	Love Divine (Zundel)	John Zundel
67	87 87 77	Gounod, Timeless Love	Charles Gounod, Norman Warren
68	10 10. 10 10. 10 10	Ravendale	John Wilson
69	12 10 12 10 X 2	Above the voices of the world	Phil Burt
70	76 76 X 2	Blackdown, Llangloffan	Andrew Maries, Welsh hymn melody

	Metre	Tune	Composers and sources
71	11 10 11 10 X 2	Above the voices of the world	Phil Burt
72	87 87 X2	Calon Lân, Llangloffan	John Hughes (Glandŵr), Welsh hymn melody
73	87 87 X2	Arwelfa	John Hughes (Dolgellau)
74	11 10 11 10 X2	Sovereign God	John Crothers
75	LM	Bow Brickhill, Wareham	Sydney Nicholson, William Knapp
76	88 88 88	Magdalen=Rest	John Stainer
77	87 87 X2	Cefn Nawr	Wilfred Jones
		In Memoriam (Roberts)	Caradog Roberts
78	10 10 10 10 X2	new tune needed	
79	11 10 11 10 X 2	Sovereign God	John Cruthers
80	10 10 10 10 X 2	new tune needed	
81	88 88 88	Reading, Chilworth	Francis Westbrook, Gill Berry
82	LM	Dunedin, Luther's chant	Vernon Griffiths, H. C. Zeuner
83	DLM	Rhyd-y-groes	T. D. Edwards
84	12 10. 12 10. 12 10. 12 12	Londonderry Air	Irish melody
85	10 10 10 10	Chilton Foliat	George C. Martin
86	10 10. 10 10. 10 10	Anirts	Robert Gower
87	87 87	Stuttgart	Adapted from a melody in *Psalmodia Sacra, Gotha*, 1715
88	10 10 10 10 X 2	new tune needed	
89	11 10 11 10 X 2	Above the voices of the world	Phil Burt
90	DCM	St Matthew, Ladywell	W. Croft, W. H. Ferguson
91	87 87 X2	Calon Lân	John Hughes (Glandŵr)
92	88 88 88	Isaac=Mozart	Mozart
93	LM	Winchester New	German Chorale, arr. W. H. Havergal
94	10 10. 10 10. 10 10	Ravendale	John Wilson
95	56 12 66 12	Harwich	Benjamin Milgrove
96	55 55 65 65	Grazeley	David G. Preston
97	LM	Niagara	Robert Jackson
98	55 55 65 65	Swallowfield	David G. Preston

	Metre	Tune	Composers and sources
99	11 10 11 10	Costain	G. A. Costain
100	(1) CM	Jackson	Thomas Jackson
	(2) 39 35 99	Jubilation, Chatsworth	Noël Tredinnick, Brian Hoare
101	76 76 x 2	Elstree	Linda Mawson
102	11 10 11 10 x 2	Above the voices of the world	Phil Burt
103	87 87 x 2	Arwelfa, Abbot's Leigh	John Hughes (Dolgellau), Cyril Taylor
104	87 87 x 2	Hyfrydol, Bethany	R. H. Pritchard, Henry Smart
105	10 10 10 10 x 2	new tune needed	
106	10 10 10 10 x 2	new tune needed	
107	10 10 10 10 x 2	new tune needed	
108	DLM	Merthyr Tydfil, St Patrick	Joseph Parry, Irish traditional melody
109	11 10 11 10 x 2	Above the voices of the world	Phil Burt
110	DSM	Jericho	from Handel
111	LM	Cross Deep	Barry Rose
112	LM	Bow Brickhill	Sydney Nicholson
113	88 88 88	Magdalen=Rest	John Stainer
		Isaac=Mozart	Mozart
114	LM	Niagara	Robert Jackson
115	87 87 x 2	Arwelfa, Love Divine	John Hughes (Dolgellau), John Zundel
116	10 4 10 4 10 10	Basingstoke	James Clarke
117	77 77 + Hallelujahs	Llanfair	Robert Williams
118	10 10. 10 10. x 2	Ambleside	Gill Berry
119	10 10 10 10	Sursum corda	A. M. Smith
		Julius	Martin Shaw
		Chilton Folliat	George C. Martin
		Rock Harbor	Alan MacMillan
120	CM	Burford	Chetham's *A Book of Psalmody*
121	11 6. 11 6	Berwyn	Caradog Roberts
122	CM	Glasgow, Arden	Moore's *Psalm-singer's Pocket companion*, George Thalben-Ball

	Metre	Tune	Composers and sources
123	77 77 x 2	Tichfield, Y. Bugail Da	John Richardson, John Richards
124	87 87 x 2	Dim ond Jesu	Robert Lowry
125	CM	St Timothy, Godre'r coed	H. W. Baker, Matthew Davies
126	87 87	Marching	Martin Shaw
127	LM	Luther's Chant	H. C. Zeuner
128	CM	Billing	R. R. Terry
129	LM	Llef	Griffith Hugh Jones
130	CM	Bangor	William Tans'ur
131	CM	Stanton, St Botolph	John Barnard, Gordon Slater
132	87 87 x 2	Rustington, In Memoriam (Roberts)	Hubert Parry, Caradog Roberts
133	66 66 88	Rhosymedre, Eastview	J. D. Edwards, J. V. Lee
134	LM	Herford	S. S. Wesley
135	DLM	Rhyd-y-goes	T. D. Edwards
136	8 8 8.8 8 8	Monmouth	Gabriel Davies
137	8 6 8 6 8 86	Herr Jesus Christ, du höchstest gut	German chorale, harmony after J. S. Bach
138	LM	Festus	Freylinghausen's *Gesangbuch* 1714
139	87 87 x 2	Blaenwern	W. P. Rowlands
140	88 88 88	Ad astra	Henry G. Ley
141	10 10 10 10 10 10	Unde et memores	W. H. Monk
142	DCM	Hands of the poor	Alfred V. Fedak
143	LM	Bishopsteignton	Linda Mawson
144	11 11 11 11	Mongomery	*Magdalen Hospital Hymns* c. 1762
145	66 66 88	Millennium	Anon.
146	LM	Festus	Freylinghausen's *Gesangbuch* 1714
147	87 87 x 2	Ascension (Bancroft)	H. H. Bancroft
148	65 65 x 2	Cuddeston, Camberwell	W. H. Ferguson, J. M. Brierley
149	55 55 65 65	Houghton	H. J. Gauntlett
150	77 77 + Hallelujahs	Llanfair	Robert Williams